To Christophe & Amélie,
my best souvenirs from Paris.

Contents

Introduction

Dear Reader,

The Paris Letters project began in a café in Paris. I was filled to the brim with the desire to share all the treasures I was finding in my new city. I had recently discovered the illustrated letters of Percy Kelly through my friends Karen and Rob while visiting them on a trip through the UK. His combination of art and words sent as a letter to a friend was magical. A letter would be the perfect art form to share Paris through my eyes. Plus, I was investigating a charming new beau I had met in Paris. The lovely Christophe and I had locked eyes on rue Mouffetard, a market street in the Latin Quarter. He was roasting chickens at the *boucherie*. I was sitting at a café across the narrow street. Soon, other things began to click, and I moved in with him. He didn't speak English. I barely spoke French. He was a butcher with sharp knives. Logically, this was a bad idea, but we leaned in anyway, as if forces beyond our control were magnetizing us to each other.

The details of this little love affair appeared in my book *Paris Letters,* which is where I describe just how I came to be an artist in Paris by creating illustrated letters and mailing them out to those who subscribed on my Etsy shop. Some of the letters in the volume before you can be found in *Paris Letters*. Other bits of artwork and words from the letters were reconfigured as journal entries in the subsequent book *A Paris Year*, a travel journal of my time in Paris, which contrary to the book title, was a great deal

longer than a year. In fact, my little project spans the time from 2012 to 2020. Most letters made their splashy debut in mailboxes of loyal subscribers. I also created a few travel letters and added the most popular, since life in Paris tends to include travel.

The letters presented here could be considered at best a best-of album, or at least a most-of album. Once I reached the 140-letter mark, I noticed my binder of letters was getting thick and heavy. My subscribers who dutifully added their letters into their own binders felt the same. We wanted something easy to handle and flip through, something to slip into a bag for perusing on a park bench or café, something to sum up the project nicely. I think this volume does it.

When I first arrived in Paris, I felt like I was late. All the museums and plaques and galleries referred to events that happened already: Napoleon, the Revolution, the Belle Époque, the Lost Generation, and the Beat Generation had already come, conquered, and left an army of statues and books in their wake. But as I sifted through my letters in anticipation of this book, I noticed that so many significant events *did* happen between 2012 and 2020: elections, terrorist attacks, the World Cup, the Gilet Jaunes (Yellow Vests) demonstrations, the Notre Dame fire, and the loss of icons like crooner Johnny Hallyday, chef Paul Bocuse, and designer Karl Lagerfeld. Stuff happened. And stuff happened to me, too. These letters hint at my own history with Paris. I arrived alone, fell in love, started a business, married, wrote books, had a baby, survived cancer, and still managed to write, illustrate, and send out letters to thousands of people around the world month after month. My book *Paris Letters* ended up on the the *New York Times* bestseller list;

A Paris Year was hailed as one of *USA Today*'s most beautiful books; and the letters themselves were studied in an Oxford University textbook, which astounds me to this day. *Pas mal*. So it seems I wasn't late. I was just getting a taste of the top layer of a thick mille-feuille of Paris history.

The letters are addressed to Áine (Pronounced aahn-ya, rhymes with lasagna), who is my lovely friend who has written letters to me for ages. There is one exception: this is the letter written in March 2014 featuring Café Le Papillon. This letter was written to a lady named Patricia Lutz. She subscribed to everything I had. There was a moment in time when I had started an offshoot series of letters. I had one subscriber: Patricia. Years later, her family would contact me to let me know that she had passed away suddenly and they had found all the letters tucked in a drawer, including this particular letter, of which I didn't even have a copy. On the day I wrote the letter, I was sitting in a café *(quelle surprise)* and thought I should take it home and make a copy. But I was on the other side of town, my feet hurt, and the post office was nearby. Plus, I never thought I'd need it for an anthology. I folded it, stamped it, and popped it in the post. Thankfully, her daughter Bernadette was able to send this humble author a copy. Now I continue to send and address letters to Bernadette, but I write them for Patricia, whose ghost, I hope, is peering over Bernadette's shoulder to read the latest missive.

Some letters are missing because I cannot bear to look at them again and will not subject you to the horror. There were some real stinkers. If you own a letter from me that didn't end up in this book, burn it. And I'm sorry. I've also gone back and edited, smoothed

out some lines, and repainted as I bettered my skills. So if your letter doesn't look like the one presented, I hope the edit presented here is considered an improvement.

Finally, a word about endless optimism. That's what these letters reveal. When you really think about it, Paris' history is a bloodbath. So many murders, wars, and plagues. And today, the disgruntled Parisian has even become cliché. To deal with the strikes, leaky pipes, high prices, crime, and air quality on a daily basis requires a tough skin. Despite all this, I love her. I love her though all this, perhaps *because* of all this. She is able to feed my curious mind month after month, year after year. What other city can say this? Rome is so good at being Rome, with all those brilliantly lit ruins, but it does lean a little too closely to one time period for me. New York, too young. London, already covered by deep divers, like those scholars from Oxford and Cambridge who are compelled to investigate and write about something, but nationalism keeps them close to the clotted cream and Marks & Spencer. For me, the only other place that comes close to Paris is the whole rest of France, which shares the rich history but loses marks on the vast space in between. In Paris, it's all crammed into one crooked street after another . . . this is where so and so lived, and just down the street, so and so lived here. They could have walked by each other had they not been born a hundred years apart. In Paris, they can easily be connected by a street, an artistic style, or a café they both frequented. Just connecting two famous thinkers who lived in Paris on the same street can have me pondering them for days. Did they have similar thoughts about the same cafés? One of them angry that a new modern café opens, then a century later, the other delighting to have this old relic at his doorstep. This is the kind of thing that ends up in a letter.

My final letter is at the end of this book. I've had such fun writing about my dear Paris, one letter at a time. I still have these and other Paris art selling in my Etsy shop, which astounds me. Before I started this project, there wasn't even a category for letter subscriptions on Etsy. Now, industrious artists are sending letters about their gardens, their cities, and whatever else. I arrived in Paris when people had forgotten about sending letters (email being so much easier and not requiring a stamp), but my little letter biz stirred up something. People picked it up again. There is, indeed, still a thirst for fun mail. And I have garnered many pen pals who started as subscribers and sent me letters in return. For this, I am glad. We could all use a treat in the day, and having a fun letter arrive in the mail is indeed a treat. The letters had a great run, and letters from the archive are dutifully sent out daily to those who order from my Etsy shop, but it's time to get back to, or start, something else. I'm not sure what that looks like, but I had no idea when I landed in Paris that I'd be doing this for the next decade of my life. And now . . . what will I do with this one wild life of mine? Not sure. But I think I'll ponder the idea at a café around the corner.

Janice

January 2012, Paris

Dear Áine,

I cannot believe my luck. What you see painted here is the view I see when I first walk out of my apartment here in Paris. I live on a market street and the fruit stands are bursting with orange and yellow citrus fruit. Just today a grapefruit leapt into my bag and has found a temporary home on my countertop, but will soon make its final journey down the hatch and into my belly, except for a drop or two, which will likely land on my shirt. It seems even the citrus itself can hardly contain itself. It must be delighted to be gazed at so lovingly by admirers like me who lick their lips in anticipation of its sweet demise.

Janice

"Paris was all so . . . Parisian. I was captivated by the wonderful wrongness of it all—the unfamiliar fonts, the brand names in the supermarket, the dimensions of the bricks and paving stones. Children, really quite small children, speaking fluent French!"

David Nicholls, *Us*

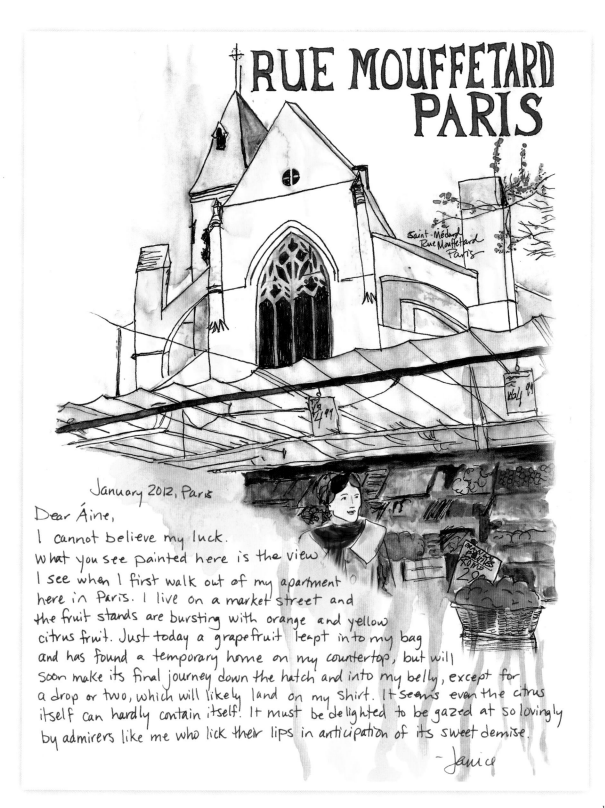

RUE MOUFFETARD PARIS

Saint-Médard
Rue Mouffetard
Paris

January 2012, Paris

Dear Áine,

I cannot believe my luck.
What you see painted here is the view
I see when I first walk out of my apartment
here in Paris. I live on a market street and
the fruit stands are bursting with orange and yellow
citrus fruit. Just today a grapefruit leapt into my bag
and has found a temporary home on my countertop, but will
soon make its final journey down the hatch and into my belly, except for
a drop or two, which will likely land on my shirt. It seems even the citrus
itself can hardly contain itself! It must be delighted to be gazed at so lovingly
by admirers like me who lick their lips in anticipation of its sweet demise.

— Janice

1

Le Métro

February 2012, Paris

Dear Áine,

I thought when I arrived in Paris that my first hurdle would be the language. That fear fell away the moment I had to use the Métro, Paris' transit system. There are currently 302 stations, which makes the newcomer to Paris want to walk. But you soon learn that Paris is too much city for your aching feet. Plus, the Art Nouveau design of the underground stations is seductive. They draw you in and soon you are swallowed by the belly of the city. To your surprise and relief, the Métro is easier to master than you thought it would be. Maps are everywhere—above ground, below ground, and above each door on each train so you can check and check and check again all along your route. As I sit on the train, I think about those who carved out the Métro system underneath the city—likely blowing out ancient ruins and catacombs in the process. No one seems to mind. We sit in silent contemplation as we zip under the city, occasionally verifying with a sideways glance at the map that we are, in fact, headed in the right direction.

Janice

"When we turned into the Paris boulevards from the high-way, I caught my breath. I'd forgotten the art nouveau Métro arches and lampposts . . . The fruit trees were in blossom. 'Stop!' I cried as we passed a boulangerie where a woman in a white crimped baker's hat was putting profiteroles into a window case. My cousin swerved over so that I could run out to buy six in a box, the aroma filling my nostrils. We ate them all, sitting on a park bench in the dappled sun . . ."

Roxane Farmanfarmaian, *Paris Was Ours*

Dear Áine, February 2012, Paris

I thought when I arrived in Paris that my first hurdle would be the
language. Not so. That fear fell away the moment I had to use the
Métro, Paris' transit system. There are currently 302 stations, which
makes the newcomer to Paris want to walk. But you soon learn that
Paris is too much city for your aching feet. Plus, the Art Nouveau
design of the underground stations is seductive. They draw you in and
soon you are swallowed by the belly of the city. To your surprise and
relief, the Métro is easier to master than you thought it would be. Maps
are everywhere — above ground, below ground, and above each door on each
train so you can check and check and check again all along your route.
As I sit on the train, I think about those who carved out the Métro system
underneath the city — likely blowing out ancient ruins and catacombs
in the process. No one seems to mind. We sit in silent contemplation as
we zip under the city, occasionally verifying with a sideways glance at
the map that we are, in fact, headed in the
 right direction.
 —Janice

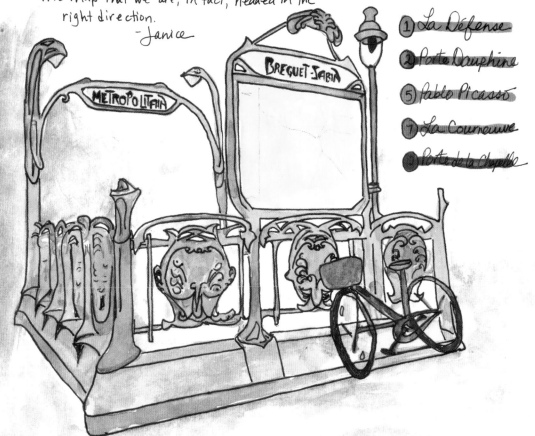

1 La Défense
2 Porte Dauphine
5 Pablo Picasso
7 La Courneuve
• Porte de la Chapelle

March 2012, Paris

Dear Áine,

I spent the day meandering through a flea market. When you're an old country like France, a lot of stuff piles up. Random things are passed down through the generations or are found after years of hibernation in dresser drawers or long forgotten boxes in attics. So I was not surprised to come across a pile of postcards from the turn of the century. After purchasing a stack, I zipped off to the Angelina café to take a closer look at my new acquisitions.

The Angelina café serves such a thick hot chocolate that I dare not ask for the ingredients. Stops the heart just imagining the amount of cream, sugar, and chocolate it takes to make something this heavenly. The powdered concoctions of my youth should hang their heads in shame. This hot chocolate trumps them all. Upon closer inspection of my postcards, I noticed many from a M. Deluchar to a Mme. Martinazo.

The messages were innocent—happy birthdays and happy new years. But the volume of postcards made me wonder if there was a hidden romance or unrequited love. She clearly kept them all. Did he agonize over his choice of postcard? Hoping it conveyed a secret message of a love that could never be? Was it one love letter that took a lifetime to write? For the sake of my romantic heart, I hope so. My imagination spilled over with delicious possibilities. Looking back, I wonder if I was simply drunk in love with my hot chocolate.

Janice

"What you see before you, my friend, is the result of a lifetime of chocolate."

Katharine Hepburn

Dear Áine,

I spent the day meandering through a flea market. When you're an old country like France, a lot of stuff piles up. Random things are passed down through the generations or are found after years of hibernation in dresser drawers or long forgotten boxes in attics. So I was not surprised to come across a pile of postcards from the turn of the century. After purchasing a stack, I zipped off to the Angelina café to take a closer look at my new acquisitions.

The Angelina café serves such a thick hot chocolate that I dare not ask for the ingredients. Stops the heart just imagining the amount of cream, sugar, and chocolate it takes to make something this heavenly. The powdered concoctions of my youth should hang their heads in shame. This hot chocolate trumps them all. Upon closer inspection of my postcards, I noticed many from a M. Deluchar to a Mme. Martinazo.

ANGELINA

PARIS

The messages were innocent — happy birthdays and happy new years. But the volume of postcards made me wonder if there was a hidden romance or unrequited love. She clearly kept them all. Did he agonize over his choice of postcard? Hoping it conveyed a secret message of a love that could never be? Was it one love letter that took a lifetime to write? For the sake of my romantic heart, I hope so. My imagination spilled over with delicious possibilities. Looking back, I wonder if I was simply drunk in love with my hot chocolate.

— Janice

April 2012, Paris

Dear Áine,

Paris does something to a person. It unleashes the pent-up romantic. Even if you're not the touchy-feely type, you find yourself begging to hold hands and grope the nearest person as you walk over a bridge just so you can say later that you did it and wasn't that marvelous. What was his name? Does it matter?

You gasp at statues, staring at their curves, forming crushes. Even all the Jesus statues in the churches get you flustered. Those abs. The hero. I shake my head at the inappropriate thoughts, but still keep staring.

In my wandering, I came across this fountain in Jardin du Luxembourg. When I saw this embracing couple, I came undone. I hadn't yet started dating Christophe. Despite my best efforts to embrace being alone, what I really wanted was to be the girl on the rock in the arms of an adoring man. A quiet voice from deep within said, "Yes, please."

A few days later, Christophe and I began our little Paris love affair. Sometimes we sit next to this fountain and listen to the water that makes the noise of the city fade away. Afterward, if we don't know what to say or how to say it, we meander over to the Seine and cross a bridge hand-in-hand so I can say later, "Wasn't that marvelous?!"

Janice

"This was Paris. You didn't eat in bed when you were in Paris. You got out, you explored, you rolled home at an hour during which you were normally asleep. Usually you did this with someone else . . ."

Michelle Gable, *A Paris Apartment*

Dear Áine,

Paris does something to a person. It unleashes the pent-up romantic. Even if you're not the touchy-feely type, you find yourself begging to hold hands and grope the nearest person as you walk over a bridge just so you can say later that you did it and wasn't that marvelous. What was his name? Does it matter?

You gasp at statues, staring at their curves, forming crushes. Even all the Jesus statues in the churches get you flustered. Those abs. The hero. I shake my head at the inappropriate thoughts, but still keep staring.

In my wandering, I came across this fountain in Jardin du Luxembourg. When I saw this embracing couple, I came undone. I hadn't yet started dating Christophe. Despite my best efforts to embrace being alone, what I really wanted was to be the girl on the rock in the arms of an adoring man. A quiet voice from deep within said, "Yes, please."

A few days later, Christophe and I began our little Paris love affair. Sometimes we sit next to this fountain and listen to the water that makes the noise of the city fade away. Afterward, if we don't know what to say or how to say it, we meander over to the Seine and cross a bridge hand-in-hand so I can say later, "Wasn't that marvelous?!"

— Janice

May 2012, Paris

Dear Áine,

I do a lot of walking in Paris. And on these walks, I come across plenty of statues. It's as though the city is standing guard, looking out pensively at something important in the distance. Some of them are heroic generals on horses. Others are serene, like the collection of queens and duchesses at Jardin du Luxembourg. Anne Marie Louise d'Orléans, Duchess of Montpensier, was one of the greatest duchesses in history. She was a defiant young lady, refusing a string of proposals from European ruling families and wanting only to marry for love. When she didn't find it, she opted out of the scene and died unmarried and childless. Many admire her for her strength, but I like her because she is situated under a shady tree and looks over to a grand fountain where children sail boats.

The duchess doesn't do as much exploring as I do around Paris, preferring to stay put as statues are wont to do. By the time I reach her, my dogs are barking and I pull up a chair to rest my feet. We all must find places to explore in this world, but also places to rest. Paris is good about this. It's easy to walk for hours. Once you've lost your way or your zip, you'll likely find a place to sit and take a breather.

The gentleman near me is reading the paper. There is a couple nearby reading a map. And there are dogs—a healthy population of prancing pups, but not as many poodles as I thought there would be. Pugs seem to be the dog du jour, which suits me just fine. Their snorting makes me laugh. Not the duchess though. She's as serious as always, keeping guard over Paris, and perhaps me, too, as I write this letter to you.

Janice

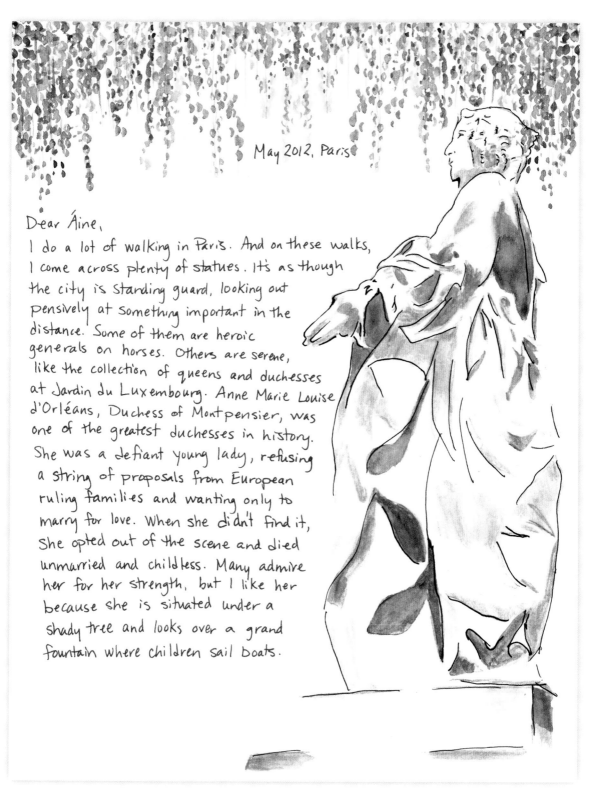

May 2012, Paris

Dear Áine,

I do a lot of walking in Paris. And on these walks,
I come across plenty of statues. It's as though
the city is standing guard, looking out
pensively at something important in the
distance. Some of them are heroic
generals on horses. Others are serene,
like the collection of queens and duchesses
at Jardin du Luxembourg. Anne Marie Louise
d'Orléans, Duchess of Montpensier, was
one of the greatest duchesses in history.
She was a defiant young lady, refusing
a string of proposals from European
ruling families and wanting only to
marry for love. When she didn't find it,
she opted out of the scene and died
unmarried and childless. Many admire
her for her strength, but I like her
because she is situated under a
shady tree and looks over a grand
fountain where children sail boats.

"I don't suppose I really know you very well—but I know you smell like the delicious damp grass that grows near old walls and that your hands are beautiful opening out of your sleeves and that the back of your head is a mossy sheltered cave when there is trouble in the wind and that my cheek just fits the depression in your shoulder."

Zelda Fitzgerald, in a letter to F. Scott Fitzgerald

The duchess doesn't do as much exploring as I do around Paris, preferring to stay put as statues are wont to do. By the time I reach her, my dogs are barking and I pull up a chair to rest my feet. We all must find places to explore in this world, but also places to rest. Paris is good about this. It's easy to walk for hours. Once you've lost your way or your zip, you'll likely find a place to sit and take a breather.

The gentleman sitting near me is reading the paper. There is a couple nearby reading a map. And there are dogs — a healthy population of pups, but not as many poodles as I thought there would be. Pugs seem to be the dog du jour, which suits me just fine. Their snorting makes me laugh. Not the duchess though. She's as serious as always, keeping guard over Paris, and perhaps me, too, as I write this letter to you.

— Janice

June 2012, Paris

Dear Áine,

It's raining in Paris today. Not all day. Just when I gear up to go. The clouds seem to know when I'm putting on my coat and they take it as a cue to downpour. So, while I wait for the latest deluge to subside, I'm writing this letter to you. My haste to get outside is based on an exciting call I received after lunch. The book I ordered has arrived at the local English bookstore. There is something poetic about a good old-fashioned bookstore. I could have Amazon deliver. I've always loved receiving mail and packages. And, I'll be the first to brag about the convenience and pleasure of e-books. The instant access to English books in a French-speaking land is a magical delight. But, there is magic in traditional bookstores, too. You can feel it in the air, like a quiet excitement. And the smell of aging paper and ink is oddly pleasing. To think, some of the people sniffing around these great bookstores have been some of the greatest writers that ever lived.

The rain has subsided for now. The clouds are likely waiting for me to lace up.

Janice

———— ≈ ————

"She breathed deeply of the scent of decaying fiction, disintegrating history, and forgotten verse, and she observed for the first time that a room full of books smelled like dessert: a sweet snack made of figs, vanilla, glue, and cleverness."

Joe Hill, *NOS4A2*

Dear Áine, June 2012, Paris

It's raining in Paris today. Not all day. Just when I gear up to go. The clouds seem
to know when I'm putting on my coat and they take it as a cue to downpour. So,
while I wait for the latest deluge to subside, I'm writing this letter to you. My
haste to get outside is based on an exciting call I received after lunch. The book
I ordered has arrived at the local English bookstore. There is something
poetic about a good old-fashioned bookstore. I could have Amazon deliver.
I've always loved receiving mail and packages. And, I'll be the first to brag
about the convenience and pleasure of e-books. The instant access to English
books in a French-speaking land is a magical delight. But, there is magic
in traditional bookstores, too. You can feel it in the air, like a quiet excitement.
And the smell of aging paper and ink is oddly
pleasing. To think, some of the
people sniffing around these great
bookstores have been some of
the greatest writers that
ever lived.

The rain has subsided
for now. The clouds
are likely waiting
for me to lace up

— Janice

Eiffel Tourists

July 2012, Paris

Dear Áine,

Even though there are only four seasons in Paris, it seems to be the rainy season all year long. And though the tourist season is technically early summer, they seem to be here all year long, too. Lately, I've become the Ambassador of Directions to confused map-gripping vacationers. But if I come upon a group tour, I slink around quickly to get where I want to be. Tourists eventually arrive at the Eiffel Tower. Only here do I hover closer to the groups, who are usually led by a person carrying a large plastic flower that is easily visible for anyone who meanders too far from the pack. The leader rattles off facts and figures about the world's most recognized monument. I don't pay much attention. Instead, I eavesdrop.

It's easy to do and I can't resist. As we all look up into the belly of iron, I hear wives talking about the campaign to convince their husbands to come to Paris, employees talking about the vacation time they had to earn, and students who saved every dime and are willing to eat crêpes on the street for every meal just to be here in this moment. It takes some effort to get where you want to be in this life. Now that they are in Paris looking at the tower they've imagined for so long, they sigh with satisfaction, snap a photo, and look for that big plastic flower to find their way home.

Janice

"I like the Eiffel Tower because it looks like steel and lace."

Natalie Lloyd, *Paperdoll*

Dear Áine,

Even though there are only four seasons in Paris, it seems to be the rainy season all year long. And though the tourist season is technically early summer, they seem to be here all year long, too. Lately, I've become the Ambassador of Directions to confused map-gripping vacationers. But if I come upon a group tour, I slink around quickly to get where I want to be. Tourists eventually arrive at the Eiffel Tower. Only here do I hover close to the groups, who are usually led by a person carrying a large plastic flower that is easily visible for anyone who meanders too far from the pack. The leader rattles off facts and figures about the world's most recognized monument. I don't pay much attention. Instead, I eavesdrop.

It's easy to do and I can't resist. As we all look up into the belly of iron, I hear wives talking about the campaign to convince their husbands to come to Paris, employees talking about the vacation time they had to earn, and students who saved every dime and are willing to eat crêpes on the street for every meal just to be here in this moment. It takes some effort to get where you want to be in this life. Now that they are in Paris looking at the tower they've imagined for so long, they sigh with satisfaction, snap a photo, and look for that big plastic flower to find their way home.

—Janice

Boulangerie Patisserie

August 2012, Paris

Dear Áine,

Back before my life in Paris, when I was working in the old advertising agency, the most challenging aspect of status meetings was to avoid being caught doodling flowers in the margins of my notebook. If left to my own devices, my pages would become lush gardens of inky geraniums. Now, when I see flowers spilling out of windows all over Paris, I realize my doodles were really wishes for a life filled with tendrils and blooms. And now it is. Sweet!

Janice

*"And the day came,
when the risk
to remain tight
in a bud
was more painful
than the risk
it took
to blossom."*

Anaïs Nin, "Risk"

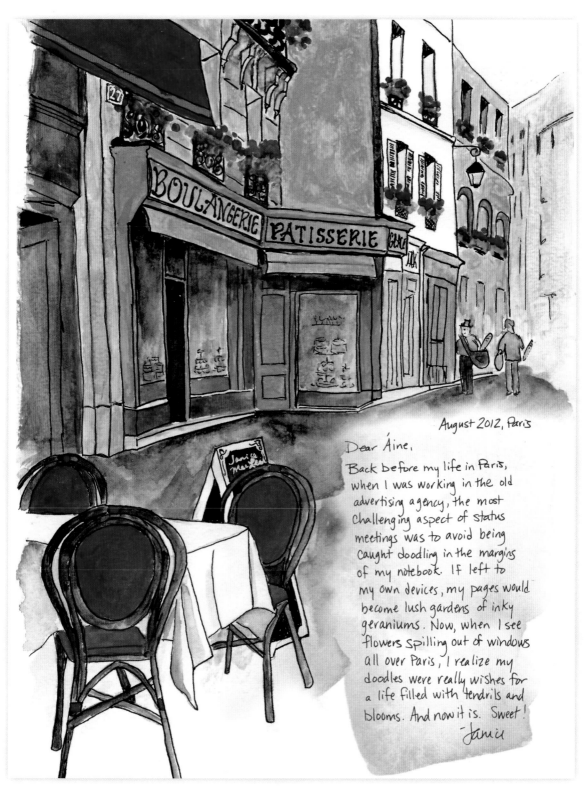

August 2012, Paris

Dear Áine,

Back before my life in Paris, when I was working in the old advertising agency, the most challenging aspect of status meetings was to avoid being caught doodling in the margins of my notebook. If left to my own devices, my pages would become lush gardens of inky geraniums. Now, when I see flowers spilling out of windows all over Paris, I realize my doodles were really wishes for a life filled with tendrils and blooms. And now it is. Sweet!

Janice

Boats

September 2012, Paris

Dear Áine,

You don't realize how much time you spend in Paris deliberating over purchase decisions until all your preferred boutiques close their doors for the month. I was warned about this, that most people go on vacation in August, but I didn't realize the extent of the mass exodus. You have to rejig your mental map of Paris, adjusting for what stays open since so much is closed. I spent more time walking the quay along the Seine and deliberating between which boats I would buy if I was to have a life along the river. I could easily adapt to the space since I can currently clear my apartment in seven paces. France has Europe's largest inland waterway network so there are a variety of interesting vessels coming and going in these waters, making the mental barge shopping more interesting here than in other ports. Perhaps one day I'll revel in life on the water, but for now the shopkeepers are turning their *fermé* signs *ouvert,* so I have more boutiques to visit.

Janice

I can still recall our last summer
I still see it all
Walks along the Seine
Laughing in the rain
Our last summer
Memories that remain"

ABBA, "Our Last Summer"

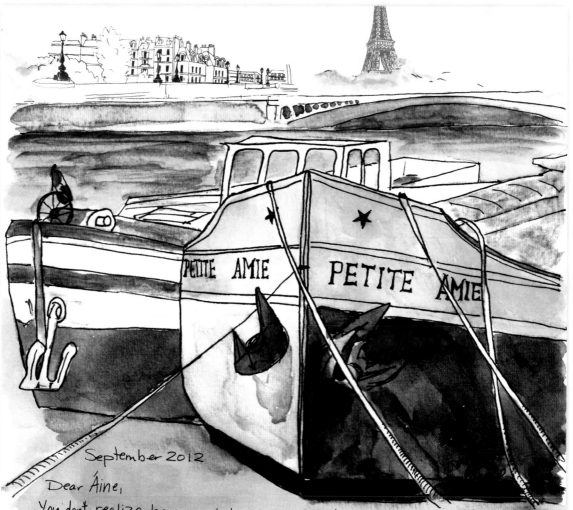

September 2012

Dear Áine,

You don't realize how much time you spend in Paris deliberating over purchase decisions until all your preferred boutiques close their doors for the month. I was warned about this, that most people go on vacation in August, but I didn't realize the extent of the mass exodus. You have to rejig your mental map of Paris, adjusting for what stays open since so much is closed. I spent more time walking the quay along the Seine and deliberating between which boats I would buy if I were to have a life along the river. I could easily adapt to the space since I can currently clear my apartment in seven paces. France has Europe's largest inland waterway network so there are a variety of interesting vessels coming and going on these waters, making the mental barge shopping more interesting here than in other ports. Perhaps one day I'll revel in life on the water, but for now the shop keepers are turning their "Fermé" signs "ouvert," so I have more boutiques to visit. —Janice

October 2012, Paris

Dear Áine,

The weather doesn't know what to do with itself at this time of the year. One day it's hot and humid, the next it's cold and wet—and some days it's both. But that doesn't keep me from exploring—as long as I dress in layers and have my umbrella handy. A scarf is also key, and *très* French!

Though the air seems confused, the earth knows exactly what to do with autumn. Butternut squash is the superstar at the market these days. I am happy to report that the vendors use the English word "Butternut." So that's one less word I need to worry about.

Learning the French language is coming along—slower than I'd prefer, but steady. Some days I feel like I've got it, and other days I feel like I'll never get it. Just as the weather volleys between summer and autumn, I volley between comprehension and confusion. But as each day gets shorter, my vocabulary list gets longer. I hope to understand all of it someday—or even most of it. In the meantime, I'm taking a break from studying and making butternut squash soup, instead. The weather may not know what to do with itself in autumn, but I've got a few ideas on how to get through the season.

Janice

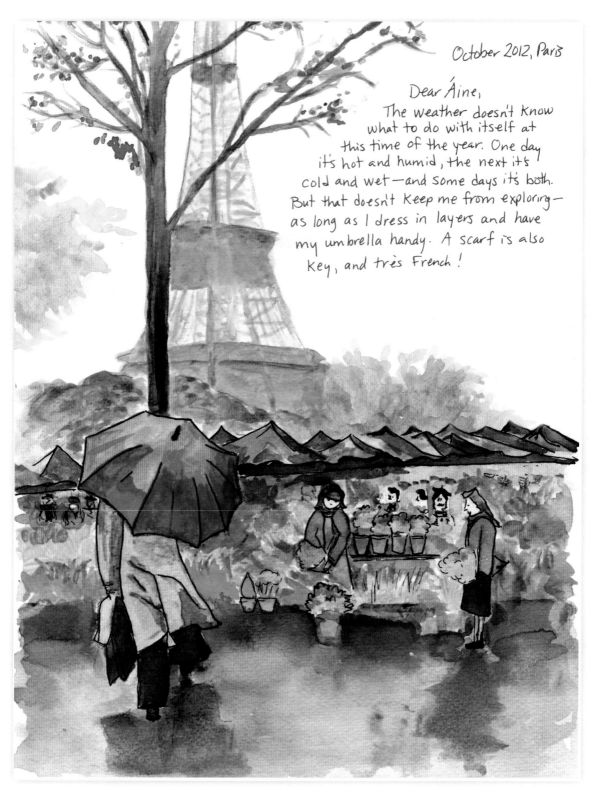

October 2012, Paris

Dear Áine,
The weather doesn't know
what to do with itself at
this time of the year. One day
it's hot and humid, the next it's
cold and wet—and some days it's both.
But that doesn't keep me from exploring—
as long as I dress in layers and have
my umbrella handy. A scarf is also
key, and très French!

"Actually, Paris is the most beautiful in the rain."

Woody Allen, *Midnight in Paris*

Though the air seems confused, the earth knows exactly what to do with autumn. Butternut squash is the superstar at the market these days. I am happy to report that the vendors use the English word "Butternut." So that's one less word I need to worry about.

Learning the French language is coming along — slower than I'd prefer, but steady. Some days I feel like I've got it, and other days I feel like I'll never get it. Just as the weather volleys between summer and autumn, I volley between comprehension and confusion. But as each day gets shorter, my vocabulary list gets longer. I hope to understand all of it some day — or even most of it. In the meantime, I'm taking a break from studying and making butternut squash soup, instead. The weather may not know what to do with itself in autumn, but I've got a few ideas on how to get through the season.

—Janice

November 2012, Paris

Dear Áine,

French women and their fur! The moment the temperature plunged, ladies all over Paris started strutting their stuff in fur—REAL fur. I have seen bulbous fur collars, puffy fur ear warmers, and fur coats that drape nearly to the ground. The whole city is a catwalk and every lady is a supermodel. In my old life, I was surrounded by animal rights activists, so all this fur makes me gasp and wonder if they got the memo. The memo likely came around the same time as the memo about smoking being bad for health. The French likely rolled up both memos with tobacco and smoked them, declaring "Joie de vivre!" between puffs.

Oh the delicious scandal of it all! I walked into a vintage clothing store the other day. So many coats it was like being in a bear cave. I stroked a few that were so soft I wanted to name them Fluffy or Cuddles. Soon I was leaning into the racks and hugging them, whispering "Joie de vivre."

Janice

*"The most courageous act is still
to think for yourself. Aloud."*

Coco Chanel

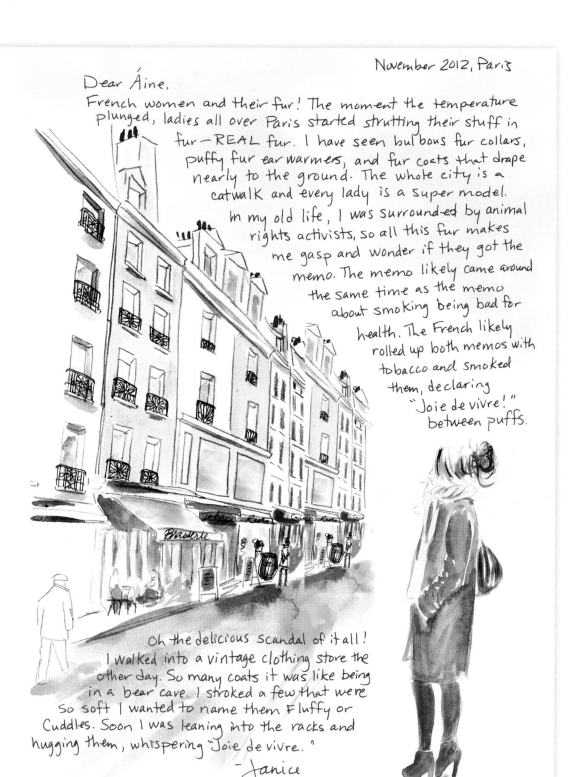

November 2012, Paris

Dear Áine,

French women and their fur! The moment the temperature plunged, ladies all over Paris started strutting their stuff in fur—REAL fur. I have seen bulbous fur collars, puffy fur ear warmers, and fur coats that drape nearly to the ground. The whole city is a catwalk and every lady is a super model.

In my old life, I was surrounded by animal rights activists, so all this fur makes me gasp and wonder if they got the memo. The memo likely came around the same time as the memo about smoking being bad for health. The French likely rolled up both memos with tobacco and smoked them, declaring "Joie de vivre!" between puffs.

Oh the delicious scandal of it all! I walked into a vintage clothing store the other day. So many coats it was like being in a bear cave. I stroked a few that were so soft I wanted to name them Fluffy or Cuddles. Soon I was leaning into the racks and hugging them, whispering "Joie de vivre."

— Janice

December 2012, Paris

Dear Áine,

The City of Lights lives up to its nickname at Christmas. With dusk arriving by late afternoon and twinkle lights draped from the trees, Paris is truly enchanting. There is something indulgent about walking under the deep blue sky beneath the gaze of old streetlamps, then popping into a boutique to absorb the cozy warmth. Parisians overheat their stores. Not that I'm complaining. I love it. Though I spend a lot of time peeling off layers, then bundling up again.

The windows at the large department stores are a dazzling display of animatronic hypnotic wonder that keeps kids young and old gawking from the sidewalk. Usually, designers from the big fashion houses are in charge of the windows. The results are always magnificent. Even my street, rue Mouffetard, is a shimmering wonderland with long strings of lights cascading down the length of the street like a waterfall. It's all rather tasteful around here, which makes me wonder why many of the Christmas trees are heavily sprayed with fake snow of fuchsia, teal, and—I'm sorry to say—yellow. There isn't much snow in Paris, which is surprising since every souvenir shop has walls of dreamy snow globes. They remind me of my French teacher from my life before Paris. He had asked me if I'd ever been to Paris. "No," I said. "I dream of Paris." He shook his head. "Mademoiselle," he said. "You've got your verbs wrong again. It's not 'to dream.' It's *aller*, 'to go.'"

Joyeux Noël!

Janice

———— ✦ ————

"Well, I know now. I know a little more how much
a simple thing like a snowfall can mean to a person."

Sylvia Plath, *The Unabridged Journals of Sylvia Plath*

Dear Áine,

The City of Lights lives up to its nickname at Christmas. With dusk arriving by late afternoon and twinkle lights draped from the trees, Paris is truly enchanting. There is something indulgent about walking under the deep blue sky beneath the gaze of old streetlamps, then popping into a boutique to absorb the cozy warmth. Parisians overheat their stores. Not that I'm complaining. I love it. Though I spend a lot of time peeling off layers, then bundling up again.

The windows at the large department stores are a dazzling display of animatronic hypnotic wonder that keeps kids young and old gawking from the sidewalk. Usually, designers from the big fashion houses are in charge of the windows. The results are always magnificent. Even my street, rue Mouffetard, is a shimmering wonderland with long strings of lights cascading down the length of the street like a waterfall. It's all rather tasteful around here, which makes me wonder why so many of the Christmas trees are heavily sprayed with fake snow of fuchsia, teal, and—I'm sorry to say—yellow. There isn't much snow in Paris, which is surprising since every souvenir shop has walls of dreamy snow globes. They remind me of my French teacher from my life before Paris. He had asked me if I had ever been to Paris. "No," I said. "I dream of Paris." He shook his head.

"Mademoiselle," he said. "You've got your verbs wrong again. It's not 'to dream.' It's 'aller,' 'to go.'"

Joyeux Noël!

—Janice

January 2013, Paris

Dear Áine,

Happy New Year! In Paris, they say *"Bonne année,"* and often answer with a singsong *"et bonne santé."* And good health. Back home, we wish each other a prosperous New Year, but in France, prosperity isn't as big of a mark of success. In fact, the French have been known to chop off the heads of anyone who has risen above the crowd. All this probably explains why, when the world is talking about fiscal cliffs and recessions, the mayor is talking about carousels. Paris has recently added 20 more carousels to the 35 permanent ones in its collection as a gift to citizens and visitors of Paris. Now, along with being the City of Lights, it's the City of Carousels. And the rides are FREE! All winter, these merry-go-rounds of wonder sparkle like whirling jewels. Don't think for one minute I won't be trying to out-race kids to get to the best horse. Game on! I've been living in Paris for a while now. I thought the enchantment would fade, but then the carousels came back to town and I'm back to being amazed, my mouth agape in awe around nearly every bend in this magical city.

Janice

"Nostalgia. It's delicate but potent. . . . Teddy told me that, in Greek, 'nostalgia' literally means 'the pain from an old wound.' It's a twinge in your heart far more powerful than memory alone. This device isn't a spaceship; it's a time machine. It goes backwards and forwards. It takes us to a place where we ache to go again. It's not called the wheel, it's called the carousel. It lets us travel the way a child travels—round and around and back home again to a place where we know we are loved."

Matthew Weiner and Robin Veith, *Mad Men*

BONNE ANNÉE

Dear Áine,

Happy New Year! In Paris, they say "Bonne Année," and often answer with a sing song "et Bonne Santé" — and good health. Back home, we wish each other a prosperous New Year, but in France, prosperity isn't as big of a mark of success. In fact, the French have been known to chop off the heads of anyone who has risen above the crowd. All this probably explains why, when the world talks of fiscal cliffs and recessions, the mayor is talking about carousels. Paris has recently added 20 more carousels to the 35 permanent ones in its collection as a gift to citizens and visitors of Paris. Now, along with being the City of Lights, it's the City of Carousels. And the rides are FREE! All winter, these merry-go-rounds of wonder sparkle like whirling jewels. Don't think for one minute I won't be trying to out-race kids to get to the best horse. Game on! I've been living in Paris for a while now. I thought the enchantment would fade, but then the carousels came to town and I'm back to being amazed, my mouth agape in awe around nearly every bend in this magical city.

—Janice

29

F. Scott & Zelda

February 2013, Paris

Dear Áine,

I've got the Fitzgeralds on my mind these days. F. Scott and Zelda were the emblem expats of the 1920s Lost Generation in Paris. It was in these cafés, on cold wintery days, where they sat huddled together writing, sipping, and discussing their work. "What do you think of *The Great Gatsby* as a title?" he would ask, and history would be made. Right here in these cafés! It boggles the mind. Eventually, madness and jealousy came along, but before they did, F. Scott and Zelda sat in these cafés kissing, writing letters, piecing together story lines and poems, always believing that the happiness would never end and inspiration could always be plucked out of thin air. These days, I sit in the same cafés and wonder if I'm sitting next to the future F. Scott or Zelda. Perhaps they wonder the same about me. What do you think of *Paris Letters* as a title?

Janice

"They had created themselves together, and they always saw themselves, their youth, their love, their lost youth and lost love, their failures and memories, as a sort of living fiction."

Elizabeth Hardwick, *Seduction and Betrayal: Women and Literature*

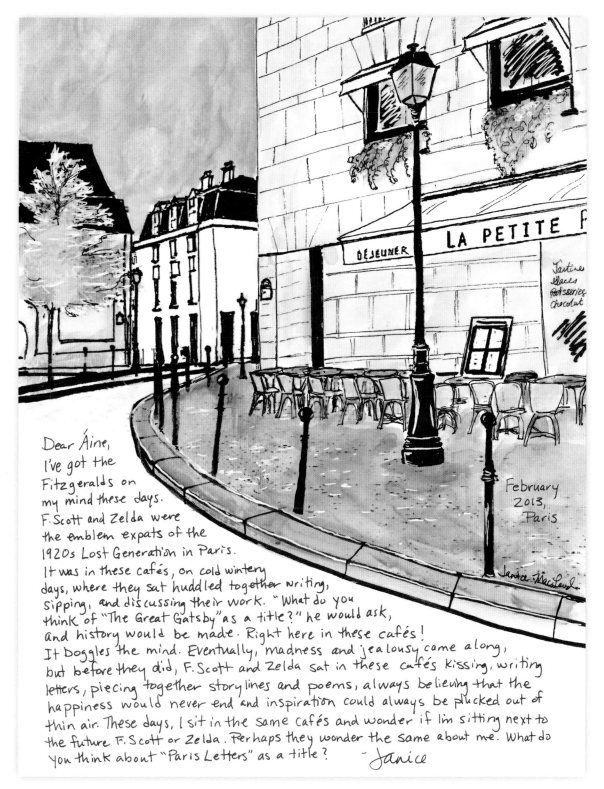

Dear Áine,
I've got the
Fitzgeralds on
my mind these days.
F. Scott and Zelda were
the emblem expats of the
1920s Lost Generation in Paris.
It was in these cafés, on cold wintery
days, where they sat huddled together writing,
sipping, and discussing their work. "What do you
think of "The Great Gatsby" as a title?" he would ask,
and history would be made. Right here in these cafés!
It boggles the mind. Eventually, madness and jealousy came along,
but before they did, F. Scott and Zelda sat in these cafés kissing, writing
letters, piecing together story lines and poems, always believing that the
happiness would never end and inspiration could always be plucked out of
thin air. These days, I sit in the same cafés and wonder if I'm sitting next to
the future F. Scott or Zelda. Perhaps they wonder the same about me. What do
you think about "Paris Letters" as a title?
 - Janice

February
2013,
Paris

Anaïs Nin

March 2013, Paris

Dear Áine,

As I look up at the apartments in Paris, I wonder about all the lives behind those windows. Who lives there? What circumstances brought them here? Who lived there before and why have they gone? History helps answer a few of these questions. In the 1920s, behind one of these windows was a young Anaïs Nin. She and her husband rented a place where she found a library of erotic French literature. All that reading got her hot and flustered. In walks Henry Miller, who was in Paris writing *Tropic of Cancer*. Their literary friendship turned into an intense love affair that lasted years. She also had a love affair with Henry's wife June! When they weren't together, Henry and Anaïs wrote each other passionate love letters of desire, angst, and betrayal. And some of those letters were written behind windows of these Paris apartments.

Janice

"You don't find love, it finds you. It's got a little bit to do with destiny, fate, and what's written in the stars."

Anaïs Nin

Dear Áine,

As I look up at the apartments of Paris, I wonder about the lives behind those windows. Who lives there? What circumstances brought them here? Who lived there before and why have they gone? History helps answer a few of these questions. In the 1920s, behind one of these windows was a young Anaïs Nin. She and her husband rented a place where she found a library of erotic French literature. All that reading got her hot and flustered. In walks Henry Miller, who was in Paris writing "Tropic of Cancer." Their literary friendship turned into an intense love affair that lasted years. She also had a love affair with Henry's wife June! When they weren't together, Henry and Anaïs wrote each other passionate love letters filled with desire, angst, and betrayal. And some of those letters were written behind windows of these Paris apartments.

– Janice

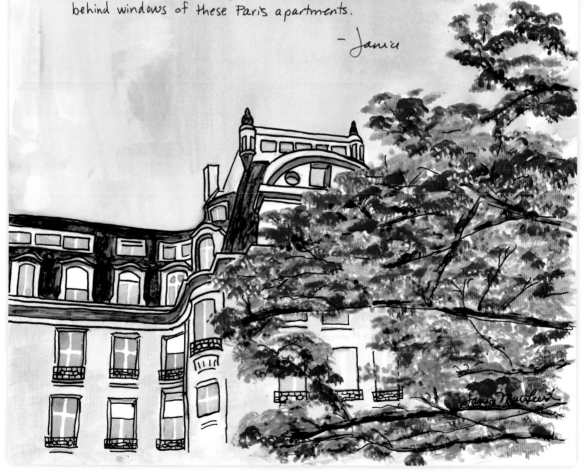

33

The Zouave

March 2013, Paris

Dear Áine,

It's 50 shades of neutral here in Paris. The sun must have zipped off to the Alps for March break, for it is shady skies around here. On the one hand, it's quite pretty—matching the tightly regulated palette of the buildings' creams, whites, and greys. But on the other hand, it makes one yearn for an early spring. The other day, the sun burst through. People claimed seats on park benches, sat and closed their eyes, aimed their faces toward the sun, and grinned. It was a glorious moment, but soon we were back to being shrouded in shade, and life continued on at a glum pace until word got out that the water level in the Seine was rising. Parisians flock to the Zouave statue at the foot of Pont de l'Alma to gauge the water level. When his feet are soaked, the road along the river is closed. When his signature puffy pants are soaked, the river itself is closed, as boats can't pass beneath the bridge. By the time I arrived at the Zouave, the water level receded and he hadn't even dipped his big toe into the serpentine sea. They say the water level could rise, as April showers bring May flowers. The Zouave and I will be standing by to see it coming—but me from a higher elevation—looking down at him from the bridge above.

Janice

"*Most people weren't aware that books chose us, at the time when we needed them most.*"

Rebecca Raisin, *The Little Bookshop on the Seine*

Dear Áine,

It's 50 shades of neutral here in Paris. The sun must have zipped off to the Alps for March break, for it is shady skies around here. On the one hand, it's quite pretty—matching the tightly regulated palette of the buildings' creams, whites, and greys. But on the other hand, it makes one yearn for an early spring. The other day, the sun burst through. People claimed seats on park benches, sat and closed their eyes, aimed their faces toward the sun, and grinned. It was a glorious moment, but soon we were back to being shrouded in shade, and life continued on at a glum pace until word got out that the water level in the Seine was rising. Parisians flock to the Zouave statue at the foot of Pont de l'Alma to gauge the water level. When his feet are soaked, the road along the river is closed. When his signature puffy pants are soaked, the river itself is closed, as boats can't pass beneath the bridge. By the time I arrived at the Zouave, the water level receded and he hadn't even dipped his big toe into the serpentine sea. They say the water level could rise, as April showers bring May flowers. The Zouave and I will be standing by to see it coming—but me from a higher elevation—looking down at him from the bridge above.

—Janice

March 2013, Paris

Dear Áine,

After reading *My Life in France* by Julia Child, I bounded down my spiral staircase to walk in her footsteps along these ancient Paris streets. She wrote the culinary go-to tome *Mastering the Art of French Cooking* ages ago, yet as I visit the same market stalls as Julia, I wonder if my vendors share the same DNA as her vendors. That's how it goes here. Family businesses can last centuries. It boggles the mind of yours truly who is from a very young Canada. After I bought her cookbook, I thought I could start whipping up amazing dishes tout de suite. Not so! There was a lot of reading. I sent Christophe out for Mexican food while I studied the merits of cast iron and copper. Then I needed supplies. Not surprising, her preferred kitchen supply store, E.Dehillerin, is still open. When I went, I stood at the walls of spatulas and wondered what on earth to do with them. I suspect Julia felt the same. So many kitchen tools, all keys to unlocking the mysteries of the French kitchen. She was a honeymooner at the time, just a few years into her marriage with Paul, who would wait patiently for her meals to be ready so they could explore French cuisine together. Christophe has had to wait a LONG time for me to read, stir, and simmer. He plays me love songs on the guitar. Paul would sit in the kitchen, too, writing letters. Julia and Paul lived into their 90s, which is considerable considering all that cream and butter. I hope to do the same with Christophe, one scrumptious meal at a time.

Bon appétit!

Janice

———————

"We had a happy marriage because we were together all the time. We were friends as well as husband and wife. We just had a good time."

Julia Child

Dear Áine,

After reading "My Life in France" by Julia Child, I bounded down my spiral staircase to walk in her footsteps along these ancient Paris streets. She wrote the culinary go-to tome "Mastering the Art of French Cooking" ages ago, yet as I visit the same market stalls as Julia, I wonder if my vendors share the same DNA as her vendors. That's how it goes here. Family businesses can last centuries. It boggles the mind of yours truly who is from a very young Canada. After I bought her cookbook, I thought I could start whipping up amazing dishes 'tout de suite.' Not so! There was a lot of reading. I sent Christophe out for Mexican food while I studied the merits of cast iron and copper. Then I needed supplies. Not surprising, her preferred kitchen supply store, E. Dehillerin, is still open. When I went, I stood at the walls of spatulas and wondered what on earth to do with them. I suspect Julia felt the same. So many kitchen tools, all keys to unlocking the mysteries of the French kitchen. She was a honeymooner at the time, just a few years into her marriage with Paul, who would wait patiently for her meals to be ready so they could explore French cuisine together. Christophe has had to wait a LONG time for me to read, stir, and simmer. He plays me love songs on the guitar. Paul would sit in the kitchen, too, writing letters. Julia and Paul lived into their 90s, which is considerable considering all that cream and butter. I hope to do the same with Christophe, one scrumptious meal at a time.

Bon appétit! Janice

April 2013, Paris

Dear Áine,

History is everything and everywhere in Paris. You walk on it, sit on it, and live with it every day.

Train stations, streets, and cafés are named after famous people or events and everyone seems to know why. Everyone knows where Hemingway sipped cocktails (Where didn't he?), where Edith Piaf sang for cents on the streets of Pigalle, and that Georges-Eugène Haussmann carved Paris into the grand city it is today. He gave himself the title of Baron even though technically he was merely a Monsieur. He tore down and rebuilt Paris under the rule of Napoleon III, who gave himself a title, too—Emperor of France. Napoleon III is not to be confused with Napoleon I, who actually WAS the Emperor of France.

"Baron" Haussmann built bridges, apartments, and grand boulevards. These streets "happened" to be wide enough for the government to flex its military muscle on the people. A cannonball, after all, can't make a sharp right in a medieval town.

It all worked out in the end—more or less—and these days, come Bastille Day, crowds gather to cheer the tanks, trucks, and soldiers as they strut their stuff in the parade.

A few streets escaped Haussmann's ambitious plans—my street included, which makes my apartment older than any building across the Atlantic. People have been making meals, making babies, washing, and sleeping in my *petit* palace for centuries. And though I try not to think about it, they've likely died here, too. People who may have even had a hand in building up the new city around them.

I don't sense ghosts though. They are probably out enjoying the warm weather. I think I'll do the same right after I head to the post office to send off this letter. The flowers are in bloom. It's a new season in Paris. History in the making.

Empress Janice

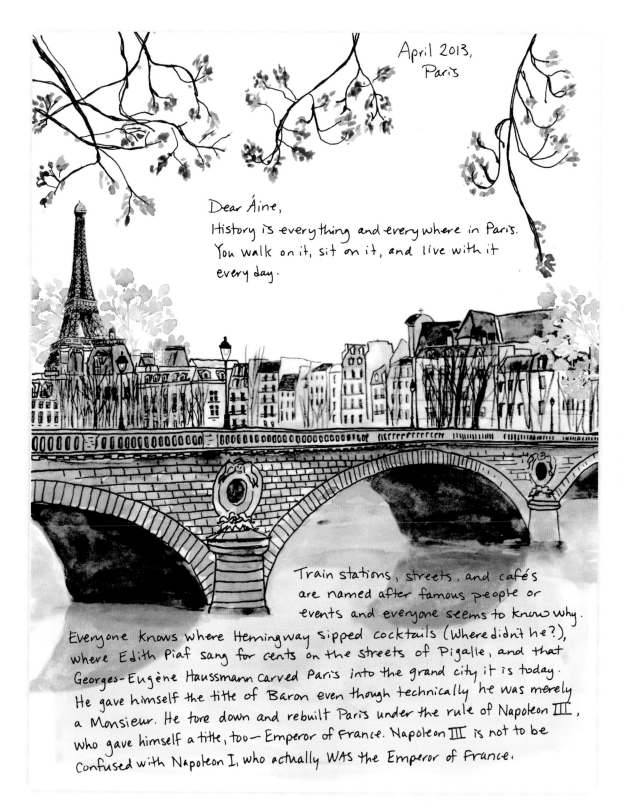

April 2013,
Paris

Dear Áine,
History is everything and everywhere in Paris.
You walk on it, sit on it, and live with it
every day.

Train stations, streets, and cafés
are named after famous people or
events and everyone seems to know why.
Everyone knows where Hemingway sipped cocktails (Where didn't he?),
where Edith Piaf sang for cents on the streets of Pigalle, and that
Georges-Eugène Haussmann carved Paris into the grand city it is today.
He gave himself the title of Baron even though technically he was merely
a Monsieur. He tore down and rebuilt Paris under the rule of Napoleon III,
who gave himself a title, too— Emperor of France. Napoleon III is not to be
confused with Napoleon I, who actually WAS the Emperor of France.

"It's spring fever. That is what the name of it is. And when you've got it, you want—oh, you don't quite know what it is you do want, but it just fairly makes your heart ache, you want it so!"

Mark Twain

"Baron" Haussmann built bridges, apartments, and grand boulevards. These streets "happened" to be wide enough for the government to flex its military muscle on the people. A cannonball, after all, can't make a sharp right in a medieval town.

It all worked out in the end — more or less — and these days, come Bastille Day, crowds gather to cheer the tanks, trucks, and soldiers as they strut their stuff in the parade.

A few streets escaped Haussmann's ambitious plans — my street included, which makes my apartment older than any building across the Atlantic. People have been making meals, making babies, washing, and sleeping in my petit palace for centuries. And though I try not to think about it, they've likely died here, too. People who may have even had a hand in building up the new city around them.

I don't sense ghosts though. They are probably out enjoying the warm weather. I think I'll do the same right after I head to the post office to send off this letter. The flowers are in bloom. It's a new season in Paris. History in the making.

— Empress Janice

Notre Dame Blooms

April 2013, Paris

Dear Áine,

Notre Dame turns 850 this year. She's looking *fantastique* for her age. How French of her. Paris has grown out from this Gothic masterpiece of gurgling gargoyles and flying buttresses. An English King, Henri VI, was crowned King of France here *(Mon Dieu!)*, and later Napoleon was crowned Emperor. Now, Notre Dame peers out to the green waters of the Seine, standing tall for the constant stream of tourists snapping photos from the riverboats. To celebrate her birthday, she's getting a new set of bells. The originals were melted down to make cannonballs during the French revolution. The replacements were temporary and always out of tune. I had the chance to see the new bells up close before they were hoisted to the towers. First, they were paraded through Paris on flatbed trucks, then displayed inside on the cathedral floor. Each bell is named after a different saint and tuned to the only original bell, called Emmanuel, which was the bell Quasimodo liked best and would swing from with delight. Despite all this bell hoopla, they were silent in the days leading up to Easter. Apparently, all the church bells of France grow wings and fly to Rome to get a special Easter blessing from the Pope. On Easter Sunday, they return and drop chocolates all over France. So while children in other countries are hoping to catch a glimpse of the Easter Bunny, French children look to the skies for falling chocolate. I, however, head to *les chocolateries*.

Janice

"Do not abandon yourselves to despair. We are the Easter people and Alleluia is our song."

Pope John Paul II

Dear Áine,

Notre Dame turns 850 this year. She's looking "fantastique" for her age. How French of her. Paris has grown out from this Gothic masterpiece of gurgling gargoyles and flying buttresses. An English King, Henri VI, was crowned King of France her (Mon Dieu!), and later Napoleon was crowned Emperor. Now, Notre Dame peers out to the green waters of the Seine, standing tall for the constant stream of tourists snapping photos from the riverboats. To celebrate her birthday, she's getting a new set of bells. The originals were melted down to make cannonballs during the French revolution. The replacements were temporary and always out of tune. I had the chance to see the new bells up close before they were hoisted to the towers. First, they were paraded through Paris on flatbed trucks, then displayed inside on the cathedral floor. Each bell is named after a different saint and tuned to the only original bell, called Emmanuel, which was the bell Quasimodo liked best and would swing from with delight. Despite all this bell hoopla, they were silent in the days leading up to Easter. Apparently, all the church bells of France grow wings and fly to Rome to get a special Easter blessing from the Pope. On Easter Sunday, they return and drop chocolates all over France. So while children in other countries are hoping to catch a glimpse of the Easter Bunny, French children look to the skies for falling chocolate. I, however, will head to "les chocolateries."

Janice

May 2013, Paris

Dear Áine,

May 1st is Labor Day here in France. This means that those who have jobs don't have to work so they can join those who don't have jobs so they can all attend demonstrations to scream about . . . jobs. May 1st is also the day when you can buy small bouquets of Lily-of-the-Valley from the street vendors dotted all over the city. The idea is to give the flowers to friends, but I didn't know about that until later, so my little bouquet is adorning my window and honoring my friendship to myself. My windows are finally open and I can feel a warm breeze. Since winter lingered in Paris, the city was slow to turn on the fountains. For months, they were dry and silent, crusted with last year's leaves. But now they are gurgling, spitting, splashing, and inviting wishes and coins. I'm not sure how the city manages décor, but I'd like to think that a big meeting is called at City Hall—the VIPs of Paris gather and agree that NOW would be the ideal moment to turn on the waterworks. The mayor nods and saunters over to a giant switch on the wall. Everyone holds their breath as it is turned on. Cheers, applause, and champagne follow. Meanwhile, water rushes through the labyrinth of underground pipes, along the Métro tunnels and catacombs to reach the hundreds of thirsty fountains that explode in joyful rapture. And there I am waiting with a wish in my heart and a coin in my hand.

Amitiés (Best wishes),

Janice

"Few people know so clearly what they want. Most people can't even think what to hope for when they throw a penny in a fountain."

Barbara Kingsolver, *Animal Dreams*

Dear Áine,

May 1st is Labor Day here in France. This means that those who have jobs don't have to work so they can join those who don't have jobs so they can all attend demonstrations to scream about.... jobs. May 1st is also the day when you can buy small bouquets of Lily-of-the-Valley from the street vendors dotted all over the city. The idea is to give the flowers to friends, but I didn't know about that until later, so my little bouquet is adorning my window and honoring my friendship to myself. My windows are finally open and I can feel a warm breeze. Since winter lingered in Paris, the city was slow to turn on the fountains. For months, they were dry and silent, crusted with last year's leaves. But now they are gurgling, spitting, splashing, and inviting wishes and coins. I'm not sure how the city manages urban décor, but I'd like to think that a big meeting is called at City Hall — the VIPs of Paris gather and agree that NOW would be the ideal moment to turn on the waterworks.

The mayor nods and saunters over to a giant switch on the wall. Everyone holds their breath as it is turned on. Cheers, applause, and champagne follow. Meanwhile, water rushes through the labyrinth of underground pipes, along the Métro tunnels and catacombs to reach the hundreds of thirsty fountains that explode in joyful rapture. And there I am waiting with a wish in my heart and a coin in my hand.

Amitiés (Best Wishes),

Janice

May 2013, Paris

Dear Áine,

There is this blue door I walk by often on my walks through Paris. It looks like an ordinary blue door, but this is the blue door at 74 rue du Cardinal Lemoine, the first Paris residence of Hemingway, back when he was just Ernest. Before the novels, before the accolades, before the fall, he was trying to build a new life here with his new wife Hadley and their son Bumby. And Hadley, she was building a happy family despite the cold Paris winters, post-war conditions, and tight budget. They had a nice handful of literary friends—James Joyce, F. Scott Fitzgerald, and Gertrude Stein to name a few— and the charms of Paris itself to weave into the narrative of their lives. He would go on to write books that changed literature forever. She would go on to be known as the first wife.

As I look up at the building, I imagine these newlyweds trying to make a go of it. If you walk by at twilight, you can hear doors opening and closing, friendly murmurs of conversation, and the smell of dinners on the stove. I wonder if it's Ernest and Hadley haunting the place.

Janice

"We ate well and cheaply and drank well and cheaply and slept well and warm together and loved each other."

Ernest Hemingway, *A Moveable Feast*

May 2013, Paris

Dear Áine,

There is this blue door I walk by often on my walks through Paris. It looks like an ordinary blue door, but this is the blue door at 74 rue du Cardinal Lemoine, the first Paris residence of Hemingway, back when he was just Ernest. Before the novels, before the accolades, before the fall, he was trying to build a new life here with his new wife Hadley and their son Bumby. And Hadley, she was building a happy family despite the cold Paris winters, post-war conditions, and tight budget. They had a nice handful of literary friends — James Joyce, F. Scott Fitzgerald, and Gertrude Stein to name a few — and the charms of Paris itself to weave into the narrative of their lives.

He would go on to write books that changed literature forever. She would go on to be known as the first wife.

As I look up at the building, I imagine these newlyweds trying to make a go of it. If you walk by at twilight, you can hear doors opening and closing, friendly murmurs of conversation, and the smell of dinners on the stove. I wonder if it's Ernest and Hadley haunting the place.

— Janice

May 2013, Paris

Dear Áine,

My romantic imagination is running wild with the discovery of a Paris apartment left untouched for 70 years. The owner abandoned the apartment just before World War II. She left for the South of France, never to return. By the look of the place, I suspect it was more of an escape. Hairbrushes sat on the vanity, newspapers were in a pile, and a stuffed bird stood guard with no one but ghosts for company. Only after her death at 91, when her heirs hired someone to take inventory, was this jewel discovered. Among the dusty gilded mirrors and peeling wallpaper was a painting of her grandmother, painted by Giovanni Boldini, who was one of Paris' most important artists of the Belle Époque— worth *beaucoup de Euros*! She was an alluring French actress, Boldini's muse, and his lover. We know this because a bundle of his love letters was also discovered. Tied with a ribbon! Wouldn't you love to find something like this in a long forgotten attic. That's Paris for you—full of treasures . . . and secrets.

Janice

"*We believed Paris was the start of us. It's the kind of city that makes you think of beginnings, or even juicy middles. Paris is a book to savor, in whole or in part, at any time and in any season. At age ninety or at thirty-four, you can open any chapter and read from there.*"

Michelle Gable, *I'll See You in Paris*

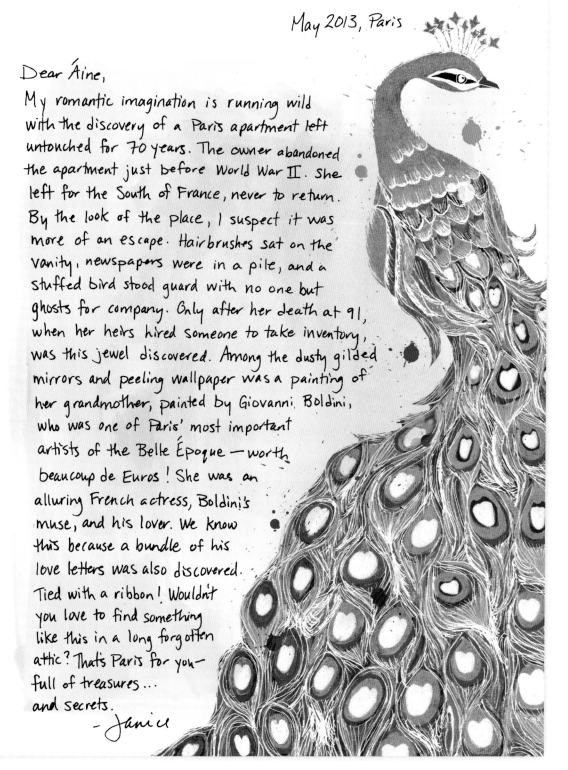

May 2013, Paris

Dear Áine,

My romantic imagination is running wild
with the discovery of a Paris apartment left
untouched for 70 years. The owner abandoned
the apartment just before World War II. She
left for the South of France, never to return.
By the look of the place, I suspect it was
more of an escape. Hairbrushes sat on the
vanity, newspapers were in a pile, and a
stuffed bird stood guard with no one but
ghosts for company. Only after her death at 91,
when her heirs hired someone to take inventory,
was this jewel discovered. Among the dusty gilded
mirrors and peeling wallpaper was a painting of
her grandmother, painted by Giovanni Boldini,
who was one of Paris' most important
artists of the Belle Époque — worth
beaucoup de Euros! She was an
alluring French actress, Boldini's
muse, and his lover. We know
this because a bundle of his
love letters was also discovered.
Tied with a ribbon! Wouldn't
you love to find something
like this in a long forgotten
attic? That's Paris for you—
full of treasures...
and secrets.
　　　— Janice

June 2013, Paris

Dear Áine,

I have found the most romantic spot in Paris. It's not the Eiffel Tower, nor is it the lock bridge behind Notre Dame cathedral. It's a rose garden tucked in behind the Natural History Museum in Jardin des Plantes. The June sun has burned through grey skies, whispering to the flowers that it's time. Bulbous blooms burst open in every shade, from crimson and violet to blush pink and white. The bees are pleased. In the breeze, a rainbow of petals floats by, caressing cheeks before stowing away in picnic bags.

Statues sit or stand along the path under the rose trellises, politely posing for artists who come along to capture the scene. As I sit and paint, I wonder if the statues are aware of each other, contemplating who will make the first move.

Janice

"Gardens are poems where you stroll with your hands in your pockets."
Pierre Albert-Birot, *The Cubist Poets in Paris*

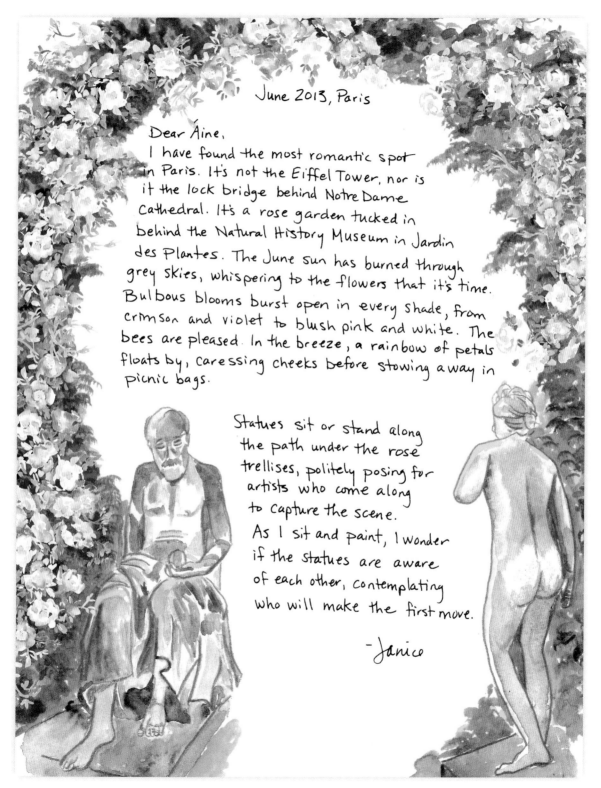

June 2013, Paris

Dear Áine,
I have found the most romantic spot
in Paris. It's not the Eiffel Tower, nor is
it the lock bridge behind Notre Dame
Cathedral. It's a rose garden tucked in
behind the Natural History Museum in Jardin
des Plantes. The June sun has burned through
grey skies, whispering to the flowers that it's time.
Bulbous blooms burst open in every shade, from
crimson and violet to blush pink and white. The
bees are pleased. In the breeze, a rainbow of petals
floats by, caressing cheeks before stowing away in
picnic bags.

Statues sit or stand along
the path under the rose
trellises, politely posing for
artists who come along
to capture the scene.
As I sit and paint, I wonder
if the statues are aware
of each other, contemplating
who will make the first move.

— Janice

51

June 2013, Paris

Dear Áine,

For the first two years in Paris, I was like Goldilocks, traipsing all over the city in search of the best café. A place I could call my own. One café would have a cozy atmosphere but terrible coffee. Another would have great coffee but terrible food. Then I came upon the café that was just right. It had it all—great coffee, cozy atmosphere, and delicious traditional French cuisine. Plus, its location on the pedestrian-friendly rue Mouffetard makes it the perfect perch for people watching. Being here makes me feel like I'm in a timeless Paris—the version you see on all those postcards. People still sit and write letters, read the paper, and catch up on the latest gossip. I often linger here with my journal—sipping, dreaming, and listening to French words flutter by on the breeze. I plan on putting in plenty of time here, and at the end of my days I'll likely haunt it ever after. We all must find our place in this world. Here in Paris, I believe I have found mine.

Janice

———————— ❧ ————————

"I don't want to own anything until I know I've found the place where me and things belong together. I'm not quite sure where that is just yet. But I know what it's like.' She smiled, and let the cat drop to the floor. 'It's like Tiffany's,' she said."

Truman Capote, *Breakfast at Tiffany's*

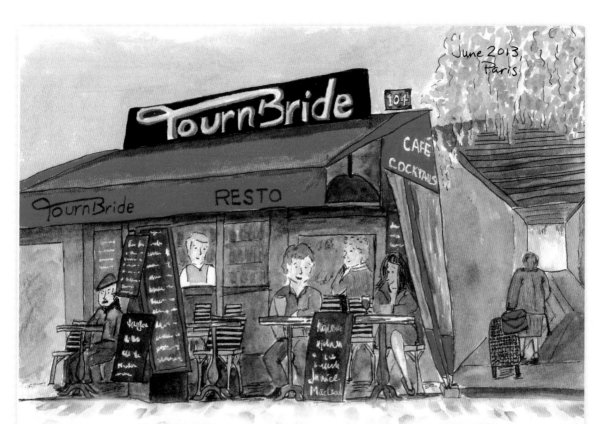

Dear Áine,

For the first two years in Paris, I was like Goldilocks, traipsing all over the city in search of the best café. A place I could call my own. One café would have a cozy atmosphere but terrible coffee. Another would have great coffee but terrible food. Then I came upon the café that was just right. It had it all—great coffee, cozy atmosphere, and delicious traditional French cuisine. Plus, its location on the pedestrian-friendly rue Mouffetard makes it the perfect perch for people watching. Being here makes me feel like I'm in a timeless Paris—the version you see on all those postcards. People still sit and write letters, read the paper, and catch up on the latest gossip. I often linger here with my journal—sipping, dreaming, and listening to French words flutter by on the breeze. I plan on putting in plenty of time here, and at the end of my days I'll likely haunt it ever after. We all must find our place in this world. Here in Paris, I believe I have found mine.

 — Janice

July 2013, Paris

Dear Áine,

A cemetery may seem like an odd place to come across a love story, but they say these types of things come along when you least expect them. After finding all the notable celebrities at Père-Lachaise cemetery—Oscar Wilde, Jim Morrison, and Edith Piaf to name a few—I came across an old lady carrying a heavy load. Normally, I don't stop to talk to strangers in Paris because they'll likely talk back in French and I'm still soaking up the words from my textbooks, but this frail-looking creature looked like she could have used an extra hand, so I asked if I could help. She nodded. "It's water," she explained. "I fill up the bottles at the main gate." Strangely, I understood her even though she spoke French. I asked her the universal traveler question, "Where are you from?" She told me she was from Poland, which explains why I understood her. I told her about Christophe, who is also from Poland but speaks to me in French. By now, I can't quite grasp the French language with a French accent, but I can understand some of it when spoken with a Polish accent.

As we walked through the cemetery, she told me that she and her husband left Poland during the war. "Everything was gone," she said. "Gone." They started again in Paris and had a good life. "It wasn't always easy, but we always had love, and that meant we had more than most." She stopped and we set down the water. She looked over to a grave. "He died last year," she said. In front of his grave was a lush flower garden. She bent down to pull a few weeds. "We lived in a small apartment nearby," she said. "He always wanted to give me a garden." I told her I was sorry for her loss. "Don't be, dear," she said. "I loved him enough to want him to go first. I was always better at handling the difficulties." She smiled wide. "He was better at the lighter side of life. He may be gone, but not everything is gone. He left me with enough good memories to see me through until it's my time."

She straightened up, put her hands on her hips, and said, "Now, you're learning French. It's all about the verbs. Learn your verbs." We spoke further about this and that and

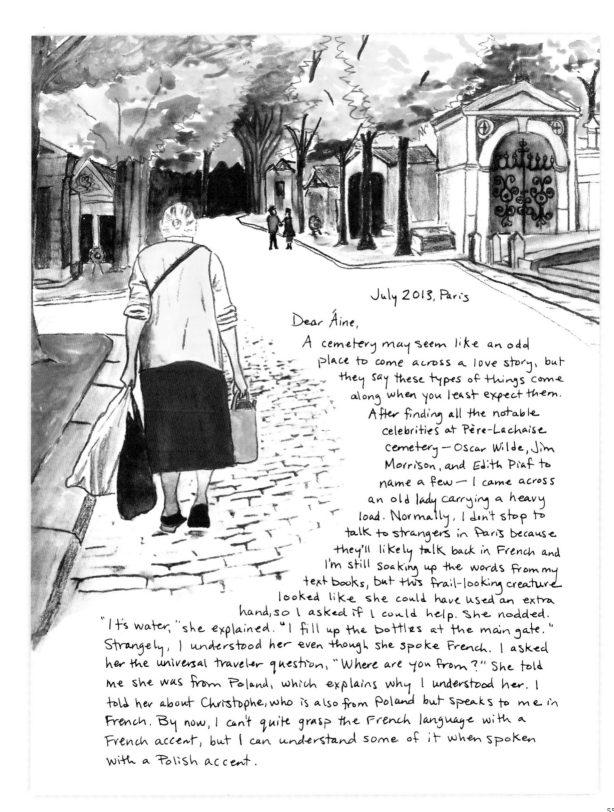

July 2013, Paris

Dear Áine,

A cemetery may seem like an odd place to come across a love story, but they say these types of things come along when you least expect them.

After finding all the notable celebrities at Père-Lachaise cemetery — Oscar Wilde, Jim Morrison, and Edith Piaf to name a few — I came across an old lady carrying a heavy load. Normally, I don't stop to talk to strangers in Paris because they'll likely talk back in French and I'm still soaking up the words from my text books, but this frail-looking creature looked like she could have used an extra hand, so I asked if I could help. She nodded. "It's water," she explained. "I fill up the bottles at the main gate." Strangely, I understood her even though she spoke French. I asked her the universal traveler question, "Where are you from?" She told me she was from Poland, which explains why I understood her. I told her about Christophe, who is also from Poland but speaks to me in French. By now, I can't quite grasp the French language with a French accent, but I can understand some of it when spoken with a Polish accent.

55

soon it was time for me to continue on. As I turned to leave, she said, "Don't be sad for me, dear. This is how it should be. Though it may not seem like it, this is a happy ending to a long love story. It's what we all hope for. Thank you for helping me carry my load."

I realized later that I didn't catch her name. Whenever I return to the cemetery, I stop by his grave. I check on the flowers and pull a few weeds. For a long time, the flowers bloomed beautifully until one day I returned to find a garden of stems and withered leaves. It was then when I found out that her name was Rose.

Janice

"'I will find you,' he whispered in my ear. 'I promise. If I must endure two hundred years of purgatory, two hundred years without you—then that is my punishment, which I have earned for my crimes. For I have lied, and killed, and stolen; betrayed and broken trust. But there is the one thing that shall lie in the balance. When I shall stand before God, I shall have one thing to say, to weigh against the rest.' His voice dropped, nearly to a whisper, and his arms tightened around me. 'Lord, ye gave me a rare woman, and God! I loved her well.'"

Diana Gabaldon, *Dragonfly in Amber*

As we walked through the cemetery, she told me that she and her husband left Poland during the war. "Everything was gone," she said. "Gone." They started again in Paris and had a good life. "It wasn't always easy, but we always had love, and that meant we had more than most." She stopped and we set down the water. She looked over to a grave. "He died last year," she said. In front of his grave was a lush flower garden. She bent down to pull a few weeds. "We lived in a small apartment nearby," she said. "He always wanted to give me a garden." I told her I was sorry for her loss. "Don't be, dear," she said. "I loved him enough to want him to go first. I was always

better at handling the difficulties." She smiled wide. "He was better at the lighter side of life. He may be gone, but not everything is gone. He left me with enough good memories to see me through until it's my time."

She straightened up, put her hands on her hips, and said, "Now, you're learning French. It's all about the verbs. Learn your verbs." We spoke further about this and that and soon it was time for me to continue on. As I turned to leave, she said, "Don't be sad for me, dear. This is how it should be. Though it may not seem like it, this is a happy ending to a long love story. It's what we all hope for. Thank you for helping me carry my load."

I realized later that I didn't catch her name. Whenever I return to the cemetery, I stop by his grave. I check on the flowers and pull a few weeds. For a long time, the flowers bloomed beautifully until one day I returned to find a garden of stems and withered leaves. It was then when I found out that her name was Rose.

—Janice

Boulangerie

July 2013, Paris

Dear Áine,

Each day I walk up to the boulangerie and pick up a *baguette du chef*, distinguished by its end, the *quignon*. The chef snips the end in two prior to baking, creating a two-pronged end.

This bread is so popular that the ovens are pumping out fresh batches all day long, and this means almost all my baguettes are still warm. I walk my freshly baked prize over to Christophe, who is roasting chickens at the *boucherie*. He leans down from his perch and we discuss lunch options for the day. (He comes home each day to eat lunch and have a nap. How civilized!) I offer him the baguette. He yanks off his end of the *quignon* and I yank off mine, wishbone-style. The crunchy crust gives way to an ivory chewy inside (the *mie*). It's a holy moment. I bid him farewell as I make my way down the *rue* to the *fromagerie* to choose a soft cheese to accompany my baguette. And to think, the French do this every single day. Bliss!

Janice

"But I promise you there is no croissant as crisp and flaky or as sweetly buttery as the one you eat, still warm from the oven, on your first morning in Paris after a long absence."

Ann Mah, *Mastering the Art of French Eating*

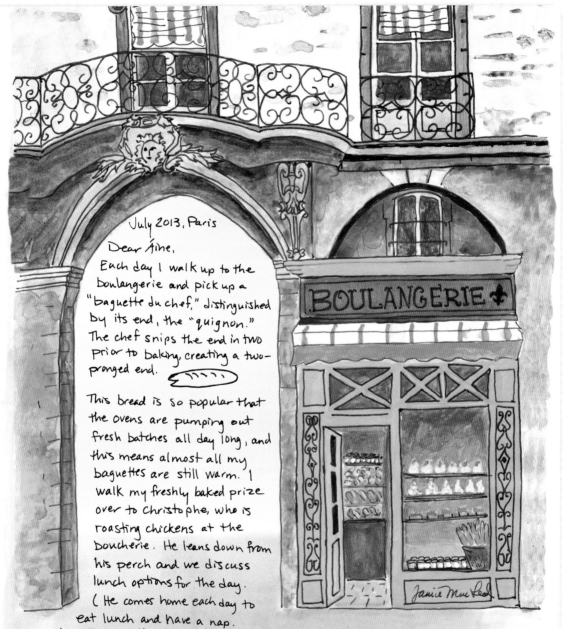

July 2013, Paris

Dear Áine,

Each day I walk up to the boulangerie and pick up a "baguette du chef," distinguished by its end, the "quignon." The chef snips the end in two prior to baking, creating a two-pronged end.

This bread is so popular that the ovens are pumping out fresh batches all day long, and this means almost all my baguettes are still warm. I walk my freshly baked prize over to Christophe, who is roasting chickens at the boucherie. He leans down from his perch and we discuss lunch options for the day. (He comes home each day to eat lunch and have a nap. How civilized!) I offer him the baguette. He yanks off his end of the quignon and I yank off mine, wishbone-style. The crunchy crust gives way to an ivory chewy inside (the "mie"). It's a holy moment. I bid him farewell as I make my way down the "rue" to the fromagerie to choose a soft cheese to accompany my baguette. And to think, the French do this every single day. Bliss!

—Jamie

Bastille Day

August 2013, Paris

Dear Áine,

I can hardly describe what I saw on Bastille Day this year, but I'll try. Bastille Day started as a national holiday to celebrate the beginning of the French Revolution. These days, it seems to be a day to celebrate the military. But I think Paris uses the day to celebrate itself. It started with soldiers marching down the Champs-Élysées with feathers in their caps—literally. The French LOVE feathers. The pinnacle moment was when the Air Force flew over, leaving a gigantic smoky French flag in its wake. All day, we saw soldiers "at ease" and strutting their stuff around Paris with medals dangling from their lapels. They often stopped to pose for photos with children. But the pièce de résistance came at night when the fireworks burst around the Eiffel Tower. This dazzling light show radiated the colors of the rainbow for nearly an hour—and with musical accompaniment. It was pyrotechnics of epic proportion. After the final firecracker cracked, I stood with my friends—all of us hardly able to believe or talk about what we had just witnessed. Later that night, eyes closed in bed, sparks still danced behind my eyelids. The only words that came to mind were, "Bravo, Paris. Bravo."

Janice

"I love Paris in the summer, when it sizzles."

Cole Porter, "I Love Paris"

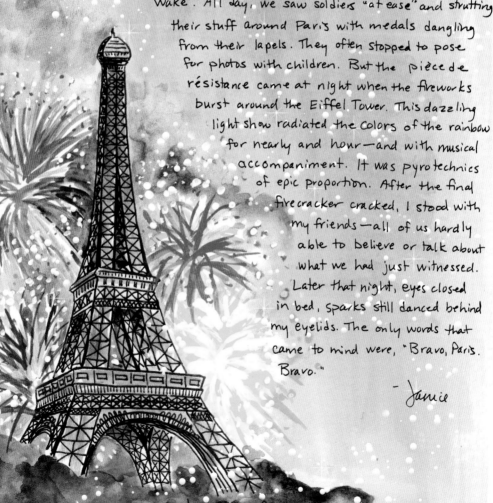

August 2013, Paris

Dear Áine,

I can hardly describe what I saw on Bastille Day this year, but I'll try. Bastille Day started as a national holiday to celebrate the beginning of the French Revolution. These days, it seems to be a day to celebrate the military. But I think Paris uses the day to celebrate itself. It started with soldiers marching down the Champs-Élysées with feathers in their caps—literally. The French LOVE feathers. The pinnacle moment was when the Air Force flew over, leaving a gigantic smoky French flag in its wake. All day, we saw soldiers "at ease" and strutting their stuff around Paris with medals dangling from their lapels. They often stopped to pose for photos with children. But the pièce de résistance came at night when the fireworks burst around the Eiffel Tower. This dazzling light show radiated the colors of the rainbow for nearly and hour—and with musical accompaniment. It was pyrotechnics of epic proportion. After the final firecracker cracked, I stood with my friends—all of us hardly able to believe or talk about what we had just witnessed. Later that night, eyes closed in bed, sparks still danced behind my eyelids. The only words that came to mind were, "Bravo, Paris. Bravo."

 - Jamie

Jamie MacLeod

August 2013, Paris

Dear Áine,

I'm thrilled to announce that the lovely Christophe and I were married in the City of Amour last month. It was a balmy summer day. We and our guests met at City Hall—you can't have a legal marriage anywhere but City Hall in France. Lucky for us, ours is one of the most beautiful in Paris. We walked up the grand staircase to the gold gilt-encrusted *sale de mariage*. Under chandeliers draped in shimmering crystals, we shared our vows, rings, and kisses. After rose petals were jubilantly tossed, we paraded to Jardin du Luxembourg for photos and champagne. We followed with a stroll down the old market street of rue Mouffetard—where we live and work. Shopkeepers stepped out to shake his hand and offer me *Félicitations*. Once arriving at our restaurant, while the guests enjoyed another round of bubbly, Christophe and I stole away around the corner for a private toast of our own. *Quelle romantique!* As the day turned to night, our group took a cruise down the Seine to admire the lit buildings, the Eiffel Tower, and the people having picnics along the banks. The next day, Christophe and I flew to Canada for a honeymoon in the mountains, then to visit family. I always thought I'd get married in Canada and honeymoon in Paris. It's funny how life turns out. I wouldn't have it any other way.

Janice

"Je m'en irai poser tes portraits
A tous les plafonds de tous les palais

(I'll hang your portrait
On all the ceilings of all the palaces)"

Frances Cabrel, "Je T'aimais, Je T'aime, et Je T'aimerai"

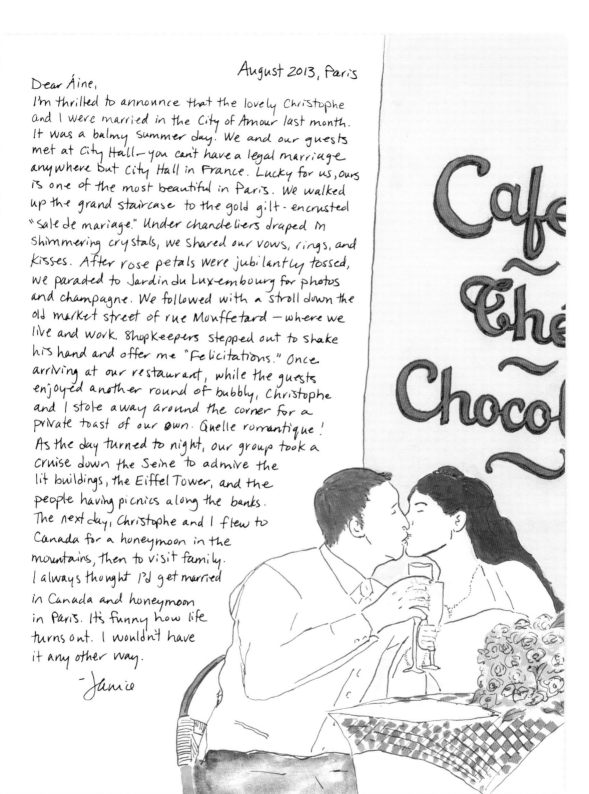

August 2013, Paris

Dear Áine,

I'm thrilled to announce that the lovely Christophe and I were married in the City of Amour last month. It was a balmy summer day. We and our guests met at City Hall—you can't have a legal marriage anywhere but City Hall in France. Lucky for us, ours is one of the most beautiful in Paris. We walked up the grand staircase to the gold gilt-encrusted "sale de mariage." Under chandeliers draped in shimmering crystals, we shared our vows, rings, and kisses. After rose petals were jubilantly tossed, we paraded to Jardin du Luxembourg for photos and champagne. We followed with a stroll down the old market street of rue Mouffetard—where we live and work. Shopkeepers stepped out to shake his hand and offer me "Felicitations." Once arriving at our restaurant, while the guests enjoyed another round of bubbly, Christophe and I stole away around the corner for a private toast of our own. Quelle romantique! As the day turned to night, our group took a cruise down the Seine to admire the lit buildings, the Eiffel Tower, and the people having picnics along the banks. The next day, Christophe and I flew to Canada for a honeymoon in the mountains, then to visit family. I always thought I'd get married in Canada and honeymoon in Paris. It's funny how life turns out. I wouldn't have it any other way.

— Janice

63

Montmartre

September 2013, Paris

Dear Áine,

I hardly know what to do with myself on these hot September days in Paris. After our wedding in July, honeymoon in August, and the delivery of a manuscript in September, I'm not sure how to take advantage of the rich "get back to it" energy that comes in September. What to do, what to do. So I went in search of inspiration in Montmartre. This hillside district of Paris has been home to obscure artists such as Picasso, Matisse, and Van Gogh.

They lived in this bohemian fringe village not because of the picturesque streets or stunning views of Paris. They came because this area was once outside of Paris and therefore not subject to the same tariffs. Plus, the further you lived up the hill, the lower the rent. A bunch of nuns made cheap wine here, too. Cheap wine + cheap rent = artist haven. These days it's not quite so affordable, but artists still come and set up easels in the café-laden square Place du Tertre. One can buy a still-wet painting and wait for it to dry while indulging in steak and fries at a nearby bistro. I sighed with glee at all the art. I didn't buy any though. I had my own painting to do.

Janice

"When I was a child my mother said to me, 'If you become a soldier, you'll be a general. If you become a monk, you'll end up as pope.' Instead I became a painter and wound up as Picasso."

Pablo Picasso

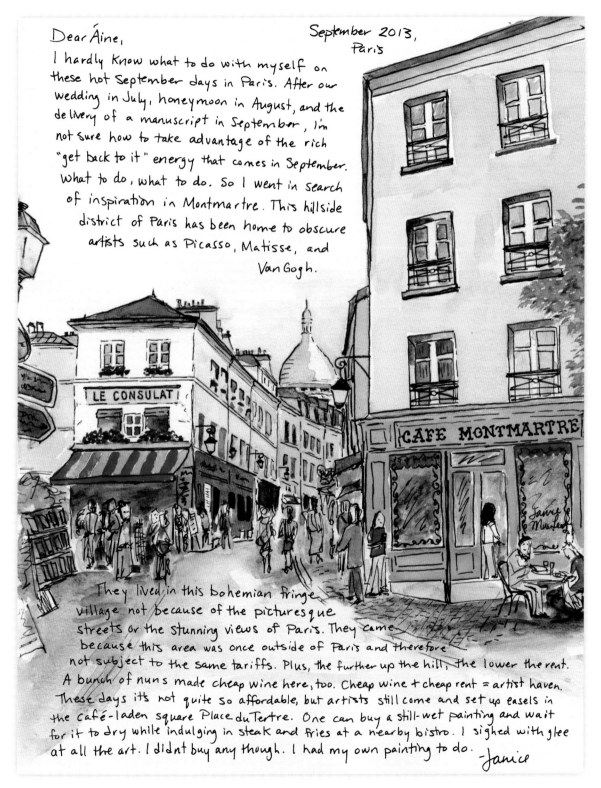

Dear Áine,

I hardly know what to do with myself on these hot September days in Paris. After our wedding in July, honeymoon in August, and the delivery of a manuscript in September, I'm not sure how to take advantage of the rich "get back to it" energy that comes in September. What to do, what to do. So I went in search of inspiration in Montmartre. This hillside district of Paris has been home to obscure artists such as Picasso, Matisse, and Van Gogh.

LE CONSULAT

CAFÉ MONTMARTRE

They lived in this bohemian fringe village not because of the picturesque streets or the stunning views of Paris. They came because this area was once outside of Paris and therefore not subject to the same tariffs. Plus, the further up the hill, the lower the rent. A bunch of nuns made cheap wine here, too. Cheap wine + cheap rent = artist haven. These days it's not quite so affordable, but artists still come and set up easels in the café-laden square Place du Tertre. One can buy a still-wet painting and wait for it to dry while indulging in steak and fries at a nearby bistro. I sighed with glee at all the art. I didn't buy any though. I had my own painting to do.

Janice

65

Autumn Rain

October 2013, Paris

Dear Áine,

It was autumn. Right in the middle of the leaf change—bright yellows and oranges with hints of fiery reds. I took off for the café in Jardin du Luxembourg for front row seats to nature's most brazen costume change. I sat outside under the awning when it began to lightly rain. Just then a breeze turned up and thousands of leaves began to fall. It was the most glorious symphony of leaves, rain, and wind. An older gentleman noticed, too. He promptly took a seat nearby, grabbed an abandoned copy of *Le Monde,* and started reading.

Just then a loud racket of DANCE MUSIC erupted from inside the café. Instant rage! I rose from my seat, walked to the open door, glared at the waiter within, and closed it firmly with an audible huff. Monsieur *Le Monde* looked up from his paper and nodded. I have never felt so French, so old, or so cool as I did in that glorious moment in the rain.

Janice

"'It is not everyone,' said Elinor, 'who has your passion for dead leaves.'"

Jane Austen, *Sense and Sensibility*

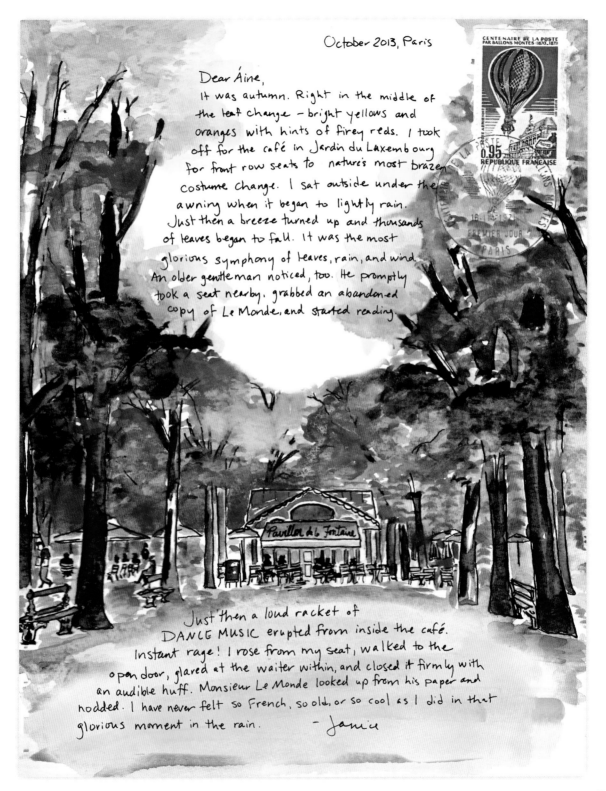

October 2013, Paris

Dear Áine,

It was autumn. Right in the middle of
the leaf change — bright yellows and
oranges with hints of firey reds. I took
off for the café in Jardin du Luxembourg
for front row seats to nature's most brazen
costume change. I sat outside under the
awning when it began to lightly rain.

Just then a breeze turned up and thousands
of leaves began to fall. It was the most
glorious symphony of leaves, rain, and wind.
An older gentleman noticed, too. He promptly
took a seat nearby, grabbed an abandoned
copy of Le Monde, and started reading.

Just then a loud racket of
DANCE MUSIC erupted from inside the café.
Instant rage! I rose from my seat, walked to the
open door, glared at the waiter within, and closed it firmly with
an audible huff. Monsieur Le Monde looked up from his paper and
nodded. I have never felt so French, so old, or so cool as I did in that
glorious moment in the rain.
— Janice

Les Deux Magots

October 2013, Paris

Dear Áine,

I'm writing to you from Les Deux Magots, the café where Simone de Beauvoir sat most mornings and wrote out her theories on existentialism and feminism. On occasion, her lifelong mate, Jean-Paul Sartre, would join her. They were essentially scientists of the human experience and they used their relationship as a lifelong experiment. Early on, he asked her to marry him. She declined. They agreed to be committed to each other (in a way) by full disclosure about how they were feeling and with whom they were sleeping. They had plenty of lovers, but Sartre once confessed that at times he couldn't leave the bed of his latest fling fast enough so he could meet Simone for coffee at Les Deux Magots. Their relationship experiment worked, it seems, and at the end of their successful lives, they were buried together in a cemetery in Paris. Hemingway (who coincidentally also frequented Les Deux Magots) tried this relationship experiment with his first wife Hadley and that vixen Pauline. His desire for both the cake and the icing would be the start of a lifetime of broken marriages. Near the end, he admitted that the worst mistake of his life was ending his marriage with Hadley. Imagine . . . all these notions were infused with coffee from this one café on Boulevard Saint-Germain in Paris.

Janice

"It's quite an undertaking to start loving somebody. You have to have energy, generosity, blindness. There is even a moment right at the start where you have to jump across an abyss: if you think about it you don't do it."

Jean-Paul Sartre, *Nausea*

Dear Áine,

I'm writing to you from Les Deux Magots, the café where Simone de Beauvoir sat most mornings and wrote out her theories on existentialism and feminism. On occasion, her lifelong mate, Jean-Paul Sartre, would join her. They were essentially scientists of the human experience and they used their relationship as a lifelong experiment. Early on, he asked her to marry him. She declined. They agreed to be committed to each other (in a way) by full disclosure about how they were feeling and with whom they were sleeping. They had plenty of lovers, but Sartre once confessed that at times he couldn't leave the bed of his latest fling fast enough so he could meet Simone for coffee at Les Deux Magots. Their relationship experiment worked, it seems, and at the end of their successful lives, they were buried together in a cemetery in Paris. Hemingway (who coincidentally also frequented Les Deux Magots) tried this relationship experiment with his first wife Hadley and that vixen Pauline. His desire for both the cake and icing would be the start of a lifetime of broken marriages. Near the end, he admitted that the worst mistake of his life was ending his marriage with Hadley. Imagine... all these notions were infused with coffee from this one café on Boulevard Saint-Germain in Paris.

Janice

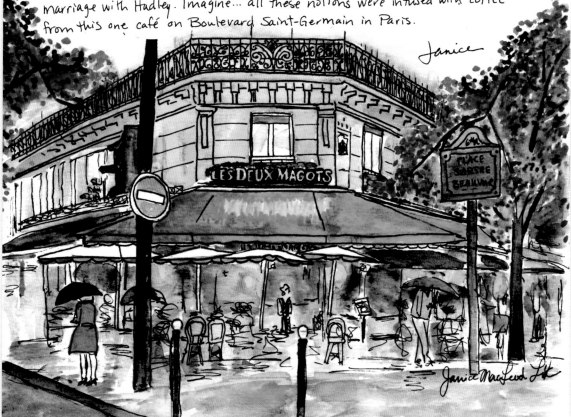

LES DEUX MAGOTS

PLACE
SARTRE
BEAUVOIR

Janice MacLeod Ltd

October 2013, Paris

Dear Áine,

A friend of mine recently told me how she met her husband. A long time ago in Poland, where they lived at the time, they met at a festival. He was smitten. She mentioned that she worked in a camera shop. A week later, he walked into that shop and asked her out. On their first date, he arrived with a watermelon under his arm. Poland was still under Communist rule at the time, so luxury items like watermelons were rare and expensive. He wanted to impress her. He struggled with that watermelon for two hours before they sat along the river and ate it. She marveled at how he happened to walk into <u>her</u> camera shop. What are the chances? He nodded and kissed her. Months later, when he felt more sure of things, he admitted that hers was the 52nd camera shop he had visited that week. They've been married over 30 years. She recently had a stroke that left her temporarily paralyzed down one half of her body, so he carries her at times. "It's good that he is strong," she said. "Must have been from carrying that watermelon."

Janice

"He told me how he had first met her during the war and then lost her and won her back . . . This first version that he told me of Zelda and a French naval aviator falling in love was a truly sad story and I believe it was a true story. Later he told me other versions of it as though trying them for use in a novel, but none was as sad as this first one and I always believed the first one . . . They were better told each time; but they never hurt you the same way the first one did."

Ernest Hemingway, *A Moveable Feast*

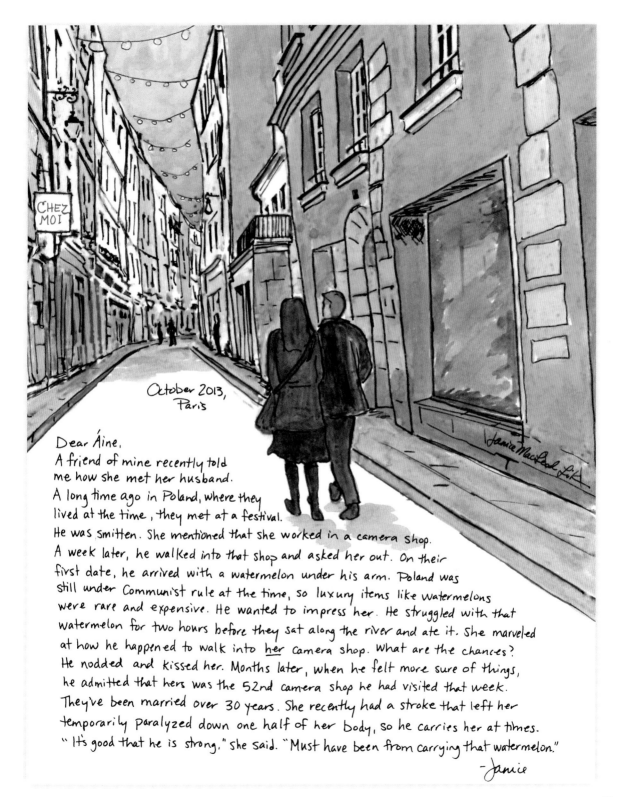

CHEZ MOI

October 2013,
Paris

Dear Áine,
A friend of mine recently told
me how she met her husband.
A long time ago in Poland, where they
lived at the time, they met at a festival.
He was smitten. She mentioned that she worked in a camera shop.
A week later, he walked into that shop and asked her out. On their
first date, he arrived with a watermelon under his arm. Poland was
still under Communist rule at the time, so luxury items like watermelons
were rare and expensive. He wanted to impress her. He struggled with that
watermelon for two hours before they sat along the river and ate it. She marveled
at how he happened to walk into her camera shop. What are the chances?
He nodded and kissed her. Months later, when he felt more sure of things,
he admitted that hers was the 52nd camera shop he had visited that week.
They've been married over 30 years. She recently had a stroke that left her
temporarily paralyzed down one half of her body, so he carries her at times.
"It's good that he is strong," she said. "Must have been from carrying that watermelon."

—Janice

Le Bonaparte

November 2013, Paris

Dear Áine,

The crisp air has brought with it a silent lull. I haven't been taking my usual grand urban hikes across Paris, preferring instead to spend long lingering hours huddled under heat lamps in cafés close to home. I have found myself at a loss for what to write, what to do, and even what to say. Silence is usually a lovely companion as it often helps me hear that place inside where the words flow, but these days even that voice isn't much of a talker. I suppose it's my brain taking a rest after a busy spell. I know what you would say. "Go to museums and find hidden boutiques full of beautiful baubles. It's Paris!"

But I can't seem to muster the energy to venture further than my local café. I sit near a man who orders a glass of wine, then stares out at a distant thought, never touching his drink. As I watch him watching his thoughts, I wonder if someone is watching me watch mine. Perhaps this is just how Paris is in November. The tourists have gone home, the holiday cheer hasn't begun, so we are all taking a breather.

Janice

"Courage isn't having the strength to go on. It is going on when you don't have the strength."

Napoleon Bonaparte

Dear Áine,

The crisp air has brought with it a silent lull. I haven't been taking my usual grand urban hikes across Paris, preferring instead to spend long lingering hours huddled under heat lamps in cafés close to home. It has been quiet. Lately, I have found myself at a loss for what to write, what to do, and even what to say. Silence is usually a lovely companion as it often helps me hear that place inside where the words flow, but these days even that voice isn't much of a talker. I suppose it's my brain taking a rest after a busy spell. I know what you would say. "Go to museums and find hidden boutiques full of beautiful baubles. It's Paris!"

Le Bonaparte

CAFE

RUE
GUILLAUME
APOLLINAIRE

But I can't seem to muster the energy to venture further than my local café. I sit near a man who orders a glass of wine, then stares out at a distant thought, never touching his drink. As I watch him watching his thoughts, I wonder if someone is watching me watch mine. Perhaps this is just how Paris is in November. The tourists have gone home, the holiday cheer hasn't begun, so we are all taking a breather.

— Janice

November 2013, Paris

Dear Áine,

I am totally exasperated by my most recent quest to find Antoine the public poet. Antoine sits on rue Rambuteau in the middle of the crowds walking to the Métro. He waits for someone to whisper a word or theme in his ear and his fingers start plunking away on his typewriter. I have made it my mission to find Antoine and whisper "Love" in his ear so he could plunk out a love poem for me to send to you. But day after day, I've scoured the street and haven't found him. I suppose his job is "weather permitting" and it has been chilly here in the City of Lights. I searched with such intensity that I was reminded by my own searches for love—the hot stress of time being wasted, of being left empty-handed, of accepting that I might have to go without. Ugh! Eventually, it all worked out. As for Antoine, he's likely soaking up sunshine in Marseille, writing pithy poems along the port, waiting out the wind when he will return to Paris to conjure a poem for me and you.

Janice

───── ≈ ─────

"It is the time you have wasted for your rose that makes your rose so important."

Antoine de Saint-Exupéry, *The Little Prince*

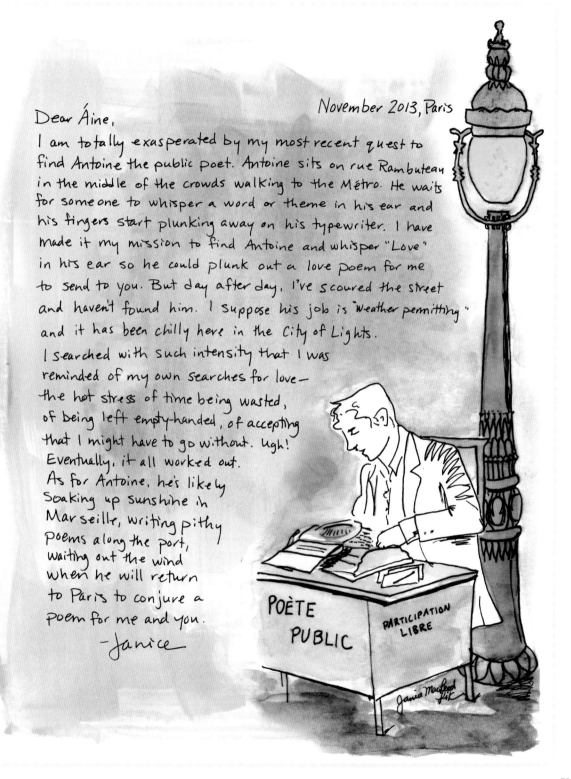

November 2013, Paris

Dear Áine,

I am totally exasperated by my most recent quest to find Antoine the public poet. Antoine sits on rue Rambuteau in the middle of the crowds walking to the Métro. He waits for someone to whisper a word or theme in his ear and his fingers start plunking away on his typewriter. I have made it my mission to find Antoine and whisper "Love" in his ear so he could plunk out a love poem for me to send to you. But day after day, I've scoured the street and haven't found him. I suppose his job is "weather permitting" and it has been chilly here in the City of Lights.

I searched with such intensity that I was reminded of my own searches for love— the hot stress of time being wasted, of being left empty-handed, of accepting that I might have to go without. Ugh! Eventually, it all worked out. As for Antoine, he's likely soaking up sunshine in Marseille, writing pithy poems along the port, waiting out the wind when he will return to Paris to conjure a poem for me and you.

—Janice

POÈTE PUBLIC

PARTICIPATION LIBRE

December 2013, Paris

Dear Áine,

December in Paris is enchanting. Christmas markets have popped up all over the city, offering everything from hot chocolate to glass-blown ornaments. The department stores have dolled up their windows and erected gravity-defying Christmas trees. It's all so very magical. In these early days of winter, I am often tempted to stay in, cozy in my tiny apartment, but to miss the twinkle lights? No way. I have the rest of winter to hibernate. So I've been lacing up, layering, and taking long walks in the brisk evenings. I watch the azure sky fade to black as the city's glow brightens. Last night, as I walked under a canopy of lights cascading down my street, I pondered what to ask for from Santa this year. I gazed up at the lights and laughed. I already had everything I could ever want. I was walking in a winter wonderland.

Janice

"...In a city like Paris where there was a way of living well and working, no matter how poor you were, was like having a great treasure given to you."

Ernest Hemingway, *A Moveable Feast*

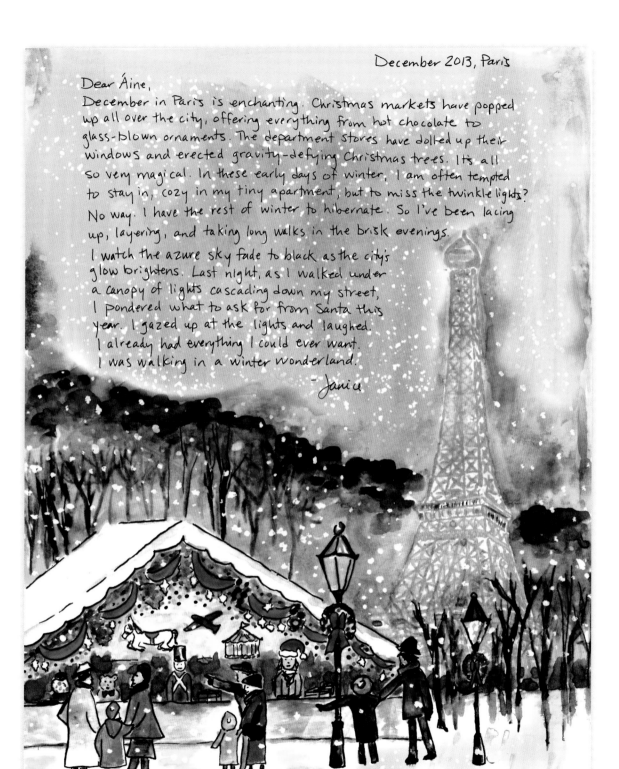

December 2013, Paris

Dear Áine,

December in Paris is enchanting. Christmas markets have popped up all over the city, offering everything from hot chocolate to glass-blown ornaments. The department stores have dolled up their windows and erected gravity-defying Christmas trees. It's all so very magical. In these early days of winter, I am often tempted to stay in, cozy in my tiny apartment, but to miss the twinkle lights? No way. I have the rest of winter to hibernate. So I've been lacing up, layering, and taking long walks in the brisk evenings.

I watch the azure sky fade to black as the city's glow brightens. Last night, as I walked under a canopy of lights cascading down my street, I pondered what to ask for from Santa this year. I gazed up at the lights and laughed. I already had everything I could ever want. I was walking in a winter wonderland.

— Janice

January 2014, Paris

Dear Áine,

Bonne année et bonne santé—Happy New Year and a wish for good health is the greeting du jour here in Paris. Shopkeepers are taking down the decorations and restocking for the new year ahead. One of the most darling of shopkeepers is Monsieur de Tugny. For the last 26 years, he has owned Mélodies Graphiques at 10, rue du Pont Louis-Philippe—a papeterie a short stroll from the Seine on the Right Bank. He offers the most marvelous collection of pens, inks, and paper. When he's not seeing customers, he sits behind his desk and writes out wedding invitations. You see, our monsieur is also a professional calligrapher and lover of the written word. A few days ago, I walked into his shop and told him I was in the market for the best calligraphy pen. He leapt from his seat and scurried around to the calligraphy pen area. He sifted through a series of nibs and in one Eureka moment he chose one and attached it to a handle. Beside the pens lay a massive book provided for pen testing. With a flourish he flipped to a fresh page, dipped the pen in the ink, and wrote "Calligraphy." He turned to me. "The most beautiful word written with the best pen. This is your pen." It wasn't the most expensive pen, nor was it the most beautiful. I inquired about those. He dismissed them with a wave and reminded me that I had not asked for the most beautiful pen. I had asked for the best. He returned to his desk to wrap my new pen. "I have the best job in the world," he said. "The biggest problem someone has in my boutique is to find the right pen, ink, and paper. These are problems I can solve." I walked into his store on my birthday. He solved more than a pen problem for me. He gave me a happy birthday.

Janice

"'The wand chooses the wizard, Mr. Potter.'"

J.K. Rowling, Mr. Ollivander in *Harry Potter and the Sorcerer's Stone*

Dear Nine,

Bonne année et bonne santé—Happy New Year and a wish for good health is the greeting du jour here in Paris. Shopkeepers are taking down the decorations and restocking for the new year ahead. One of the most darling of shopkeepers is Monsieur de Tugny. For the last 26 years, he has owned Mélodies Graphiques at 10, rue du Pont Louis-Philippe—a papeterie a short stroll from the Seine on the Right Bank. He offers the most marvelous collection of pens, inks, and paper. When he's not seeing customers, he sits behind his desk and writes out wedding invitations. You see, our monsieur is also a professional calligrapher and lover of the written word. A few days ago, I walked into his shop and told him I was in the market for the best calligraphy pen. He leapt from his seat and scurried around to the calligraphy pen area. He sifted through a series of nibs and in one Eureka moment he chose one and attached it to a handle. Beside the pens lay a massive book provided for pen testing. With a flourish he flipped to a fresh page, dipped the pen in the ink, and wrote "Calligraphy." He turned to me. "The most beautiful word written with the best pen. This is your pen." It wasn't the most expensive pen, nor was it the most beautiful. I inquired about those. He dismissed them with a wave and reminded me that I had not asked for the most beautiful pen. I had asked for the best. He returned to his desk to wrap my new pen. "I have the best job in the world," he said. "The biggest problem someone has in my boutique is to find the right pen, ink, and paper. These are problems I can solve."
I walked into his store on my birthday.
He solved more than a pen problem
for me. He gave me a very
happy birthday.

Janice

Café du Pont-Neuf

February 2014, Paris

Dear Áine,

The wind has been particularly harsh this winter in Paris. One strong gust tried to snatch my umbrella. I found myself in a jousting match with an older gentleman who was battling the same gust with his own umbrella. He was as shocked as I. I'm still not sure who won.

The bistros are offering up comfort food. Cassoulet is a bean and meat stew—a very fancy Pork and Beans, but more sausage.

The flower shops are selling hyacinth bulbs. I've brought a few home to watch them slowly burst forth in Easter pinks and purples on my windowsill. It's more entertaining than looking beyond the window to more grey—perpetual dusk.

And tomorrow, another day of grey, followed by darkness, with the lamps working overtime to make the city look like a big birthday cake.

Janice

"Pray don't talk to me about the weather, Mr. Worthing. Whenever people talk to me about the weather, I always feel quite certain that they mean something else. And that makes me so nervous."

Oscar Wilde, *The Importance of Being Ernest*

February 2014, Paris

Dear Áine,

The wind has been particularly harsh this winter in Paris. One strong gust tried to snatch my umbrella. I found myself in a jousting match with an older gentleman who was battling the same gust with his own umbrella. He was as shocked as I. I'm still not sure who won.

The bistros are offering up comfort food. Cassoulet is a bean and meat stew — a very fancy Pork and Beans, but more sausage.

The flower shops are selling hyacinth bulbs. I've brought a few home to watch them slowly burst forth in Easter pinks and purples on my window sill. It's more entertaining than looking beyond the window to more grey — perpetual dusk.

And tomorrow, another day of grey, followed by darkness, with the lamps working overtime to make the city look like a big birthday cake.

— Janie

February 2014, Paris

Dear Áine,

You would have thought Valentine's Day would have been some grand thing in the City of Amour. But aside from a few chocolate shops with heart-shaped sweets and flower shops bulking up inventory, the day arrived with little fanfare. Christophe and I went out for dinner. I had chicken puddled in something less cream sauce and more just cream. He remarked that the best part of his duck was the side of potatoes. We sat next to three older gentlemen, whose girlfriends were spending the evening with their husbands. This is France, after all. Free loving. There is a dry cleaner chain here called Cinq à Sec. Five to Dry is the literal translation. It's a play off the expression *Cinq à Sept*—Five to Seven—which is the affair you have between when you leave work at 5 pm and arrive home at 7 pm. And I suppose if you're not in the middle of a hot affair, you can always pick up your dry cleaning.

I stopped by the lovers lock bridge behind Notre Dame to see if there was any Valentine action. People put a lock on the bridge as some sort of commitment—a very un-French activity as they generally believe being locked in should be avoided. I expected parades, balloons and—dare I say it—valentines. But after dinner, as I walked home with Christophe hand-in-hand, I noticed the whole street was filled with people walking hand-in-hand. There may have been a parade after all.

Janice

"I asked my wife 'Is there someone else?'
She said, 'There must be.'"
Rodney Dangerfield

VALENTINE

February 2014,
Paris

Dear Áine,

You would have thought Valentine's Day would have been some grand thing in the City of Amour. But aside from a few chocolate shops with heart-shaped sweets and flower shops bulking up inventory, the day arrived with little fanfare. Christophe and I went out for dinner. I had chicken puddled in something less cream sauce and more just cream. He remarked that the best part of his duck was the side of potatoes. We sat next to three older gentlemen, whose girlfriends were spending the evening with their husbands. This is France, after all. Free loving. There is a drycleaner chain here called Cinq à Sec—Five to Dry. is the literal translation. It's a play off the expression Cinq à Sept—Five to Seven—which is the affair you have between when you leave work at 5pm and arrive home at 7pm. And I suppose if you're not in the middle of a hot affair, you can always pick up your dry cleaning.

I stopped by the lovers lock bridge behind Notre Dame to see if there was any Valentine action. People put a lock on the bridge as some sort of commitment—a very un-French activity as they generally believe being locked in should be avoided. I expected parades, balloons and—dare I say it—valentines. But after dinner, as I walked home with Christophe hand-in-hand, I noticed the whole street was filled with people walking hand-in-hand. There may have been a parade after all.

—Janice

Janice MacLeod

Midnight in Paris

February 2014, Paris

Dear Áine,

One of my preferred perches to sit and ponder in Paris is on the steps of Saint-Étienne-du-Mont church. These are the very steps made famous in the film *Midnight in Paris* where Gil, a struggling writer, sits and waits for the bell to toll midnight when a car drives up and transports him back in time to the 1920s to hobnob with Hemingway, Fitzgerald, and Picasso. It's easy to imagine Paris in the 1920s, as the buildings are all the same. The French are masters at maintenance. Only the cars and clothes are different. Back in the 1920s they couldn't have imagined what would happen—another war, television, the Internet. Layers upon ghostly layers piled up on these streets—stitched together with time and history textbook writers. And here I sit on my layer. Years from now another will sit on these steps and wonder back to these current days, and marvel at what we don't yet know.

Janice

"*I sometimes think, how is anyone ever gonna come up with a book, or a painting, or a symphony, or a sculpture that can compete with a great city. You can't. Because you look around, and every street, every boulevard is its own special art form, and when you think that in the cold, violent, meaningless universe that Paris exists, these lights, I mean, come on, there's nothing happening on Jupiter or Neptune, but from way out in space you can see these lights, the cafés, people drinking and singing. For all we know, Paris is the hottest spot in the universe.*"

Woody Allen, *Midnight in Paris*

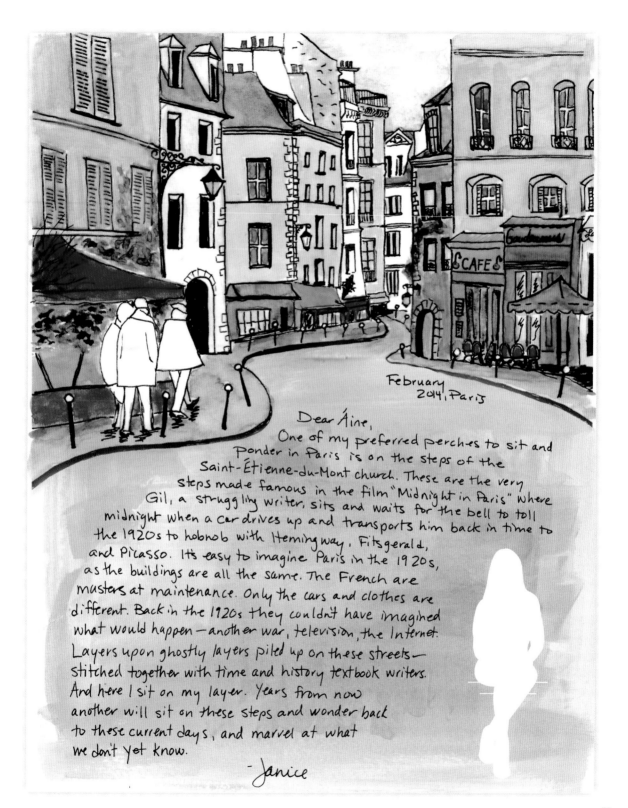

February
2014, Paris

Dear Áine,

One of my preferred perches to sit and
ponder in Paris is on the steps of the
Saint-Étienne-du-Mont church. These are the very
steps made famous in the film "Midnight in Paris" where
Gil, a struggling writer, sits and waits for the bell to toll
midnight when a car drives up and transports him back in time to
the 1920s to hobnob with Hemingway, Fitsgerald,
and Picasso. It's easy to imagine Paris in the 1920s,
as the buildings are all the same. The French are
masters at maintenance. Only the cars and clothes are
different. Back in the 1920s they couldn't have imagined
what would happen — another war, television, the Internet.
Layers upon ghostly layers piled up on these streets —
stitched together with time and history textbook writers.
And here I sit on my layer. Years from now
another will sit on these steps and wonder back
to these current days, and marvel at what
we don't yet know.

- Janice

Pont Neuf

March 2014, Paris

Dear Áine,

This is Pont Neuf, translated as "New Bridge." It's the oldest bridge in Paris. Nothing quite stirs up emotion, nostalgia, and romance like a walk along one of the many bridges of Paris. But going <u>under</u> the bridges is even better. At Pont Neuf, you'll find a small river cruise. It leaves every hour or so. The ride is also an hour or so. And I think it's the best ticket in town. I have spent a lot more on cheaper thrills. For the price of a forgettable lunch, I can have an unforgettable river cruise. The boat takes you to all the usual Seine-side sights from Notre Dame to the Eiffel Tower, and gives you a history lesson on the bridges. All have their own story. Napoleon built a few. The stones of the Bastille were used to build another. There is a bridge for making wishes, another for sharing kisses. Whether you're on the cruise with someone to kiss or not, it's still one of the most romantic things to do in Paris.

Janice

"How would you like to be
Down by the Seine with me
Oh what I'd give for a moment or two
Under the bridges of Paris with you
Darling I'd hold you tight
Far from the eyes of night
Under the bridges of Paris with you
I'd make your dreams come true"

Jean Rodor, "Under the Bridges of Paris"

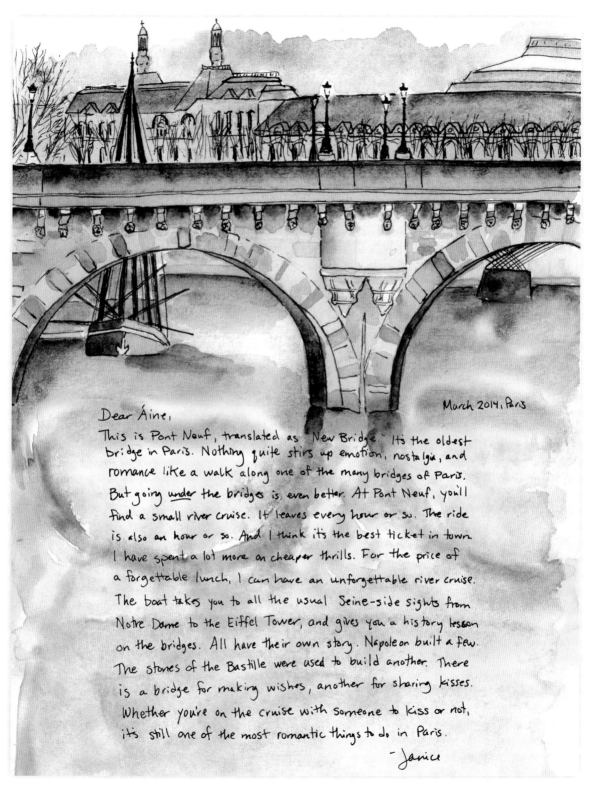

March 2014, Paris

Dear Áine,

This is Pont Neuf, translated as "New Bridge." It's the oldest bridge in Paris. Nothing quite stirs up emotion, nostalgia, and romance like a walk along one of the many bridges of Paris. But going under the bridges is even better. At Pont Neuf, you'll find a small river cruise. It leaves every hour or so. The ride is also an hour or so. And I think it's the best ticket in town. I have spent a lot more on cheaper thrills. For the price of a forgettable lunch, I can have an unforgettable river cruise. The boat takes you to all the usual Seine-side sights from Notre Dame to the Eiffel Tower, and gives you a history lesson on the bridges. All have their own story. Napoleon built a few. The stones of the Bastille were used to build another. There is a bridge for making wishes, another for sharing kisses. Whether you're on the cruise with someone to kiss or not, it's still one of the most romantic things to do in Paris.

- Janice

Café Le Papillon

March 2014, Paris

Dear Patricia,

I think we are in the clear. The winter in Paris has been long but mild. And there have been glimpses of warm days ahead.

The patio chairs have also been dusted off. Usually just the smokers puff and shiver outside. But now, bustling terraces are on the horizon. There is a dark side to the balmy spring days: Pollution. The transit system was free this weekend to encourage motorists to hop on the Métro instead. I took a few free rides but have spent more time on urban hikes. It's delightful to not be weighed down by winter gear! There is plenty of rain, so the flowers will be along shortly. I keep thinking the temperature will drop suddenly, so I haven't put my winter scarves away just yet . . . though I've dusted off my sunglasses.

Janice

"About as simple as it gets."

Anthony Bourdain about Café Le Papillon in Paris

Dear Patricia, March 2014, Paris

I think we are in the clear. The winter in Paris has been long but mild.
And there have been glimpses of warm days ahead.

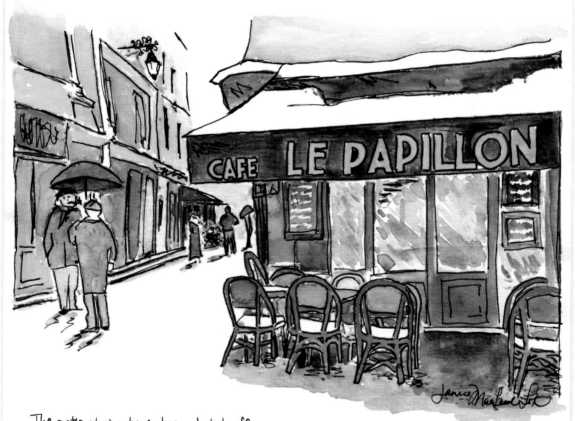

The patio chairs have been dusted off.
Usually just the smokers puff and shiver outside.
But now, bustling terraces are on the horizon. There is a dark side to the balmy
Spring days: Pollution. The transit system was free this weekend to encourage motorists
to hop on the Métro instead. I took a few free rides but have spent more time on
urban hikes. It's delightful to not be weighed down by winter gear! There is plenty of
rain, so the flowers will be along shortly. I keep thinking the temperature will drop
suddenly, so I haven't put my winter scarves away just yet... though I've dusted off
 my sunglasses.

 — Janice

Yellow Blossoms

April 2014, Paris

Dear Áine,

I feel like a flower in bloom. Over the last few winter months I've hunkered down with short walks and dim days. The sun must have been on vacation because it certainly wasn't in Paris. City of Lights? Not lately. I was in a café near Jardin du Luxembourg when it decided to come back to town. Big bright beams shone down. I moved my *café crème* to *la terrasse*. The sun stayed, soon sprouting dormant bulbs and buds, shaking them awake. The first to bloom were yellows, followed by whites and purples. The grand finale was the pink cherry blossoms, attracting camera-toting gawkers such as myself, and of course the glorious bees whose buzz could almost drown out traffic. Almost. On the first warm day, I skipped off to the Eiffel Tower. It was framed with a grand bouquet of spring flowers. As I stood at the base, looking up at the monument and feeling the warmth of the sun on my face, my expat soul could finally feel roots forming.

Janice

"It's so curious: one can resist tears and 'behave' very well in the hardest hours of grief. But then someone makes you a friendly sign behind a window, or one notices that a flower that was in bud only yesterday has suddenly blossomed, or a letter slips from a drawer . . . and everything collapses."

Colette

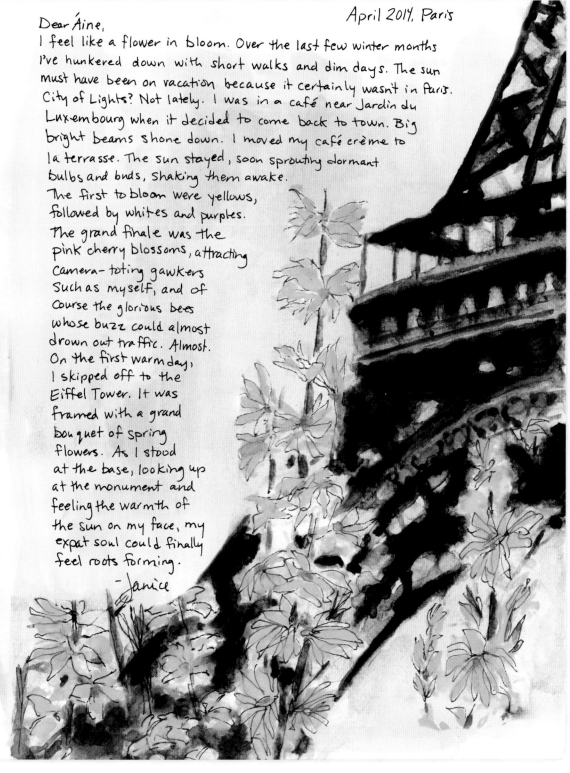

Dear Áine,

I feel like a flower in bloom. Over the last few winter months I've hunkered down with short walks and dim days. The sun must have been on vacation because it certainly wasn't in Paris. City of Lights? Not lately. I was in a café near Jardin du Luxembourg when it decided to come back to town. Big bright beams shone down. I moved my café crème to la terrasse. The sun stayed, soon sprouting dormant bulbs and buds, shaking them awake.

The first to bloom were yellows, followed by whites and purples. The grand finale was the pink cherry blossoms, attracting camera-toting gawkers such as myself, and of course the glorious bees whose buzz could almost drown out traffic. Almost. On the first warm day, I skipped off to the Eiffel Tower. It was framed with a grand bouquet of spring flowers. As I stood at the base, looking up at the monument and feeling the warmth of the sun on my face, my expat soul could finally feel roots forming.

— Janice

May 2014, Paris

Dear Áine,

When I first arrived in Paris, I would often traipse off to a museum and fill my head with ideas from some of the world's great artists. But once I settled into my life here, museums became somewhere I could visit "tomorrow," which became "rarely," which became "never." Until recently, that is! The Petit Palais opened an exhibit about La Belle Époque, that dreamy era that straddled 1900 and ended with World War I. Back then, Paris was glittering with newly installed electric lights. People were enchanted by the mysteries of electricity. Suddenly evening became a time of going out to cabarets. Toulouse-Lautrec was sketching red-lipped cancan dancers, Picasso was dipping his brush in blue, and the paint was still wet on Renoirs and Monets. The posters of the era were particularly captivating—Art Nouveau tendrils, bright hues, and promises of good times. At the exhibit, the original Chat Noir stared down at me with its perturbed yellow eyes. I wonder what it saw on its perch at Pigalle all those years ago.

Janice

"*Paris was a universe whole and entire unto herself, hollowed and fashioned by history; so she seemed in this age of Napoleon III with her towering buildings, her massive cathedrals, her grand boulevards and ancient winding medieval streets—as vast and indestructible as nature itself . . . Even the majestic trees that graced and sheltered her streets were attuned to her—and the waters of the Seine, contained and beautiful as they wound through her heart; so that the earth on that spot, so shaped by blood and consciousness, had ceased to be the earth and had become Paris.*"

Anne Rice, *Interview with the Vampire*

May 2014,
Paris

Dear Áine,
When I first arrived in Paris,
I would often traipse off to a
museum and fill my head with ideas
from some of the world's great artists.
But once I settled into my life here, museums
became somewhere I could visit "tomorrow," which
became "rarely," which became "never." Until recently,
that is! The Petit Palais opened an exhibit about
La Belle Époque, that dreamy era that straddled 1900
and ended with World War I. Back then, Paris was
glittering with newly installed electric lights. People were
enchanted by the mysteries of electricity. Suddenly
evening became a time of going out to cabarets.
Toulouse-Lautrec was sketching red-lipped cancan dancers,
Picasso was dipping his brush in blue, and the paint was
still wet on Renoirs and Monets. The posters of the era were particularly captivating—
Art Nouveau tendrils, bright hues, and promises of good times. At the exhibit,
the original Chat Noir stared down at me with its perturbed yellow eyes. I wonder
what it saw on its perch at Pigalle all those years ago.
 —Janice

La Belle Époque

June 2014, Paris

Dear Áine,

The warm winds of June have arrived, and with them my renewed exuberance for long hikes across the city. I have done my fair share of walking around Paris by now, yet each time, I come across something I haven't noticed before, such as these mer-people flanking a large doorway. They reside at a cross street, which meant I had to walk back and forth through the intersection to take photos in the middle of the street whenever the light turned red. I stood on the sidewalk for some time hoping the doors would open and I could catch a glimpse inside. It's tough to know what may be tucked away behind the doors of Paris—an ornate staircase, a secret garden? I wonder how long these statues have been whispering together about what goes on behind their closed doors. Years? A century? Centuries?! They aren't talking. Yet another secret they keep here in *la belle ville.*

Janice

·——————— ❧ ———————·

"And so with the sunshine and the great bursts of leaves growing on the trees, just as things grow in fast movies, I had that familiar conviction that life was beginning over again with the summer."

F. Scott Fitzgerald, *The Great Gatsby*

Dear Áine,
The warm winds of June have arrived, and with them my renewed exuberance for long hikes across the city. I have done my fair share of walking around Paris by now, yet each time, I come across something I haven't noticed before, such as these mer-people flanking a large doorway. They reside at a cross street, which meant I had to walk back and forth through the intersection to take photos in the middle of the street whenever the light turned red. I stood on the sidewalk for some time hoping the doors would open and I could catch a glimpse inside. It's tough to know what may be tucked away behind the doors of Paris — an ornate staircase, a secret garden? I wonder how long these statues have been whispering together about what goes on behind their closed doors. Years? A century? Centuries?! They aren't talking. Yet another secret they keep here in la belle ville. —Janice

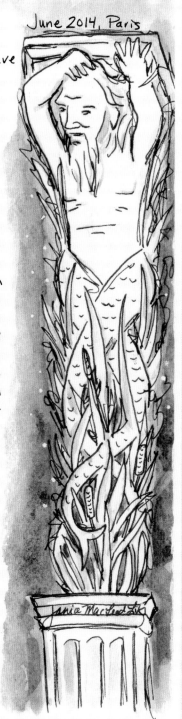

Accordionist

July 2014, Paris

Dear Áine,

Summer in Paris is a carnival. The sidewalks sizzle, the cafés come alive, and music plays all day long and into the night. Since this is tourist season, many musicians are out busking for spare Euros. The one who catches my interest most is the accordionist who plays on rue des Gobelins outside a boulangerie. He has a sad pride about him—happy to be playing but also tired. Though like any arcade automaton, he is more animated when you plunk a coin in his cup. One evening each summer is the Fête de la Musique, when anyone with a musical instrument can play on the sidewalks of Paris without a permit and children are allowed to stay out late and run around like feral animals. They drown out our accordion player, but he waits it out and serenades the street alone later with a sad lullaby.

Janice

"The body shuts down when it has too much to bear; goes its own way quietly inside, waiting for a better time, leaving you numb and half alive."

Jeanette Winterson, *The Passion*

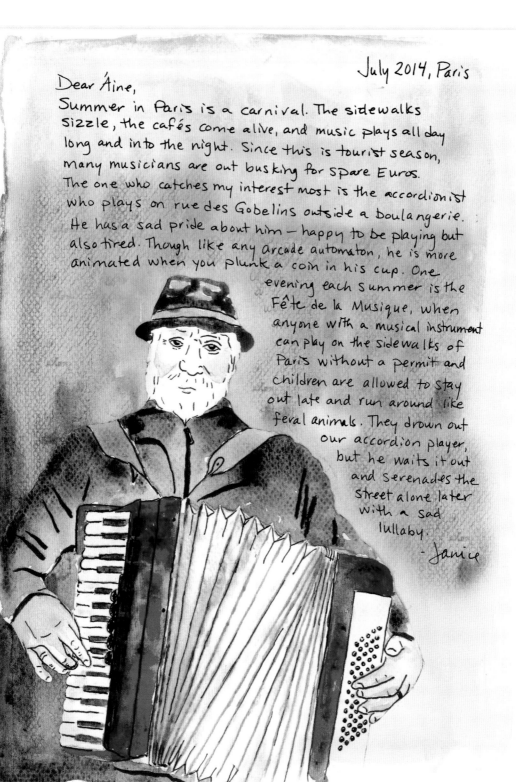

July 2014, Paris

Dear Áine,

Summer in Paris is a carnival. The sidewalks sizzle, the cafés come alive, and music plays all day long and into the night. Since this is tourist season, many musicians are out busking for spare Euros. The one who catches my interest most is the accordionist who plays on rue des Gobelins outside a boulangerie. He has a sad pride about him — happy to be playing but also tired. Though like any arcade automaton, he is more animated when you plunk a coin in his cup. One evening each summer is the Fête de la Musique, when anyone with a musical instrument can play on the sidewalks of Paris without a permit and children are allowed to stay out late and run around like feral animals. They drown out our accordion player, but he waits it out and serenades the street alone later with a sad lullaby.

—Janice

August 2014, Paris

Dear Áine,

On Tuesday nights I meet Carole for drinks. We rendezvous over in her neighborhood called République. When I emerge from the Métro I am greeted by a massive statue of Marianne. Bonjour! I recently discovered that Marianne was never a real person but was a symbol of liberty in the French Revolution and was named after the two most popular names of the day—Mary and Anne. Having a woman to symbolize the liberty of France was also a way to visually break from the all-king oppressive monarchy. Plus, the words France and Republic are feminine in the French language, so having a lady seemed more linguistically fitting. She also appears on the French postage stamp. Each new president chooses a new design. The latest incarnation of our *française* lady of liberty is said to be modeled after Inna Shevchenko, a spit-fire feminist. When she saw the new stamp, she remarked that now all the haters would have to lick her backside every time they posted a letter. Charming. For me, Marianne represents my friendship with Carole and our Tuesday evening *apéro*. We talk through problems and offer solutions, we try new wines and old cheeses, and we watch the parade of pedestrians from our own perch on *la terrasse* of a bohemian café. Later, I pass Marianne, who nods Au Revoir before I descend down into the Métro.

Janice

"I do not know which side of you I enjoy the most. I treasure each side, just as I have treasured our life together."

Nicholas Sparks, *The Notebook*

Dear Áine, August 2014, Paris

On Tuesday nights I meet Carole for drinks.
We rendezvous over in her neighborhood
called République. When I emerge from
the Métro I am greeted by a massive
statue of Marianne. Bonjour! I recently discovered
that Marianne was never a real person but was
a symbol of liberty in the French Revolution and
was named after the two most popular names of the
day—Mary and Anne. Having a woman to symbolize
the liberty of France was also a way to visually break
from the all-king oppressive monarchy. Plus, the words
France and Republic are feminine in the French language,
so having a lady seemed more linguistically fitting. She also
appears on the French postage stamp. Each new president
chooses a new design. The latest incarnation of our "française"
lady of liberty is said to be modeled after Inna Shevchenko, a spit-fire
feminist. When she saw the new stamp, she remarked that now all the
haters would have to lick
her backside every time
they posted a letter.
Charming. For me,
Marianne represents my
friendship with Carole
and our Tuesday evening
apéro. We talk through
problems and offer solutions,
we try new wines and old cheeses,
and we watch the parade of
pedestrians from our own
perch on la terrasse of
a bohemian café. Later,
I pass Marianne, who
nods Au Revoir before I
descend down into the
Métro.
 —Janice

September 2014, Paris

Dear Áine,

Paris is filled with secret spaces for those who want respite from the hectic go-go-go
of life in a modern city. One of the best secret spaces is on the rooftop of the Galeries
Lafayette department store. If you ever make your way to Paris, do try to make your way
to this special place above the hustle-bustle of the street. After you enter the building,
take the escalator to the top—so many floors I lost count. There you'll find a plain set of
stairs, so plain that the tourists turn back, assuming the stairs lead to a restricted area.
Genius! Take the stairs. They lead to the rooftop where you'll find a faux green grass
carpet, lounge chairs, and a million dollar view of <u>all</u> the great monuments of Paris.
You'll also find office workers munching salads in their suits on their breaks, weary
bag-laden marathon shoppers, and people like me who sit quietly for hours sketching,
taking photos, and counting their lucky stars to know of such a place.

Janice

"Overall, I was happiest to be alone; for it was then when
I was most aware of what I possessed. Free to look out
over the rooftops of the city. Happy to be alone in the
company of friends, the company of lovers and strangers."

Roman Payne, *Rooftop Soliloquy*

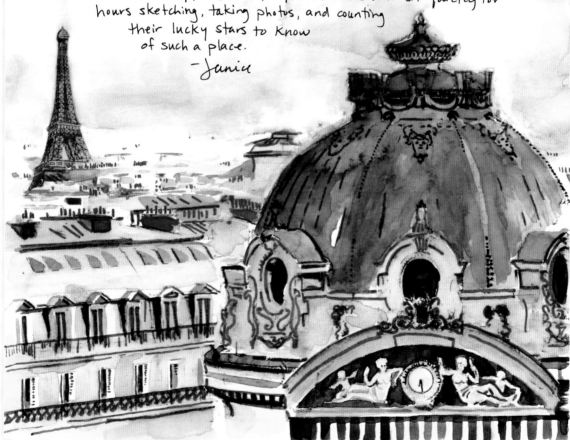

September 2014, Paris

Dear Áine,

Paris is filled with secret spaces for those who want respite from the hectic go-go-go of life in a modern city. One of the best secret spaces is on the rooftop of the Galeries Lafayette department store. If you ever make your way to Paris, do try to make your way to this special place above the hustle-bustle of the street. After you enter the building, take the escalator to the top—so many floors I lost count. There you'll find a plain set of stairs, so plain that the tourists turn back, assuming the stairs lead to a restricted area. Genius! Take the stairs. They lead to the rooftop where you'll find a faux green grass carpet, lounge chairs, and a million dollar view of all the great monuments of Paris. You'll also find office workers munching salads in their suits on their breaks, weary bag-laden marathon shoppers, and people like me who sit quietly for hours sketching, taking photos, and counting their lucky stars to know of such a place.

—Janice

October 2014, Paris

Dear Áine,

The Paris park chair may be the most uncomfortable chair in the world to provide the most gratifying experience. These hard metal chairs are scattered in gardens throughout the city. Their metal cuts into the leg, the armrest seems to be designed for someone much larger than myself, and because of their heft, when dragged across gravel, they create their own unique grating rumble. Yet when my feet are aching or my mind is full, these chairs seem to heal what's ailing. As I walk through the park, I notice the chairs are left as arranged by their last occupants—5 in a circle hints at a group of teens, 3 in a triangle was likely a couple who had a picnic and used the third chair as a table, and 2 facing each other as mine are now was probably one person using the second chair as a footstool. It's the only way I can be comfortable enough to sit for an extended period of time and watch the trees perform their vibrant costume change from summer to autumn. Nature's burlesque. Generally, park gardeners trim and cut so often around here I wonder if anything has the chance to grow. But in autumn, they relax a little and allow the fallen leaves to carpet the garden in hot hues until the final curtain call before winter. Then all the leaves will be gathered. I'll be nearby, watching and squirming in my Paris park chair.

À bientôt!

Janice

"The prospect of physical discomfort has not deterred anyone from buying, or sitting in, chairs that hurt. A painful chair, however, is more willingly bought and endured if it carries the imprimatur of a museum or some other respectable design authenticator. Randall Jarrell noted, with great wit but no exaggeration, that there are people who '. . . will sit on a porcupine if you first exhibit it at the Museum of Modern Art and say that it is a chair.'"

Ralph Caplan, *By Design*

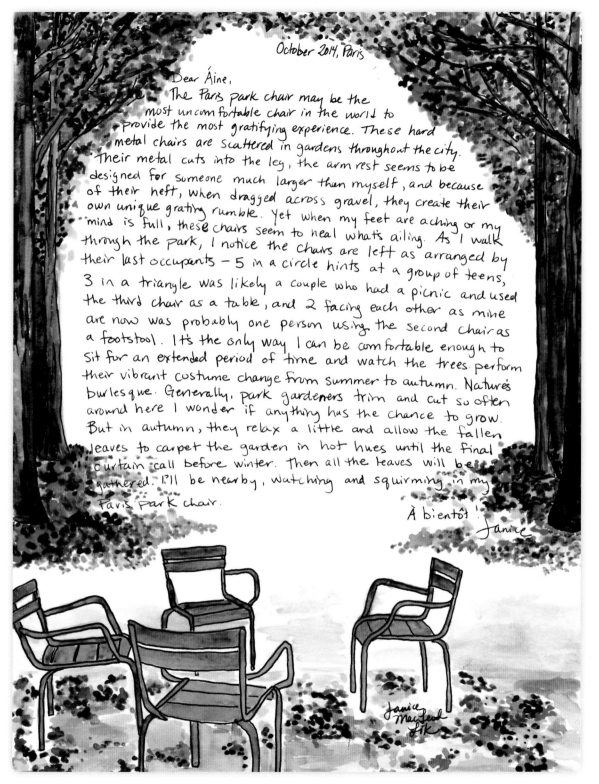

October 2014, Paris

Dear Áine,

The Paris park chair may be the
most uncomfortable chair in the world to
provide the most gratifying experience. These hard
metal chairs are scattered in gardens throughout the city.
Their metal cuts into the leg, the arm rest seems to be
designed for someone much larger than myself, and because
of their heft, when dragged across gravel, they create their
own unique grating rumble. Yet when my feet are aching or my
mind is full, these chairs seem to heal what's ailing. As I walk
through the park, I notice the chairs are left as arranged by
their last occupants — 5 in a circle hints at a group of teens,
3 in a triangle was likely a couple who had a picnic and used
the third chair as a table, and 2 facing each other as mine
are now was probably one person using the second chair as
a footstool. It's the only way I can be comfortable enough to
sit for an extended period of time and watch the trees perform
their vibrant costume change from summer to autumn. Nature's
burlesque. Generally, park gardeners trim and cut so often
around here I wonder if anything has the chance to grow.
But in autumn, they relax a little and allow the fallen
leaves to carpet the garden in hot hues until the final
curtain call before winter. Then all the leaves will be
gathered. I'll be nearby, watching and squirming in my
Paris park chair.

À bientôt !
Janice

Janice
MacLeod
Lik

Boulangerie 28

November 2014, Paris

Dear Áine,

I've been on the hunt for the perfect baguette. A baguette in France must, by law, have only four ingredients—water, salt, flour, and yeast—so you would think they all tasted exactly the same. Not so! There is the heat of an oven to consider, the time dough is given to rise, and of course, the mood of the kneader. Awards are bestowed annually to the bakers who master the art of all three. In my due diligence, I hopscotched across Paris to taste the winning baguettes. They were good, *bien sûr,* but not astoundingly better than award-less baguettes. I had to add other factors to the hunt—location, charm, and a nearby gurgling fountain all earned bonus points. As the weather cooled, I noticed that warm baguettes tasted better. Furthermore, the taste improved when I could sit outside a bakery with a friend and partake in a mini impromptu picnic with said baguette. Lucky for me, there are plenty of benches in Paris, a slew of boulangeries, and a great handful of friends who love to break bread. We are determined to soldier on, one baguette at a time.

Janice

"*Every night a truck pulls up to my neighborhood bagel place and pumps about a ton of flour into underground tanks. And then the air is filled with white dust which never seems to land.*"

Nora Ephron, *You've Got Mail*

Dear Áine,

I've been on the hunt for the perfect baguette. A baguette in France must, by law, have only four ingredients — water, salt, flour, and yeast — so you would think they all tasted exactly the same. Not so! There is the heat of an oven to consider, the time the dough is given to rise, and of course, the mood of the kneader. Awards are bestowed annually to the bakers who master the art of all three. In my due diligence, I hopscotched across Paris to taste the winning baguettes. They were good, "bien sûr", but not astoundingly better than award-less baguettes. I had to add other factors to the hunt — location, charm, and a nearby gurgling fountain all earned bonus points. As the weather cooled, I noticed that warm baguettes tasted better. Furthermore, the taste improved when I could sit outside a bakery with a friend and partake in a mini impromptu picnic with said baguette. Lucky for me, there are plenty of benches in Paris, a slew of boulangeries, and a great handful of friends who love to break bread. We are determined to soldier on, one baguette at a time.

— Janice

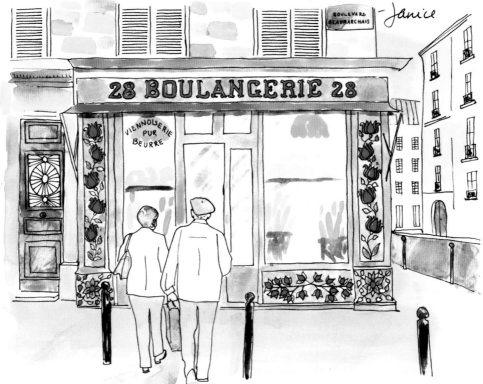

November 2014, Italy

Dear Áine,

I loved it and loathed it. Clinging to the edge of the Amalfi Coast sits the picturesque
village of Positano. It is stitched together by a labyrinth of stairs leading down to the
turquoise waters of the Mediterranean. As I meandered down the market street, I was
cramped by throngs of tourists. By definition, I was also a tourist, but don't we all
feel tourists are other people, not us. We are travelers. We behave. We fit in. We are
a blessing to the local economy. We are a pleasure to have around. I was baffled by
how these tourists binged on lemon-infused creams, soaps, candies, and liquor. On the
Amalfi Coast, lemon is king. These aren't your ordinary lemons. They are gnarled and
pockmarked, but it's the zest of this irregular skin that attracts lemon lovers. I stood at
the fray and tried the lemon gelato. I was converted instantly and soon hopped in the
crowd gathering yellow treasures. Positano itself is like that lemon. At first, you wonder
why all the fuss, but delve down and you'll know the beauty beneath.

Janice

"Nobbly like an old man's nose."

Jamie Oliver about the Italian Cedro lemon, *Food Tube*

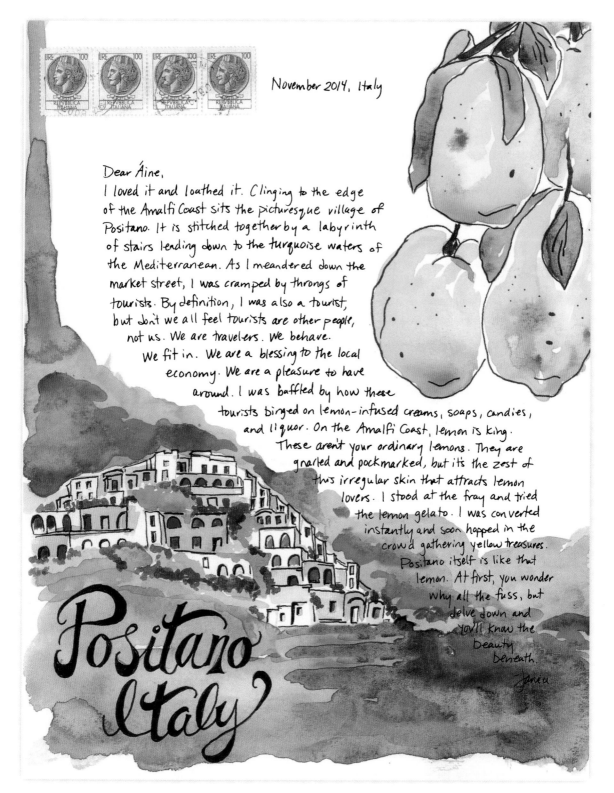

November 2014, Italy

Dear Áine,

I loved it and loathed it. Clinging to the edge of the Amalfi Coast sits the picturesque village of Positano. It is stitched together by a labyrinth of stairs leading down to the turquoise waters of the Mediterranean. As I meandered down the market street, I was cramped by throngs of tourists. By definition, I was also a tourist, but don't we all feel tourists are other people, not us. We are travelers. We behave. We fit in. We are a blessing to the local economy. We are a pleasure to have around. I was baffled by how these tourists binged on lemon-infused creams, soaps, candies, and liquor. On the Amalfi Coast, lemon is king. These aren't your ordinary lemons. They are gnarled and pockmarked, but it's the zest of this irregular skin that attracts lemon lovers. I stood at the fray and tried the lemon gelato. I was converted instantly and soon hopped in the crowd gathering yellow treasures.

Positano itself is like that lemon. At first, you wonder why all the fuss, but delve down and you'll know the beauty beneath.

Janice

Positano Italy

December 2014, Paris

Dear Áine,

At first the winter afternoons seem cruelly short. The time change plunges Paris into darkness by 5 pm. Months of evenings at home are on the horizon. People dust off the slow cooker and buy stew meat and red wine. The entire city seems to stay in for that first week of winter. While we are all perfecting our *boeuf bourguignon*, city workers are quietly stringing up Christmas lights around the city. It's the glimmer of these lights that draws us out of our apartments. We pull out the heavier scarves and stroll over to gaze at elaborate department store windows. We meander through holiday markets sipping mulled wine along the way. We huddle under heat lamps at cafés. And on the occasional clear evening, when twinkling stars mingle with holiday lights, we lace up skates and go skating on rinks set up around the city for those long winter evenings. I always seem to get lost in time as I skate around and around. There is a sense that I've been here before, perhaps centuries before—and here right now I might be skating with ghosts.

Janice

"She used to lie in bed at night . . . and she would imagine her ceiling was an ice-covered lake. She would fall asleep dreaming that she could skate on her ceiling forever."

Stuart McLean, *Dave and Morley Stories, The Vinyl Cafe*

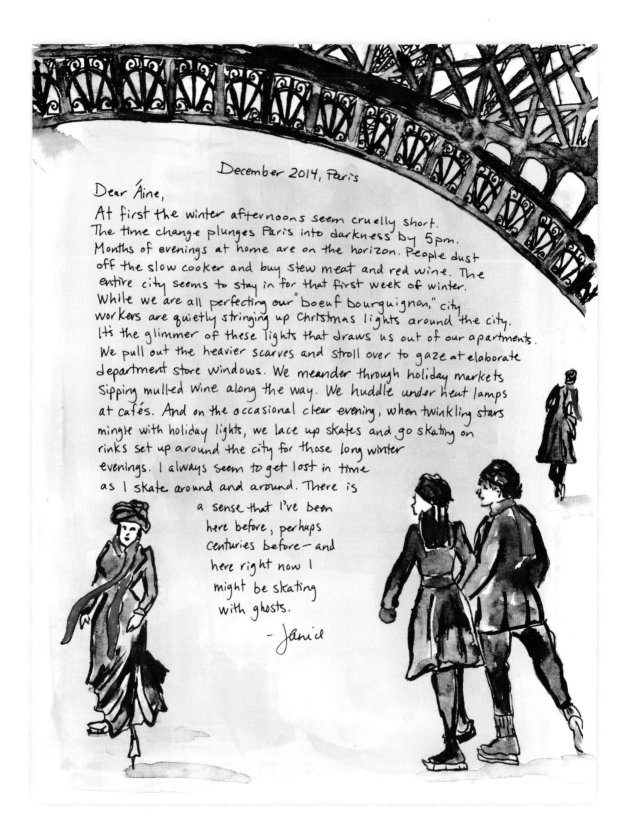

December 2014, Paris

Dear Áine,

At first the winter afternoons seem cruelly short. The time change plunges Paris into darkness by 5pm. Months of evenings at home are on the horizon. People dust off the slow cooker and buy stew meat and red wine. The entire city seems to stay in for that first week of winter. While we are all perfecting our "boeuf bourguignon," city workers are quietly stringing up Christmas lights around the city. It's the glimmer of these lights that draws us out of our apartments. We pull out the heavier scarves and stroll over to gaze at elaborate department store windows. We meander through holiday markets sipping mulled wine along the way. We huddle under heat lamps at cafés. And on the occasional clear evening, when twinkling stars mingle with holiday lights, we lace up skates and go skating on rinks set up around the city for those long winter evenings. I always seem to get lost in time as I skate around and around. There is a sense that I've been here before, perhaps centuries before — and here right now I might be skating with ghosts.

— Janie

109

December 2014, United Kingdom

Dear Áine,

Greetings from Kirkby Lonsdale, a strangely named village in the English countryside.
I arrived here to meet a friend who was heading north to Scotland at the same time I was
heading south to London. Coincidences like this happen so often on the road that
I have ceased to be astounded, but my belief in angels is reaffirmed. My weary feet
were delighted to arrive in a town you can walk across in ten minutes. Though I wanted
to stop every three minutes for tea (I was lured by the scones). The boutiques are the
perfect mix of artsy enough for tourists but practical enough for locals. Since I prefer
to encompass both realms, I purchased gloves, postcards, and the most lovely set of
paints. It's a frightful thing for a traveling artist to buy new paints. Will they perform?
How will the pigment mingle with the paper? How much is the currency conversion?!
After my purchase I headed straight for the tea shop to test them. I hope I captured the
Charles Dickens quality of this village. I half expect men to wear top hats, or to spot
Sherlock Holmes solving a murder mystery. If you were here we could imagine all the
possibilities. Instead, I'll head out for some shopping. Plenty of people will get tea in
their stockings this year.

Janice

*"But for now, let me say—without hope or
agenda, just because it's Christmas, and at
Christmas you tell the truth—to me, you are
perfect. And my wasted heart will love you . . ."*

Richard Curtis, *Love Actually*

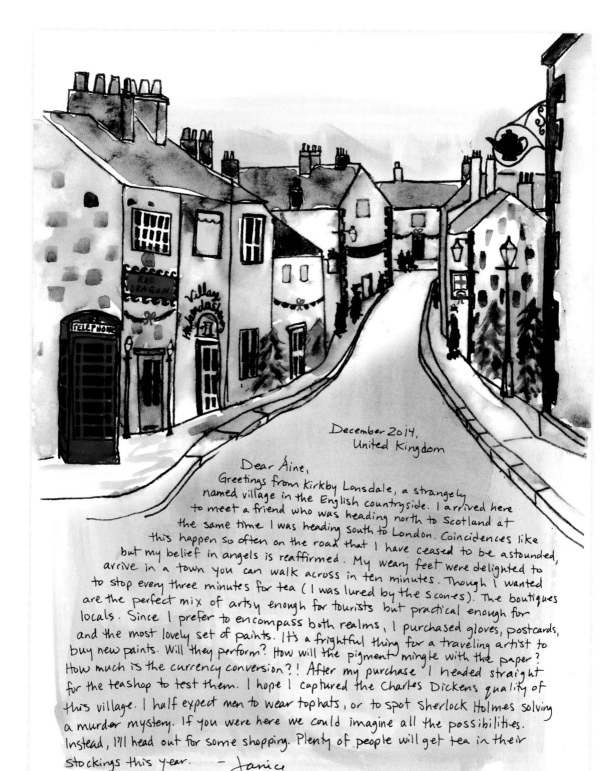

December 2014,
United Kingdom

Dear Áine,

Greetings from Kirkby Lonsdale, a strangely named village in the English countryside. I arrived here to meet a friend who was heading north to Scotland at the same time I was heading south to London. Coincidences like this happen so often on the road that I have ceased to be astounded, but my belief in angels is reaffirmed. My weary feet were delighted to arrive in a town you can walk across in ten minutes. Though I wanted to stop every three minutes for tea (I was lured by the scones). The boutiques are the perfect mix of artsy enough for tourists but practical enough for locals. Since I prefer to encompass both realms, I purchased gloves, postcards, and the most lovely set of paints. It's a frightful thing for a traveling artist to buy new paints. Will they perform? How will the pigment mingle with the paper? How much is the currency conversion?! After my purchase I headed straight for the teashop to test them. I hope I captured the Charles Dickens quality of this village. I half expect men to wear top hats, or to spot Sherlock Holmes solving a murder mystery. If you were here we could imagine all the possibilities. Instead, I'll head out for some shopping. Plenty of people will get tea in their stockings this year. — Janice

Chocolat Chaud

January 2015, Paris

Dear Áine,

The freezing mark in Paris is a lot colder than in other places. Some say it's the humidity. Others say it's because we are a city of people who sleep inside but live outside. (The bistro is considered an extension of the living room.) I think it is so cold because the buildings are old and creaky, so there is always a draft. Whatever the reason, the point is that it is <u>cold,</u> so I've had a lot more interest in hot chocolate. I enlisted a friend, who is also always cold, to help me taste-test all the best hot chocolates in Paris. We began in earnest. Who wouldn't? We were like Goldilocks in search of the perfect *chocolat chaud*. I was hoping to find it in an obscure café off a medieval street with a bartender sporting a handlebar moustache that danced about a surly lip. The kind of guy who would offer a story of how his recipe was the same as it was many years before when he was young and had just started the café with his new bride. Then he would trail off, his eyes staring into the past, examining his memory, and finishing with the famous French shrug. But no such luck. After trying hot chocolates that were too sweet, not sweet enough, too milky, or stingy in servings for the price (we once got a refill, not realizing the final bill would come to 36 Euros for two!), we ended up at Angelina on rue de Rivoli—the one place everyone always recommends. It was the clear winner just like everyone says it is. And you can get it to go, so you can sip and stroll through the Tuileries Garden across the street and look for men with handlebar moustaches.

Janice

" . . . a portrait of a muscular grey-haired man with a grim, almost demented gaze and the sort of moustache that could beat you in an arm-wrestling contest."

Ned Beauman, *The Teleportation Accident*

Dear Áine, January 2015, Paris

The freezing mark in Paris is a lot colder than in other places. Some say it's the humidity. Others say it's because we are a city of people who sleep inside but live outside. (The bistro is considered an extension of the living room.) I think it is so cold because the buildings are old and creaky, so there is always a draft. Whatever the reason, the point is that it is <u>cold</u>, so I've had a lot more interest in hot chocolate. I enlisted a friend, who is also always cold, to help me taste-test all the best hot chocolates in Paris. We began in earnest. Who wouldn't? We were like Goldilocks in search of the perfect "chocolat chaud." I was hoping to find it in an obscure café off a medieval street with a bartender sporting a handlebar moustache that danced about a surly lip. The kind of guy who would offer a story of how his recipe was the same as it was many years before when he was young and had just started the café with his new bride. Then he would trail off, his eyes staring into the past, examining his memory, and finishing with the famous French shrug. But no such luck. After trying hot chocolates that were too sweet, not sweet enough, too milky, or stingy in servings for the price (we once got a refill, not realizing the final bill would come to 36 Euros for two!), we ended up at Angelina on rue de Rivoli — the one place — the one place everyone always recommends.

It was the clear winner just like everyone says it is. And you can get it to go, so you can sip and stroll through the Tuileries Garden across the street and look for men with handlebar moustaches.

— Janice

ANGELINA
PARIS

ANGELINA
PARIS

Roy's Motel & Café, California

January 2015, California, USA

Dear Áine,

You never expect a travel revelation to occur at a gas station. Gas stations are usually one of those forgettable places in between. I was on a road trip from California to Arizona when I found Roy's Motel & Café somewhere north of Joshua Tree, east of the state line, and 70 years too late. Only the gas station was open, but it was the only place open. This was once a fully functioning desert town—complete with a school, cemetery, and landing strip. When Interstate 40 opened north of Roy's, the town dried up like a leaf in autumn. Now all that's left is a gas station and bones. Some have endeavored to revive it, but water must be trucked in and that's not going to work. It needs a rerouted river and that's not going to happen. Walking around this abandoned American dream made me want to return to its heyday, rent a room, and start clacking out the great American novel on a typewriter. I'd sweat out the days in a white muscle shirt and drink booze in the lounge with other ornery writers. I'd scoff at tourists and write like Bukowski. I'd be the poster child for tortured artists. But of course, in reality that's not me. I like cardigans . . . and water. Still, imagining the artist I could be at Roy's helped me define the artist I had hoped to be someday. And that was worth the trip to this place in between.

Janice

"Thanks to the Interstate Highway System, it is now possible to travel across the country from coast to coast without seeing anything."

Charles Kuralt

Dear Áine,

You never expect a travel revelation to occur at a gas station.
Gas stations are usually one of those forgettable places in between.
I was on a road trip from California to Arizona when I found
Roy's Motel & Café somewhere north of Joshua Tree, east of the
state line, and 70 years too late. The gas station was open, but it
was the only place open. This was once
a fully functioning desert town — complete
with a school, cemetery, and landing
strip. When Interstate 40 opened north
of Roy's, the town dried up like a
leaf in autumn. Now all thats
left is a gas station and bones.
Some have endeavored to revive it,
but water must be trucked in and thats
not going to work. It needs a rerouted
river and thats not going to happen. Walking
around this abandoned American dream
made me want to return to its heyday,
rent a room, and start clacking out the
great American novel on a typewriter.
I'd sweat out the days in a white
muscle shirt and drink booze in the
lounge with other ornery writers. I'd
scoff at tourists and write like Bukowski.
I'd be the poster child for tortured artists.
But of course, in reality thats not me.
I like cardigans... and water. Still, imagining
the artist I could be at Roy's helped
me define the artist I had hoped to be
someday. And that was worth the trip
to this place in between.

♡ Janice

California

Buci News

February 2015, Paris

Dear Áine,

When you've lived in Paris for some time, you develop an affinity for boutiques that stem out a 30-minute walk from your front door. Paris is, after all, a walking city and having a destination gives purpose to your walk—a "somewhere to be" hustle. One of my preferred destinations is a newspaper store in the 6th *quartier*. Browsing the stacks of magazines I pretend to read, I watch the same cast of characters come and go. A bellowing "Bonjour," a few coins offered, a newspaper tucked under the arm, and an "Au revoir" until tomorrow. Do they notice me too? If so, do they also find the daily unspoken intersecting of our lives charming? Unlikely. I imagine they simply continue their walk with another destination in mind. *C'est la vie à Paris.*

Janice

"Nostalgia is in my blood. My mother was a passionate teacher of history and a lover of all things 'was.' I, too, prefer the bygone, and I'm prone to waxing wistful over the end of something even as I'm living it—cherishing, hanging on."

Lisa Anselmo, *My (Part-Time) Paris Life*

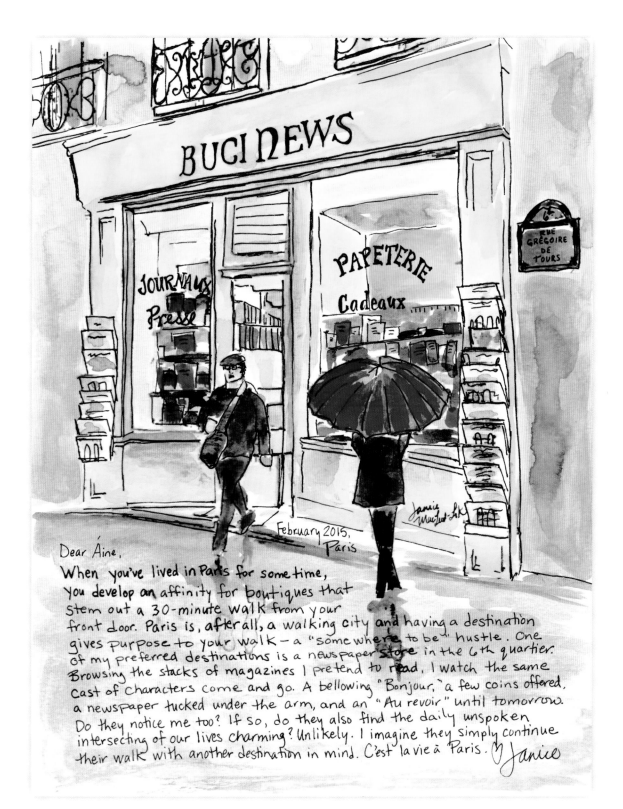

BUCI NEWS

JOURNAUX
Presse

PAPETERIE
Cadeaux

RUE
GRÉGOIRE
DE
TOURS

February 2015,
Paris

Dear Áine,

When you've lived in Paris for some time,
you develop an affinity for boutiques that
stem out a 30-minute walk from your
front door. Paris is, after all, a walking city and having a destination
gives purpose to your walk — a "somewhere to be" hustle. One
of my preferred destinations is a newspaper store in the 6th quartier.
Browsing the stacks of magazines I pretend to read, I watch the same
cast of characters come and go. A bellowing "Bonjour," a few coins offered,
a newspaper tucked under the arm, and an "Au revoir" until tomorrow.
Do they notice me too? If so, do they also find the daily unspoken
intersecting of our lives charming? Unlikely. I imagine they simply continue
their walk with another destination in mind. C'est la vie à Paris. ♡ Janice

February 2015, Japan

Dear Áine,

I'm not much of a participator. More of an observer. But when I was in Japan, not participating was not an option. At a fire festival, a costume was draped over my clothes and cinched with a festive belt as I was handed a lit torch and pulled into a parade. At a shrine in the tiny village of Morotsuka, I thought I was on a tour of the grounds until I was led into a meditation room to connect with the divine. Later at the grocery store, I was invited to a party at the local diner. Though I gave a polite noncommittal shrug, they called me later and asked why I wasn't there. No option to decline! They just pretend they don't understand. Once at the diner, I ate some of the strangest food. Why? Because it just became easier to try it than to decline it. And you know what? My memories of Japan are more vivid. I hiked those hills and went to that tea party. And I learned that the locals feel better when you show up in a real way to experience their culture. I was astounded by the kindness of these strangers. When I returned home, I received a package from my new Japanese friends—a rubber stamp with my Japanese name "Jya-ne-su," which roughly translates to Be Well. How kind is that?

Be well,

Janice

"Bizarre travel plans are dancing lessons from God."

Kurt Vonnegut

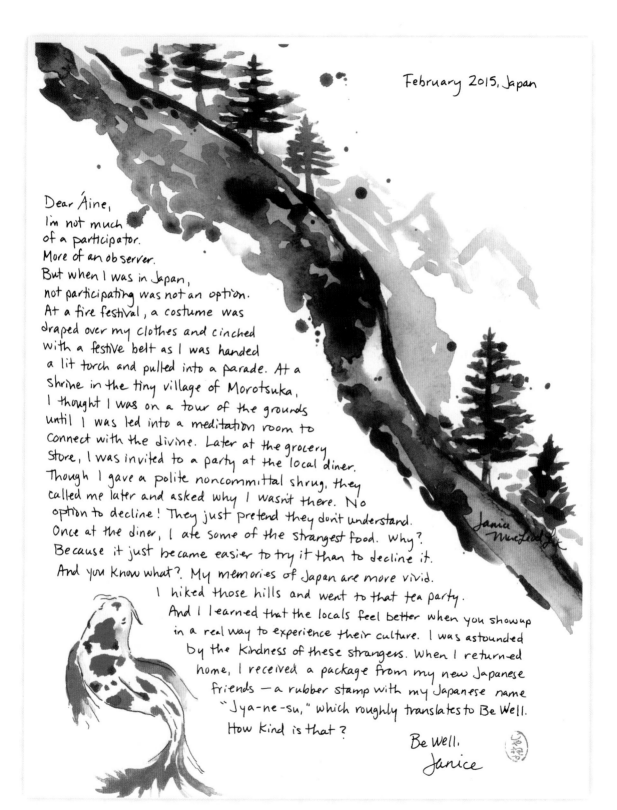

February 2015, Japan

Dear Áine,
I'm not much
of a participator.
More of an observer.
But when I was in Japan,
not participating was not an option.
At a fire festival, a costume was
draped over my clothes and cinched
with a festive belt as I was handed
a lit torch and pulled into a parade. At a
shrine in the tiny village of Morotsuka,
I thought I was on a tour of the grounds
until I was led into a meditation room to
connect with the divine. Later at the grocery
store, I was invited to a party at the local diner.
Though I gave a polite noncommittal shrug, they
called me later and asked why I wasn't there. No
option to decline! They just pretend they don't understand.
Once at the diner, I ate some of the strangest food. Why?
Because it just became easier to try it than to decline it.
And you know what? My memories of Japan are more vivid.
I hiked those hills and went to that tea party.
And I learned that the locals feel better when you show up
in a real way to experience their culture. I was astounded
by the kindness of these strangers. When I returned
home, I received a package from my new Japanese
friends — a rubber stamp with my Japanese name
"Jya-ne-su," which roughly translates to Be Well.
How kind is that?

Be Well,
Janice

March 2015, Paris

Dear Áine,

I have finally made peace with the macaron. The macaron is Paris' prettiest cookie—
two halves held together by a decadent filling. My first experience with this treat was
at Ladurée. I walked in and saw a rainbow of macarons piled to perfection. Customers
gave orders, *"Vanille, chocolat, pistache!"* and the staff neatly tucked each macaron into
pretty pastel boxes. When it was my turn to order I panicked, pointed, and ordered
what I could pronounce. *"Café, vanille, citron . . ."* Soon I was back on the street with
my jewelry box of deliciousness. I meant to have only a bite of one or two. This was
food to savor, but soon the box was empty. They are pricey so I researched how to make
them. There is mixing, timing, and even weather conditions involved. Humidity will
crack the shell, which is unacceptable. Beauty is also a necessary ingredient. This dessert
is half art, half food. Then there is the filling. The buttercream, ganache, or fruit filling
must be stiff enough to keep the cookie together but soft enough to melt in the mouth.
Oh bother! Realizing the mastery involved, I decided to leave it to the professionals and
only buy one at a time—or three.

Janice

*It's so beautifully arranged on the plate—you
know someone's fingers have been all over it."*

Julia Child

Dear Áine, March 2015, Paris

I have finally made peace with the macaron. The macaron is
Paris' prettiest cookie — two halves held together by a decadent
filling. My first experience with this treat was at Ladurée.
I walked in and saw a rainbow of macarons piled to perfection.
Customers gave orders, "Vanille, chocolat, pistache!" and the staff
neatly tucked each macaron into pretty pastel boxes. When it
was my turn to order I panicked, pointed, and ordered what I
could pronounce. "Café, vanille, citron…" Soon I was back on
the street with my jewelry box of deliciousness. I meant
to have only a bite of one or two. This was food to savor,
but soon the box was empty. They are pricey so I researched
how to make them. There is mixing, timing, and even weather
conditions involved. Humidity will crack the shell, which is
unacceptable. Beauty is also a necessary ingredient. This
dessert is half art, half food. Then there is the filling. The
buttercream, ganache, or fruit filling must be stiff enough
to keep the cookie together but soft enough to melt in the
mouth. Oh bother! Realizing the mastery involved, I decided
to leave it to the professionals and only buy one at a time —
 or three.
 —Janice

March 2015, Venice, Italy

Dear Áine,

When I first arrived in Venice I had one startling thought. "Where is everybody?" Sure the tourists were there—strolling around San Marco Square and hopping in and out of gondolas. But where were the Venetians? There was subtle evidence—laundry draped on lines swaying across alleys and bulbous geraniums leaning out from windows. I even heard children playing beyond a tall wall, but I wasn't convinced they weren't ghosts playing an eternal soccer game in an abandoned courtyard. It's almost impossible to orient yourself with all the bridges and narrow passages in this spooky town that seems to inhale and exhale with the tides. I soon gave up and put my map away, reasoning I could orient myself at the end of the day when it was time to catch the final water taxi to my hotel. Plus, a map in hand gives a girl away and I wanted to have the confident stride of a local—not that there were any.

Did the Venetians barricade their mansions and head to Rome? I wouldn't be surprised. I couldn't live here either. The city is beautiful but has a melancholy claw and suffocating thick air. How did Vivaldi ever compose happy music here? This town is more suited for Bram Stoker penning the life of Dracula than Vivaldi chirping out *The Four Seasons*. If there is a cheery Venice I couldn't find it. My Venice was quiet. Subdued. A ghost town taking a final bow.

Janice

———— ≈ ————

"Venice seems like a wonderful city in which to die a
slow and alcoholic death, or to lose a loved one, or
to lose the murder weapon with which the loved one
was lost in the first place."

Elizabeth Gilbert, *Eat, Pray, Love*

Dear Áine,

When I first arrived in Venice I had one startling thought: Where is everybody? Sure the tourists were there — strolling around San Marco Square and hopping in and out of gondolas. But where were the Venetians? There was subtle evidence — laundry draped on lines swaying across alleys and bulbous geraniums leaning out from windows. I even heard children playing beyond a tall wall, but I wasn't convinced they weren't ghosts playing an eternal soccer game in an abandoned courtyard. It's almost impossible to orient yourself with all the bridges and narrow passages in this spooky town that seems to inhale and exhale with the tides. I soon gave up and put my map away, reasoning I could orient myself at the end of the day when it was time to catch the final water taxi to my hotel. Plus, a map in hand gives a girl away and I wanted to have the confident stride of a local — not that there were any.

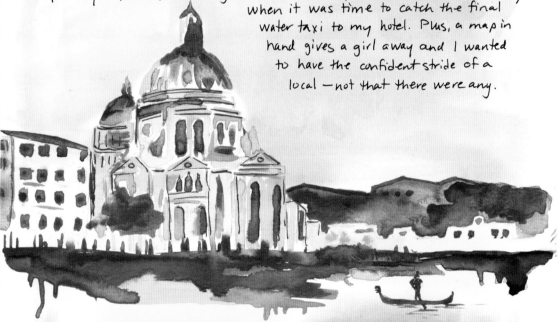

Did the Venetians barricade their mansions and head to Rome? I wouldn't be surprised. I couldn't live here either. The city is beautiful but has a melancholy claw and suffocating thick air. How did Vivaldi ever compose happy music here? This town is more suited for Bram Stoker penning the life of Dracula than Vivaldi chirping out The Four Seasons. If their is a cheery Venice I couldn't find it. My Venice was quiet. Subdued. A ghost town taking a final bow.

— Janice

April 2015, Paris

Dear Áine,

In April, we exchange our warm scarves for the thinner foulard scarf. We pack away our boots and dust off our ballerina flats. And best of all, the cafés retract their outer walls to let in the sunshine. At this time of the year, I choose a café based on its angle to the sun. I wedge in at a small round table where I am sure to have a nice view of foot traffic. I hang my coat over the back of the chair and settle in for the main event—the waiter. Watching a waiter bust his particular move is like watching a ballerina. He swoops down to wipe a table, swings around with a tray of drinks, gracefully uncorks bottles, explains the specials, gives expert sommelier advice, and still manages to make time for his break to lean against a nearby wall to soak up his own few rays of sunshine.

He is a true artist in motion.

Janice

"I had been working so hard these past few years to figure out what France was all about—how it operates, what makes it tick. In fact, most of what was important to the French was around this table: close family, old friends, and fabulous food."

Elizabeth Bard, *Lunch in Paris*

April 2015, Paris

Dear Áine,

In April, we exchange our warm scarves for the thinner 'foulard' scarf. We pack away our boots and dust off our ballerina flats. And best of all, the cafés retract their outer walls to let in the sunshine. At this time of the year, I choose a café based on its angle to the sun. I wedge in at a small round table where I am sure to have a nice view of foot traffic. I hang my coat over the back of the chair and settle in for the main event— the waiter. Watching a waiter bust his particular move is like watching a ballerina. He swoops down to wipe a table, swings around with a tray of drinks, gracefully uncorks bottles, explains the specials, gives expert sommelier advice, and still manages to make time for his break to lean against a nearby wall to soak up his own few rays of sunshine.

He is a true artist in motion.

—Janice

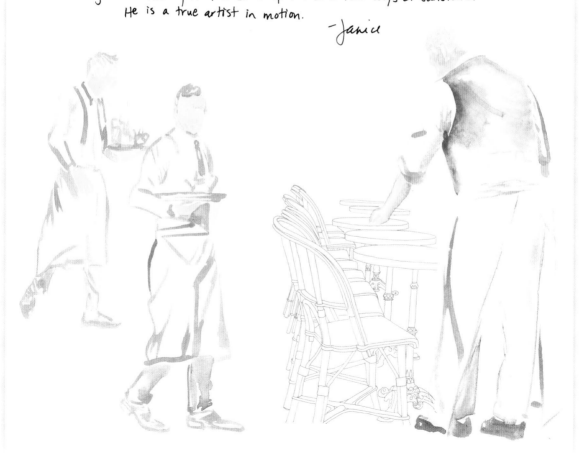

Prague, Czech Republic

April 2015, Prague, Czech Republic

Dear Áine,

War memorials are all over Europe for obvious reasons. For me, the whole city of Prague is one big war memorial. Why? It wasn't bombed in the World Wars. Why? It was first occupied by Germany then by the Soviet Union until 1989, so no bombs. Warsaw, by comparison, is completely new because it was obliterated by bombs. Paris is pieced together with pockmarked buildings. London and Budapest held together by bandaged bridges. But Prague remains as it was. So you have these feminine jewel box buildings interspersed with masculine statues of Communist propaganda—men all looking the same, working together for the common good. Gothic castles and cathedrals shine as they did in their heyday, though now they include guided tours and gift shops. Seeing this sweet unblemished city makes you mad all over again about war, and you wonder what you'll never see because it was destroyed. I mulled this over as I educated myself at a beer tasting. The Czech Republic is big on beer brewing, which is why I was shoulder to shoulder with a group of dudes from California partaking in the same school of microbrew. I was a terrible student. I can't hold my own in a pub and soon walked out of the Prague Beer Museum and over to Café Kafka. I attempted to write dark prose like him but was too taken with the view so I pulled out my art supplies instead. A much more delightful "occupation" in this pretty pastel city.

Janice

"Anyone who keeps the ability to see beauty never grows old."

Franz Kafka

Dear Áine,

War memorials are all over Europe for obvious reasons. For me, the whole city of Prague is one big war memorial. Why? It wasn't bombed in the World Wars. Why? It was first occupied by Germany then by the Soviet Union until 1989, so no bombs. Warsaw, by comparison, is completely new because it was obliterated by bombs. Paris is pieced together with pockmarked buildings. London and Budapest held together by bandaged bridges. But Prague remains as it was. So you have these feminine jewel box buildings interspersed with masculine statues of Communist propaganda— Men all looking the same, working together for the common good. Gothic castles and cathedrals shine as they did in their heyday, though now they include guided tours and gift shops. Seeing this sweet unblemished city makes you mad all over again about war, and you wonder what you'll never see because it was destroyed. I mulled this over as I educated myself at a beer tasting. The Czech Republic is big on beer brewing, which is why I was shoulder to shoulder with a group of dudes from California partaking in the same school of microbrew. I was a terrible student. I can't hold my own in a pub and soon walked out of the Prague Beer Museum and over to Café Kafka. I attempted to write dark prose like him but was too taken with the view so I pulled out my art supplies instead. A much more delightful "occupation" in this pretty pastel city.
— Janice

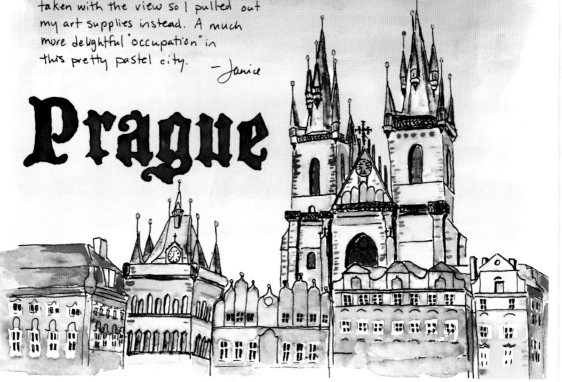

Prague

127

May 2015, Paris

Dear Áine,

Urban hikes take on an almost religious fervor in May. The warm weather allows one to travel light and it's not so hot that you'll arrive at your destination looking like a wilted flower. Plus, there are many holidays in May so the locals are out in full force, visiting museums before the tourist season officially begins in June. I stepped out of my apartment on rue Mouffetard in the 5th to walk to Petit Palais in the 8th to see the exhibit of Exposition Universelle of 1900. It was a glorious walk lined with linden trees along the Seine, blooming tulips waving Bonjour, and statues that seemed to stand a little taller now that the sun was shining. The exhibit presented an overview of Art Nouveau, a design movement that took over the modern world around 1900. Art Nouveau mimics nature. It incorporates the soft tendrils of vines and smooth curves of blooms into an array of designs: kitchen utensils, hair combs, posters, furniture, architecture, and fashion. This movement also has an innocence and gaiety about it, which was soon to be broken by the cost-effective straight lines of war. After I left the exhibit, I saw nature differently on my walk home. Instead of manmade items mimicking nature, I saw the opposite. Birds looked more like brooches. Flowers were more like hair combs. A climbing rose bush became an iron balustrade. And vines that began to climb up the walls of my courtyard became the frame for this letter.

À bientôt!

Janice

"One's destination is never a place but rather a new way of looking at things."

Henry Miller, *Big Sur and the Oranges of Hieronymus Bosch*

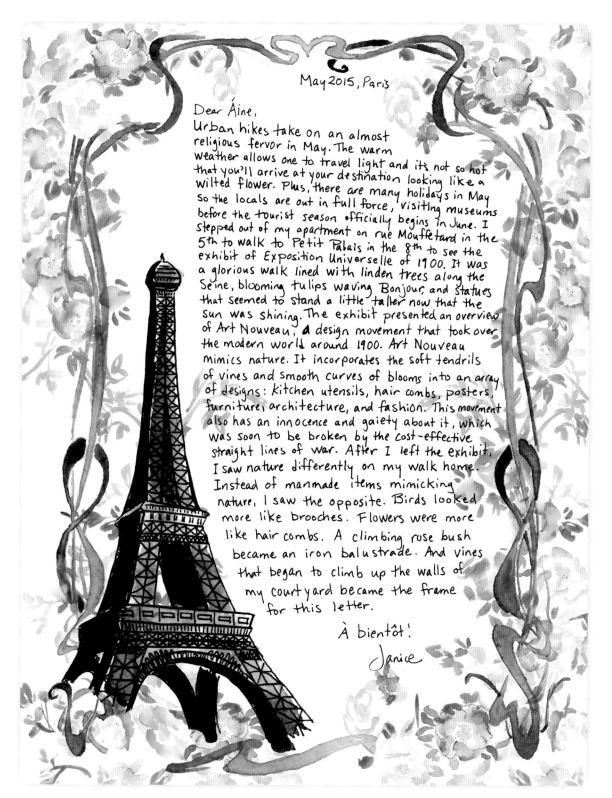

May 2015, Paris

Dear Áine,

Urban hikes take on an almost
religious fervor in May. The warm
weather allows one to travel light and it's not so hot
that you'll arrive at your destination looking like a
wilted flower. Plus, there are many holidays in May
so the locals are out in full force, visiting museums
before the tourist season officially begins in June. I
stepped out of my apartment on rue Mouffetard in the
5th to walk to Petit Palais in the 8th to see the
exhibit of Exposition Universelle of 1900. It was
a glorious walk lined with linden trees along the
Seine, blooming tulips waving Bonjour, and statues
that seemed to stand a little taller now that the
sun was shining. The exhibit presented an overview
of Art Nouveau, a design movement that took over
the modern world around 1900. Art Nouveau
mimics nature. It incorporates the soft tendrils
of vines and smooth curves of blooms into an array
of designs: kitchen utensils, hair combs, posters,
furniture, architecture, and fashion. This movement
also has an innocence and gaiety about it, which
was soon to be broken by the cost-effective
straight lines of war. After I left the exhibit,
I saw nature differently on my walk home.
Instead of manmade items mimicking
nature, I saw the opposite. Birds looked
more like brooches. Flowers were more
like hair combs. A climbing rose bush
became an iron balustrade. And vines
that began to climb up the walls of
my courtyard became the frame
for this letter.

À bientôt!

Janice

129

Paris Bookshop

June 2015, Paris

Dear Áine,

Summer in Paris has begun in earnest. On the first hot day, ladies pulled out last year's frocks—wrinkled but comfortably cool—men tucked their jackets under their arms, and we all opted to walk rather than take the sweltering Métro. Paris truly is a walker's paradise. There are treats to be found on every cobblestone street and every boulevard. Bridges beckon to be crossed, flower shops burst with blooms to behold, and bookstores lure you in with the summer's hottest titles. Of course I can't read any of them—the written word behind the cover is much more advanced than I—but the French have style, and just admiring the beautiful covers fulfills me in much the same way as a visit to the Louvre. As the long day passes into night and my feet can take no more, I return home to gaze out the window and marvel at this softly lit enchanted city.

Janice

"The day in which you decline an invitation to see a film or a concert in order to walk along roads that you already know, the day in which you say no to a journey to some island paradise so as to contemplate the greyness of your own city in the rain . . . well, that's the day you will know you are a true flâneur."

Federico Castigliano, *Flâneur: The Art of Wandering the Streets of Paris*

June 2015, Paris

Dear Áine,

Summer in Paris has begun in earnest. On the first hot day, ladies pulled out last year's frocks — wrinkled but comfortably cool — men tucked their jackets under their arms, and we all opted to walk rather than take the sweltering Métro. Paris truly is a walker's paradise. There are treats to be found on every cobblestone street and every boulevard. Bridges beckon to be crossed, flower shops burst with blooms to behold, and bookstores lure you in with the summer's hottest titles. Of course I can't read any of them — the written word behind the cover is much more advanced than I — but the French have style, and just admiring the beautiful covers fulfills me in much the same way as a visit to the Louvre. As the long day passes into night and my feet can take no more, I return home to gaze out the window and marvel at this softly lit enchanted city.

— Janice

July 2015, Paris

Dear Áine,

There are certain features of the cityscape that make Paris <u>Paris</u>. Of course there are the obvious monuments and the monochromatic cream-colored Haussmann buildings with their light blue rooftops. But then there are the less obvious—the bookstalls along the Seine, the park benches, and the Wallace fountains—all painted the same shade of "carriage green." The fountains were brought to Paris by philanthropist Richard Wallace. He thought it a great travesty that the great walking city of Paris didn't offer free drinking water to quench the thirst of those walkers. In fact, it was safer to drink beer or wine. He insisted that these fountains be stunning, so his sculptor Charles-Auguste Lebourg created a fountain featuring four lovely sisters—kindness, simplicity, charity, and sobriety. The water flows behind their arms so you just have to reach in with your water bottle for a free refill. This water is still the main source of drinking water for the homeless. How kind, simple, charitable, and, well, sober-maintaining. My preferred fountain is outside my favorite bookstore. Browsing books makes me thirsty. As I sip, I can't help but marvel at the kindness and beauty of these fountains. They truly add to the magic that makes Paris <u>Paris</u>.

Janice

She drinks pints of coffee and writes little observations and ideas for stories with her best fountain pen on the linen-white pages of expensive notebooks. Sometimes, when it's going badly, she wonders if what she believes to be a love of the written word is really just a fetish for stationery.

David Nicholls, *One Day*

Dear Áine, July 2015, Paris

There are certain features of the cityscape that make Paris Paris.
Of course there are the obvious monuments and the monochromatic
cream-colored Haussmann buildings with their light blue rooftops. But
then there are the less obvious — the bookstalls along the Seine, the park
benches, and the Wallace fountains — all painted the same shade of
"carriage green." The fountains were brought to Paris by philanthropist
Richard Wallace. He thought it a great travesty that the great walking
city of Paris didn't offer free drinking water to quench the thirst of
those walkers. In fact, it was safer to drink beer or wine. He insisted
that these fountains be stunning, so his sculptor Charles-Auguste Lebourg
created a fountain featuring four lovely sisters — kindness, simplicity,
charity, and sobriety. The water flows behind their arms so you just
have to reach in with your water bottle for a free refill. This water
is still the main source of drinking water for the homeless. How kind,
simple, charitable, and, well, sober-maintaining. My preferred fountain
is outside my favorite bookstore. Browsing books makes me thirsty.
As I sip, I can't help but marvel at the kindness and beauty of these
 fountains. They truly add
 to the magic that makes
 Paris Paris.

 — Janice

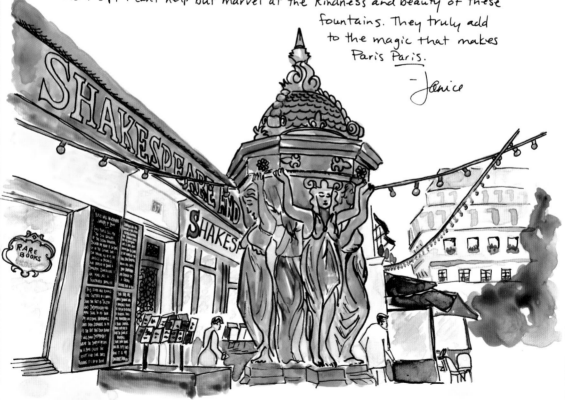

Eiffel Tower

August 2015, Paris

Dear Áine,

The Eiffel Tower is the only show in town in August. Most of Paris closes its doors, including Berthillon, the local ice cream parlor. The big touristy spots stay open, but even they are subdued. The pickpockets are on vacation, too—likely following the locals to Provence and other southern climes. Those who remain in the city have a respite from the "pushing through" required of Paris life the rest of the year. In August, the lines are short, you always get a seat on the train, and you have more free time as half your friends are sunning themselves on distant shores. For these reasons, it has become one of my preferred months in Paris, though it is difficult to find a baguette as most boulangeries are closed. It's a time for reflective strolls along the Seine, for lingering at cafés, and to revel in rare quiet moments in the cool shade of the Eiffel Tower.

Janice

"I wanted to play piano in restaurants in the south of France. I went there on holiday once and I saw this guy playing in an old tuxedo. He was all disheveled, with a whisky glass on the piano. I thought that was the coolest thing. So what's happened to me with 'Twilight' isn't really what I'd planned."

Robert Pattinson

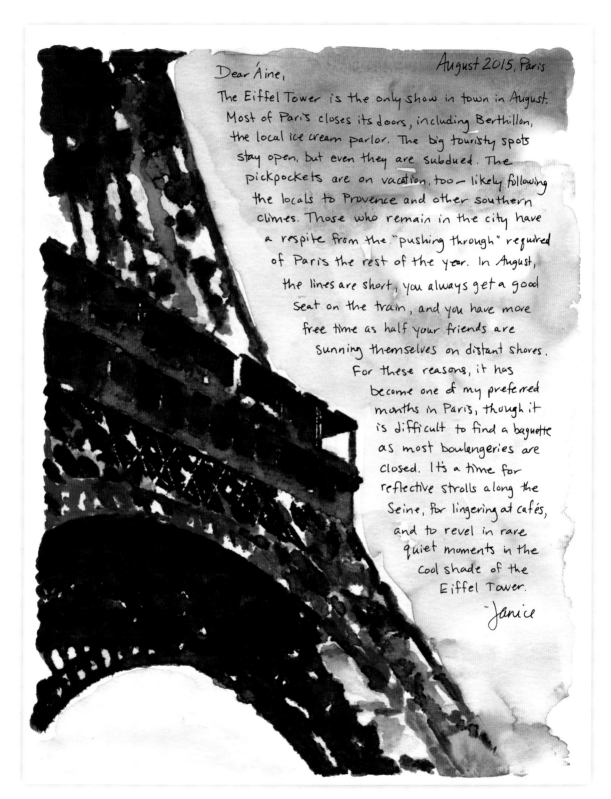

August 2015, Paris

Dear Áine,

The Eiffel Tower is the only show in town in August. Most of Paris closes its doors, including Berthillon, the local ice cream parlor. The big touristy spots stay open, but even they are subdued. The pickpockets are on vacation, too — likely following the locals to Provence and other southern climes. Those who remain in the city have a respite from the "pushing through" required of Paris the rest of the year. In August, the lines are short, you always get a good seat on the train, and you have more free time as half your friends are sunning themselves on distant shores. For these reasons, it has become one of my preferred months in Paris, though it is difficult to find a baguette as most boulangeries are closed. It's a time for reflective strolls along the Seine, for lingering at cafés, and to revel in rare quiet moments in the cool shade of the Eiffel Tower.

— Janice

September 2015, Paris

Dear Áine,

By now, most everyone has returned from their month-long vacations in August. There is something timeless about seeing a city full of shopkeepers collectively dusting off, sweeping up, and reopening boutiques.

We swept out the squatter who decided to camp in the storage room for his holiday. People who rarely spoke before August begin conversing like old friends—all asking about the vacation—with who, where to, and what did you eat. I find I advance my French language skills more in September than any other month of the year with these small conversations. The pharmacist remarked that the sea was too cold. The butcher admitted that a month away was too long, that it's nice to be back, and work keeps him in great shape. He flexed his arms for emphasis. When I asked the fishmonger how he spent his vacation, he winked and said he went fishing. He went on to say he was happy to be gone and glad to be back in equal measure. There's a life lesson. Something to strive for on the next vacation.

Janice

"To say it was a beautiful day would not begin to explain it. It was that day when the end of summer intersects perfectly with the start of fall."

Ann Patchett, *Truth & Beauty*

September 2015, Paris

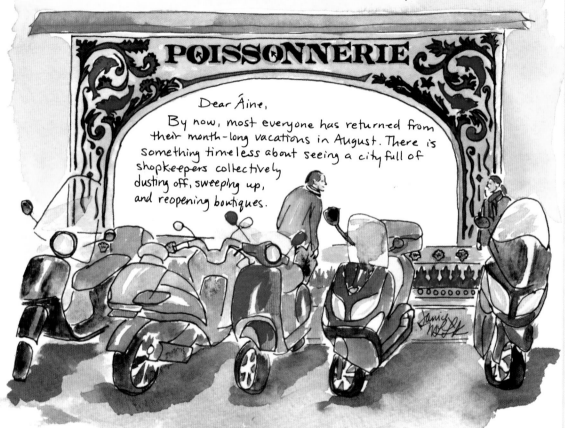

POISSONNERIE

Dear Áine,

By now, most everyone has returned from their month-long vacations in August. There is something timeless about seeing a city full of shopkeepers collectively dusting off, sweeping up, and reopening boutiques.

We swept out the squatter who decided to camp in the storage room for his holiday. People who rarely spoke before August begin conversing like old friends — all asking about the vacation — with who, where to, and what did you eat. I find I advance my French language skills more in September than any other month of the year with these small conversations. The pharmacist remarked that the sea was too cold. The butcher admitted that a month away was too long, that it's nice to be back, and work keeps him in great shape. He flexed his arms for emphasis. When I asked the fishmonger how he spent his vacation, he winked and said he went fishing. He went on to say he was happy to be gone and glad to be back in equal measure. There's a life lesson. Something to strive for on the next vacation.

— Janice

September 2015, South of France

Dear Áine,

I was touring through the South of France as one does once one realizes there is a
magnificent country beyond Paris city limits. After taking selfies in poppy fields and
running my hands through rows of lavender, I came upon the breathtaking village
of Carcassonne and its stunning fortified town, which really just looks like a massive
castle—the kind of castle you imagine but bigger. I took a tour—as one does—and
couldn't really keep all the facts straight—who ruled when and such. I was mostly lost
in my own head, imagining life here as a princess or knight. It's very easy to imagine as
the place is littered with tourist shops crammed full of costumes, and because of this, the
children were wielding plastic swords or wearing bejeweled tiaras. It was in Carcassonne
where I began to fancy myself a real photographer. I realized later that it's easier to be a
good photographer when you're shooting lovely things. The town is majestic—vibrant
markets, bistros and cafés, and that southern sun that seems to light the town just right.
Oh, and it's atop a hill and surrounded by vineyards—the bow on a beautiful cake.
How could one not be a great photographer in Carcassonne?

Janice

" And, as for the oil, it is a masterpiece.
You'll see.' Before dinner that night, we
tested it, dripping it onto slices of bread
that had been rubbed with the flesh of
tomatoes. It was like eating sunshine."

Peter Mayle, *A Year In Provence*

September 2015, South of France

Dear Áine,

I was touring through the South of France as one
does once one realizes there is a magnificent
Country beyond Paris city limits. After taking selfies
in poppy fields and running my hands through
rows of lavender, I came upon the breathtaking
village of Carcassonne and its stunning
fortified town, which really just looks like
a massive castle — the kind of castle you
might imagine but bigger. I took a tour — as
one does — and couldn't really keep all the facts
straight — who ruled when and such. I was mostly
lost in my own head, imagining life here as a princess
or knight. It's very easy to imagine as the place is
littered with tourist shops crammed full of costumes,
and because of this, the children were wielding plastic
swords or wearing bejeweled tiaras. It was in Carcassonne
where I began to fancy myself a real photographer. I realized later that
it's easier to be a good photographer when you're shooting lovely things.
The town is majestic — vibrant markets, bistros and cafés, and that
Southern sun that seems to light the town just right. Oh, and it's atop
a hill and surrounded by vineyards — the bow on a beautiful cake.
How could one not be a great photographer in Carcassonne?

– Janice

Carcassonne, France

Boots

October 2015, Paris

Dear Áine,

The preferred season for every Parisian is autumn. Sure, spring has blooming trees
and summer has a certain sizzle (winter doesn't even make the short list), but autumn
upstages them all. First off, the tourists have been thinned out so museums cease to be an
exercise in patience and tolerance. Then as the weather cools, there is a reintroduction
of red wine to the table—not that it left exactly, but in warmer seasons there is often
the dilemma between red, white, and rosé. With the leaf changing, the city is back to
the assumption that it will be red for the evening, and everyone can get back to making
other important decisions, like what cheese should accompany said red.

But the best part of autumn is the fashion. Women go positively batty for the latest
boots, and if you have a particularly stunning trench, you will be asked where you
bought it by fashion-obsessed strangers on the street. Ah there is nothing like the
approval of a Parisian lady. You feel positively chic!

Janice

*"We all need something to help us unwind at the end
of the day. You might have a glass of wine, or a joint,
or a big delicious blob of heroin to silence your silly
brainbox of its witterings but there has to be some form
of punctuation, or life just seems utterly relentless."*

Russell Brand, *My Booky Wook*

Dear Áine, October 2015, Paris

The preferred season for every Parisian is autumn. Sure, spring has blooming trees and summer has a certain sizzle (winter doesn't even make the short list) but autumn upstages them all. First off, the tourists have been thinned out so museums cease to be an exercise in patience and tolerance. Then as the weather cools, there is a reintroduction of red wine to the table — not that it left exactly, but in warmer seasons there is often the dilemma between red, white, and rosé. With the leaf changing, the city is back to the assumption that it will be red for the evening, and everyone can get back to making other important decisions, like what cheese should accompany said red.

But the best part of autumn is the fashion. Women go positively batty for the latest boots, and if you have a particularly stunning trench, you will be asked where you bought it by fashion-obsessed strangers on the street. Ah there is nothing like the approval of a Parisian lady. You feel positively chic!

Janice

141

Rome, Italy

November 2015, Rome

Dear Áine,

The best souvenir of all my travels was found in Rome. It's a stovetop espresso maker. Simple in design—just three parts and no electrical cord—has served me well wherever I roam. It sits on my stove all day long—in the morning as an appliance, the rest of the day as a trophy. You see, my trip to Rome was a pilgrimage. I didn't realize it at the time, but now I recognize in myself the Me Before Rome and the Me After Rome. Each morning, I would wander the ancient streets in search of a table in front of a "caffè" to sip and stare and write and wonder. Then I would church hop. The churches of Rome are like art galleries. I would gaze for hours at paintings and sculptures, light a candle or two, and when my stomach started to rumble, I would go find a pizza joint. After two months of this, I think I picked up more than an appreciation for art and tomato sauce. I became a serene person. And now I can conjure that feeling whenever I see my espresso maker. That's one heck of a souvenir.

Arrivederci!

Janice

"There are deeper reasons to travel—itches and tickles on the underbelly of the unconscious mind. We go where we need to go, and then try to figure out what we're doing there."

Jeff Greenwald, *Shopping for Buddhas*

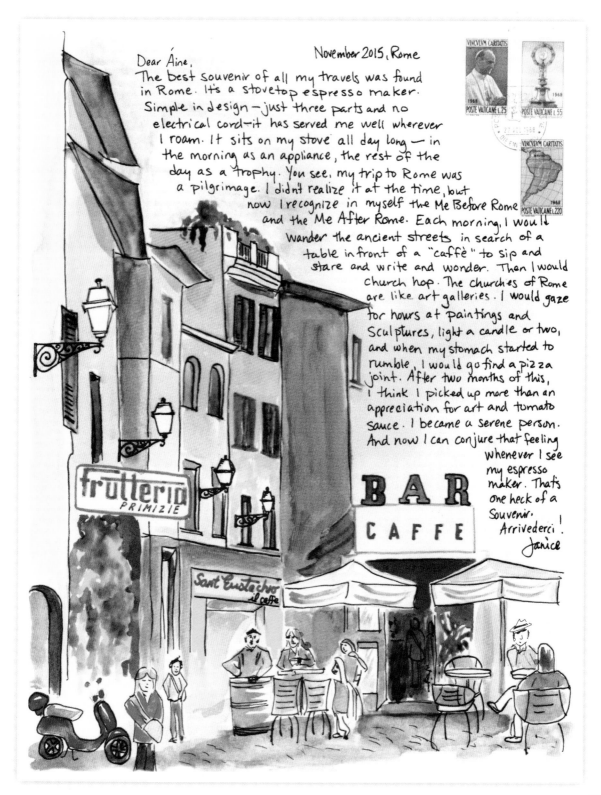

November 2015, Rome

Dear Áine,

The best souvenir of all my travels was found in Rome. It's a stovetop espresso maker. Simple in design—just three parts and no electrical cord—it has served me well wherever I roam. It sits on my stove all day long — in the morning as an appliance, the rest of the day as a trophy. You see, my trip to Rome was a pilgrimage. I didn't realize it at the time, but now I recognize in myself the Me Before Rome and the Me After Rome. Each morning, I would wander the ancient streets in search of a table in front of a "caffè" to sip and stare and write and wonder. Then I would church hop. The churches of Rome are like art galleries. I would gaze for hours at paintings and sculptures, light a candle or two, and when my stomach started to rumble, I would go find a pizza joint. After two months of this, I think I picked up more than an appreciation for art and tomato sauce. I became a serene person. And now I can conjure that feeling whenever I see my espresso maker. That's one heck of a souvenir.

Arrivederci!
Janice

frutteria
PRIMIZIE

BAR
CAFFE

Sant'Eustachio
il caffe

143

Lamps

November 2015, Paris

Dear Áine,

The days are noticeably shorter. The lamps flicker on in late afternoon and the city takes on a gloomy glow. Of course, this glow at other times of the year is revered, but in November it means one thing: we are descending into the dark season. With the trees now bare of their leaves, architectural details on buildings reveal themselves, which is nice, but a small benefit to an otherwise bleak time. After the first cold snap, the streets are bare. Everyone huddles inside for a few days, but after accepting the new normal of gloves and thick scarves, we venture out again, reclaiming our local bistros as an extension of home. The menus have changed. Cassoulet, raclette, and fondue are the specials of the day and our spirits are lifted. Pair it with a deep red from St. Émilion and you've got yourself a feast. If you're going to hibernate for the season, Paris is where you want to be. Bon appétit!

Janice

"What a strange idea: 'comfort food.' Isn't every food comforting in its own way! Why are certain foods disqualified? Can't fancy food be soothing in the same way as granny food? Must it always be about loaded memories, like Proust's madeleine? Or can it be merely quirky, like M. F. K. Fisher's tangerine ritual: she dried them on a radiator, then cooled them on her Paris windowsill."

David Tanis, *A Platter of Figs and Other Recipes*

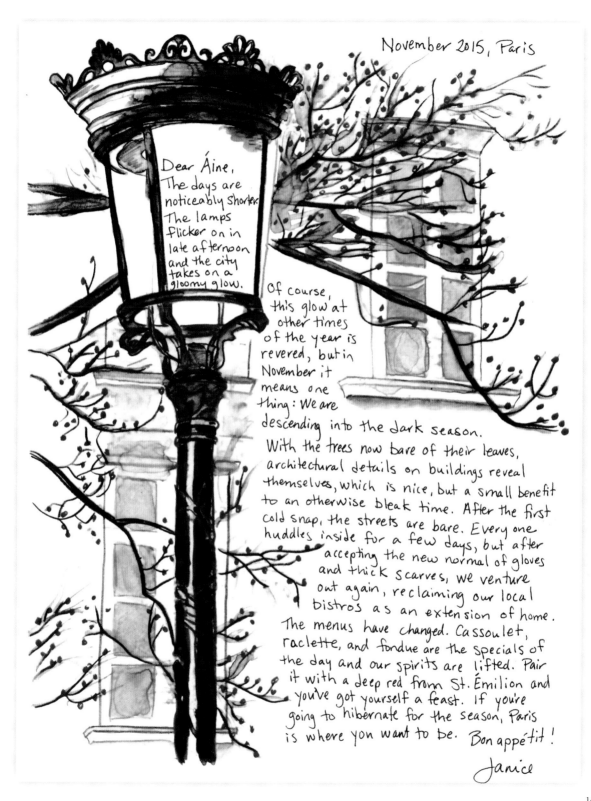

November 2015, Paris

Dear Áine,
The days are noticeably shorter. The lamps flicker on in late afternoon and the city takes on a gloomy glow.

Of course, this glow at other times of the year is revered, but in November it means one thing: We are descending into the dark season. With the trees now bare of their leaves, architectural details on buildings reveal themselves, which is nice, but a small benefit to an otherwise bleak time. After the first cold snap, the streets are bare. Everyone huddles inside for a few days, but after accepting the new normal of gloves and thick scarves, we venture out again, reclaiming our local bistros as an extension of home. The menus have changed. Cassoulet, raclette, and fondue are the specials of the day and our spirits are lifted. Pair it with a deep red from St. Émilion and you've got yourself a feast. If you're going to hibernate for the season, Paris is where you want to be. Bon appétit!

Janice

145

December 2015, Paris

Dear Áine,

Paris may have the most enchanting collection of ornaments in the world. The locals adore *le typique* Nutcracker soldier and ballerina—definitely Noël-esque, but then they have other ornaments that have a vague tie-in to the holidays. For instance, they go mad for carp and love to dangle this fish from the branches of *les sapins*. Is it a whole "Jesus fed the village with fish" thing? Is it an obscure reference to Christmas dinner (though usually lamb or goose is the main event at the French table)? Or do they simply like how the fish scales shimmer in the light? Who knows.

The Christmas markets are chocked full with a million decisions on what to buy for who—a feast for the eyes and the belly. The theme is about celebration and beauty. A welcome reminder in a year that hasn't been kind to Paris. Parisians are resilient folk. And this December I will be happy to walk among them, united in our desire for peace and joy . . . and odd ornaments.

Joyeaux Noël,

Janice

───── ≈ ─────

"And even this heart of mine has something artificial.
The dancers have sewn it into a bag of pink satin, pink
satin slightly faded, like their dancing shoes."

Edgar Degas

December 2015,
Paris

Dear Áine,

Paris may have the most enchanting collection of ornaments in the world. The locals adore *le typique* Nutcracker soldier and ballerina — definitely Noël-esque, but then they have other ornaments that have a vague tie-in to the holidays.

For instance, they go mad for carp and love to dangle this fish from the branches of *les sapins*. Is it a whole "Jesus fed the village with fish" thing? Is it an obscure reference to Christmas dinner (though usually lamb or goose is the main event of the French table)? Or do they simply like how the fish scales shimmer in the light? Who knows.

The Christmas markets are chocked full with a million decisions on what to buy for who — a feast for the eyes and the belly. The theme is about celebration and beauty. A welcome reminder in a year that hasn't been kind to Paris. Parisians are resilient folk. And this December I will be happy to walk among them, united in our desire for peace and joy... and odd ornaments.

Joyeux Noël,
Janice

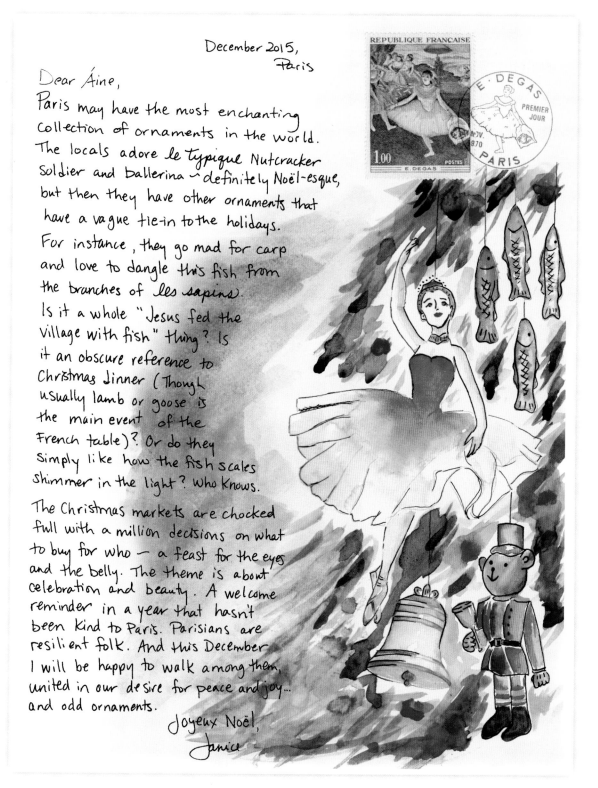

Swimmer

January 2016, Paris

Dear Áine,

Bonne année et bonne santé as the saying goes at this time of the year in Paris. January feels like a big exhale from the holiday hustle and the events of November. People are still on edge of course. No loud noises allowed in the streets lest you be scolded by your jumpy pedestrians. All understandable. I have been jumpy, too—but we all try to live as normal—to jump back in. And with New Year energy, jumping back in is somewhat easier. Speaking of, there is renewed spirit at the pools in January. Folks are eager to shed the chèvre and Brie they packed on during the holidays. There are 38 pools in Paris. Mine is Piscine Pontoise Quartier Latin. It is an art deco marvel with two mezzanine levels of private change rooms overlooking the pool. The water is so warm I can't help but wonder if there is enough chlorine to kill off bacteria. No one else seems to mind. So I guess I won't either.

Everyone snaps on their swim caps and quietly propels themselves back and forth and back again. Speed doesn't seem to be part of the value system of these swimmers. Slow and steady are what these people believe in. I think this is what keeps them young. Paris is a mecca of older, healthy, mobile people. Slow and steady seems to work, plus the emollients and creams they apply afterward in the shower. Goo galore slathered on to keep everything lubed and in good working order for the long haul of a life well- and long-lived.

Bonne santé!

Janice

"'Can you swim?' said Victor . . .
'Not very well,' said Ginger.
'Me neither,' he said. The commotion behind
them was getting worse. 'Still,' he said,
taking her hand. 'We could look on this as a
great opportunity to improve really quickly.'"

Terry Pratchett, *Moving Pictures*

Dear Áine, January 2016, Paris

Bonne année et bonne santé as the saying goes at this time of the year in Paris. January feels like a big exhale from the holiday hustle and the events of November. People are still on edge of course. No loud noises allowed in the streets lest you be scolded by your jumpy pedestrians. All understandable. I have been jumpy, too — but we all try to live as normal — to jump back in. And with New Year energy, jumping back in is somewhat easier. Speaking of, there is renewed spirit at the pools in January. Folks are eager to shed the chèvre and Brie they packed on during the holidays. There are 38 pools in Paris. Mine is "Piscine Pontoise Quartier Latin." It's an art deco marvel with two mezzanine levels of private change rooms overlooking the pool. The water is so warm I can't help but wonder if there is enough chlorine to kill off bacteria. No one else seems to mind. So I guess I won't either.

Everyone snaps on their swim caps and quietly propels themselves back and forth and back again. Speed doesn't seem to be part of the value system of these swimmers. Slow and steady are what these people believe in. I think this is what keeps them young. Paris is a mecca of older, healthy, mobile people. Slow and steady seems to work — plus the emollients and creams they apply afterward in the shower. Goo galore slathered on to keep everything in good working order for the long haul of a life well - and long - lived.

Bonne santé !

Janice

149

Le Polidor

February 2016, Paris

Dear Áine,

The Polidor is a museum of the Paris bistro. Old wood. Old menu. Frightfully old restroom (the kind where squatting is involved). This is where Hemingway ate *boeuf bourguignon* and in your mind you figure you're the same as Hemingway when you eat the same thing in the same place. It's ridiculous of course, but this is a fantasy in the quiet of your own mind, so it's acceptable. My mind, it turns out, stayed quiet. No brilliant thoughts came my way, but it sure was nice to sit there and know he saw a similar scene while thoughts swirled in his mind that made their way into books. The diners are presided over by a painting of a nameless Art Nouveau lady, who hangs over the bar. I wonder what she's thinking. Don't you?

Janice

"What really knocks me out is a book that, when you're all done reading it, you wish the author that wrote it was a terrific friend of yours and you could call him up on the phone whenever you felt like it. That doesn't happen much, though."

J.D. Salinger, *The Catcher in the Rye*

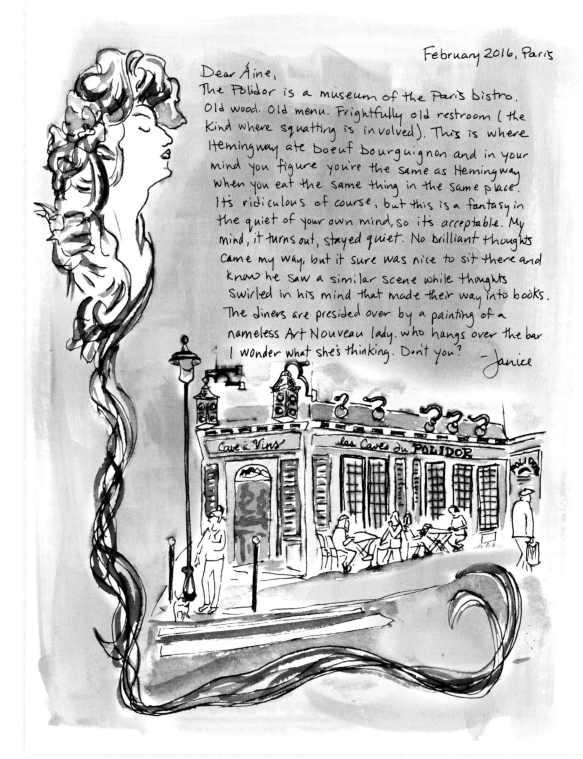

February 2016, Paris

Dear Áine,

The Polidor is a museum of the Paris bistro. Old wood. Old menu. Frightfully old restroom (the kind where squatting is involved). This is where Hemingway ate Boeuf Bourguignon and in your mind you figure you're the same as Hemingway when you eat the same thing in the same place. It's ridiculous of course, but this is a fantasy in the quiet of your own mind, so it's acceptable. My mind, it turns out, stayed quiet. No brilliant thoughts came my way, but it sure was nice to sit there and know he saw a similar scene while thoughts swirled in his mind that made their way into books. The diners are presided over by a painting of a nameless Art Nouveau lady. who hangs over the bar I wonder what she's thinking. Don't you?

— Janice

151

La Mercerie

March 2016, Paris

Dear Áine,

The trench is the coat of the month in March—warm but not too warm. Two buttons popped off mine somewhere between my house and Sylvie's hair salon. She advised a trip to a certain haberdashery (called a *mercerie* in French) up by Moulin Rouge. It's the fabric district, as well as the red-light district. She handed me a hand-drawn map. No one seems to know addresses or street names, or even shop names. We all just feel our way down alleyways and through memory banks. According to the map, I was to start from Moulin Rouge, go up one street, turn right, turn left, and look for a red shop with the word "mercerie" in the title. This was beginning to be less of an errand and more of a treasure hunt. After a few wrong turns and some backpedaling, I found the store—and buttons! An entire wall dedicated to buttons—silver, gold, ceramic, shell, and a rainbow of plastic buttons to solve any and all fashion emergencies. A matte silver caught my eye. It wasn't similar to the others already on my coat so I changed them all—18 buttons to sew that night. Now when I wear my trench I feel a bit like a glitterati of the fashion industry. I might have to re-button all my coats.

Janice

*"Dress shabbily and they remember the dress;
dress impeccably and they remember the woman."*

Coco Chanel

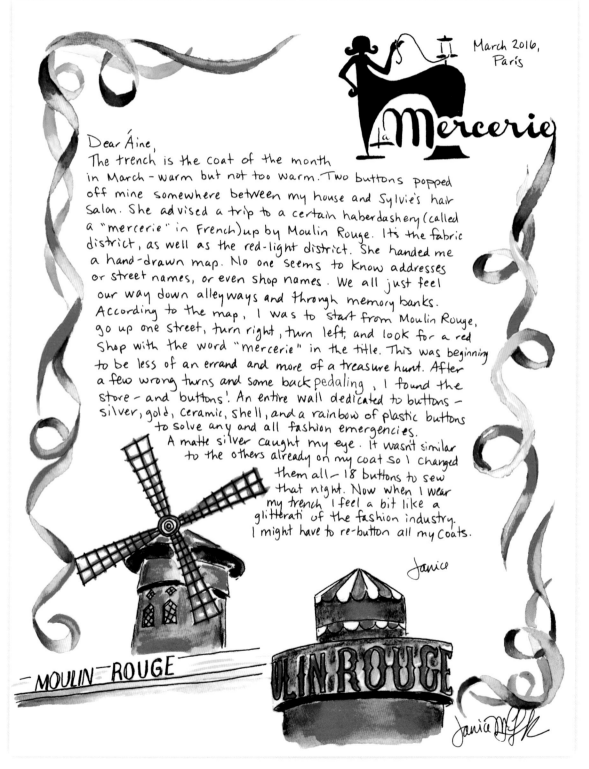

March 2016,
Paris

La Mercerie

Dear Áine,

The trench is the coat of the month in March – warm but not too warm. Two buttons popped off mine somewhere between my house and Sylvie's hair salon. She advised a trip to a certain haberdashery (called a "mercerie" in French) up by Moulin Rouge. It's the fabric district, as well as the red-light district. She handed me a hand-drawn map. No one seems to know addresses or street names, or even shop names. We all just feel our way down alleyways and through memory banks. According to the map, I was to start from Moulin Rouge, go up one street, turn right, turn left, and look for a red shop with the word "mercerie" in the title. This was beginning to be less of an errand and more of a treasure hunt. After a few wrong turns and some back pedaling, I found the store – and buttons! An entire wall dedicated to buttons – silver, gold, ceramic, shell, and a rainbow of plastic buttons to solve any and all fashion emergencies.

A matte silver caught my eye. It wasn't similar to the others already on my coat so I changed them all – 18 buttons to sew that night. Now when I wear my trench I feel a bit like a glitterati of the fashion industry. I might have to re-button all my coats.

Janice

MOULIN ROUGE

Janice M.LK

153

March 2016, Budapest

Dear Áine,

If you don't smell like chlorine during most of your stay in Budapest, you're doing it wrong. Thermal baths at the big hotels are where you'll find the locals soaking, visiting, and even playing chess at the pool's edge. You can rent towels <u>IF</u> they are available. Otherwise, you'll have to adapt your thermal dip by sunning yourself poolside to dry off before you leave. Budapest straddles the Danube, making it a hit with river cruisers. Its history is too complicated to keep track of—settled by a goulash of Magyars, Germans, Slavs, and Roma—followed by the rule of Turks, then Christians. Later, there were the Hapsburgs and eventually the Nazis and Communists. These days Budapest is delightfully democratic. Bombed buildings and bridges were restored or reconstructed— some with the original rubble—and the town is a walker's paradise. We walked back and forth over the Danube—first to Buda, then to Pest (the towns united in 1873), we shopped for lace and paprika, and on our last night, we sipped beers at an outdoor café. It was March and cold, but we were under a heat lamp and were provided blankets. It started to snow. We looked at each other and had the same thought: Let's go swimming! This time, we brought our own towels.

Janice

"AUTHOR: The thermal baths are very beautiful. MR. MOUSTAFA: They <u>were</u>, in their first condition. It couldn't be maintained, of course. Too decadent for current tastes—but I love it all, just the same. This enchanting, old ruin."

Wes Anderson, *The Grand Budapest Hotel*

The Grand Budapest

Dear Áine,

If you don't smell like chlorine during most of your stay in Budapest, you're doing it wrong. Thermal baths at the big hotels are where you'll find the locals soaking, visiting, and even playing chess at the pool's edge. You can rent towels IF they are available. Otherwise, you'll have to adapt your thermal dip by sunning yourself poolside to dry off before you leave. Budapest straddles the Danube, making it a hit with river cruisers. Its history is too complicated to keep track of — settled by a goulash of Magyars, Germans, Slavs, and Roma — followed by the rule of Turks, then Christians. Later, there were the Hapsburgs and eventually the Nazis and Communists. These days Budapest is delightfully democratic. Bombed buildings and bridges were restored or reconstructed — some with the original rubble — and the town is a walker's paradise. We walked back and forth over the Danube — first to Buda, then to Pest (the towns united in 1873), we shopped for lace and paprika, and on our last night, we sipped beers at an outdoor café. It was March and cold, but we were under a heat lamp and were provided blankets. It started to snow. We looked at each other and had the same thought: Let's go swimming! This time, we brought our own towels.

— Janice

155

Macaron Blossoms

April 2016, Paris

Dear Áine,

Paris is a bouquet in springtime. One day the dreary skies turn blue and the warm air arrives. We can finally venture outdoors with a light sweater and leave our coats to hang at home. The boutique windows are redecorated, filled with a rainbow array of products in pastel shades. Macaron Day is in spring, so the windows of tearooms are lined with creative concoctions of Paris' prettiest cookie. Orange blossom is a featured flavor at this time of the year, but I'm partial to salted caramel. Flowered dresses sashay down boulevards, and cafés roll back their glass walls to let the warm breeze roll in. All this pomp to prepare. Then it happens. One tree, then another burst into bouquets of pink, white, and purple blooms. You wonder to yourself if you are allowed to behold such splendor, allowed to be this happy. Yes! *Oui!* Weee!

Janice

"The macarons, though only a few grams, agitate our senses. The eyes have already devoured them. Fingers skim their surface, the flavors are gently smelled. When their fine crunchy shell is crushed, the ears are excited by the sound. Then the mouth experiences a delicate grace . . ."

Pierre Hermé

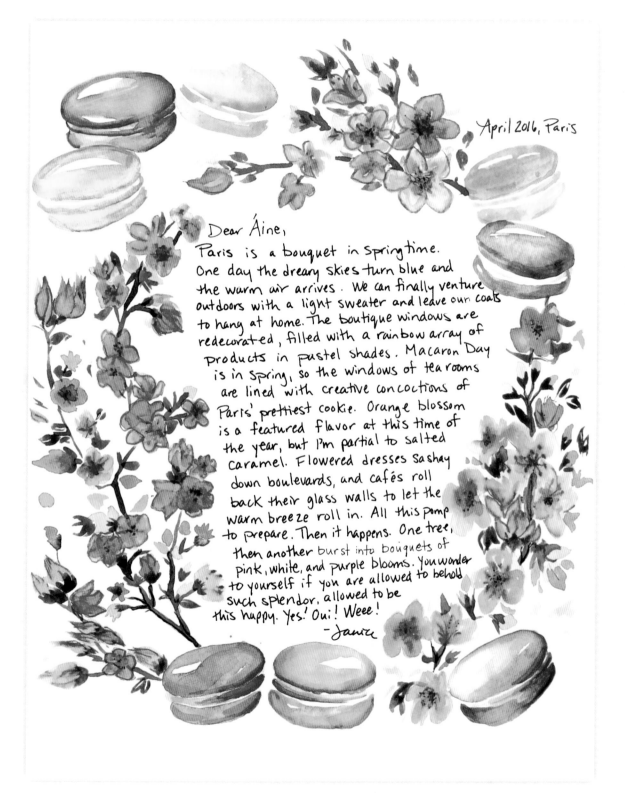

April 2016, Paris

Dear Áine,

Paris is a bouquet in springtime.
One day the dreary skies turn blue and
the warm air arrives. We can finally venture
outdoors with a light sweater and leave our coats
to hang at home. The boutique windows are
redecorated, filled with a rainbow array of
products in pastel shades. Macaron Day
is in spring, so the windows of tea rooms
are lined with creative concoctions of
Paris' prettiest cookie. Orange blossom
is a featured flavor at this time of
the year, but I'm partial to salted
caramel. Flowered dresses sashay
down boulevards, and cafés roll
back their glass walls to let the
warm breeze roll in. All this pomp
to prepare. Then it happens. One tree,
then another burst into bouquets of
pink, white, and purple blooms. You wonder
to yourself if you are allowed to behold
such splendor, allowed to be
this happy. Yes! Oui! Weee!
 — Janice

Florence, Italy

April 2016, Italy

Dear Áine,

Don't feel bad if you visit Florence and don't like it. It's not your fault. It's everyone else's. Truly. If you take one piece of advice from me, let it be this: NEVER VISIT FLORENCE IN HIGH SEASON. The mere presence of your fellow tourists will ruin your trip. I made the rookie mistake of visiting this heart of the Renaissance in the highest of high seasons. I arrived on the day after the beatification of Pope John Paul II in Rome. Every Catholic and his five brothers high-tailed it out of Rome after the religious festivities to frolic under the Tuscan sun in Florence. I was expecting walls dripping with frescoes—or even ivy. Instead I got hot pavement, beige buildings, and a hot mess of tourists. They skirmished up the Duomo (the cathedral), gobbled up the bruschetta (mispronouncing it along the way), and pretended to adore all things white bean. It was a bit much.

But even now, when I look back, I can't blame the city. It's popular for a reason, so now it's back on my Bucket List after scratching it off in haste and frustration. Florence owes me a redo—but this time it will happen in the off season.

Arrivederci, Florence!
(literally "until we meet again")

Arrivederci to you, too,

Janice

———— ⊱•⊰ ————

"My idea of heaven still is to drive the gravel farm roads of Umbria and Tuscany, very pleasantly lost."

Frances Mayes, *Under the Tuscan Sun*

April 2016. Italy

Dear Áine,
Don't feel bad if you visit Florence and don't like it.
It's not your fault. It's everyone elses. Truly.
If you take one piece of advise from me, let it be this:
 NEVER VISIT FLORENCE IN HIGH SEASON.
The mere presence of your fellow tourists will ruin
your trip. I made the rookie mistake of visiting
this heart of the Renaissance in the
highest of high seasons. I arrived on
the day after the beatification of
Pope John Paul II in Rome.

Every Catholic
and his five
brothers high-tailed
it out of Rome after
the religious festivities
to frolic under the
Tuscan sun in
Florence. I was

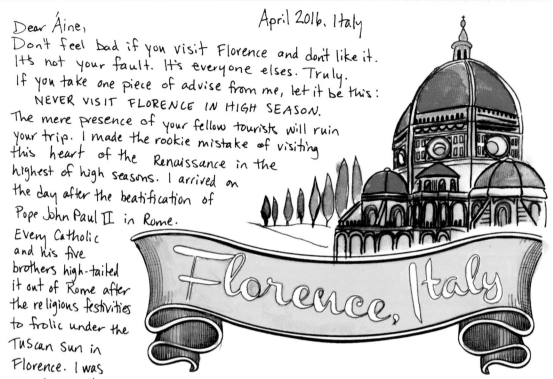

Florence, Italy

expecting walls dripping with frescoes — or even ivy. Instead I got hot pavement,
beige buildings, and a hot mess of tourists. They skirmished up the Duomo
(the cathedral), gobbled up the bruschetta (mispronouncing it along the way), and
pretended to adore all things white bean. It was all a bit much.

But even now, when I look back,
I can't blame the city. It's
popular for a reason, so now
it's back on my Bucket List
after scratching it off in
haste and frustration. Florence
owes me a redo — but
this time it will happen
in the off season.

Arrivederci, Florence!
(literally "until we meet again.")

Arrivederci, to you, too,
Janice

159

May Day

May 2016, Paris

Dear Áine,

It's impossible to forget when May 1st comes around in Paris. It's Labor Day, and on Labor Day, you can sell without a permit. Anyone who wants to make a few bucks is out selling sprigs of Lily-of-the-Valley. I bought a bouquet because—FLOWERS. I used to always go to the same girl. She was quiet and kind, and I know she was born into a hard life. After the Paris attacks, the shanty village where she lived was cleared out and that was the end of my flower girl. In Paris, there are so many fleeting relationships. Here one day, gone the next. Lily-of-the-Valley is the flower of friendship. I wish I could give her a bouquet. Since I can't, I give you this letter to honor our friendship on this May Day.

Janice

———— ◆ ————

"We were created to look at one another, weren't we?"

Edgar Degas

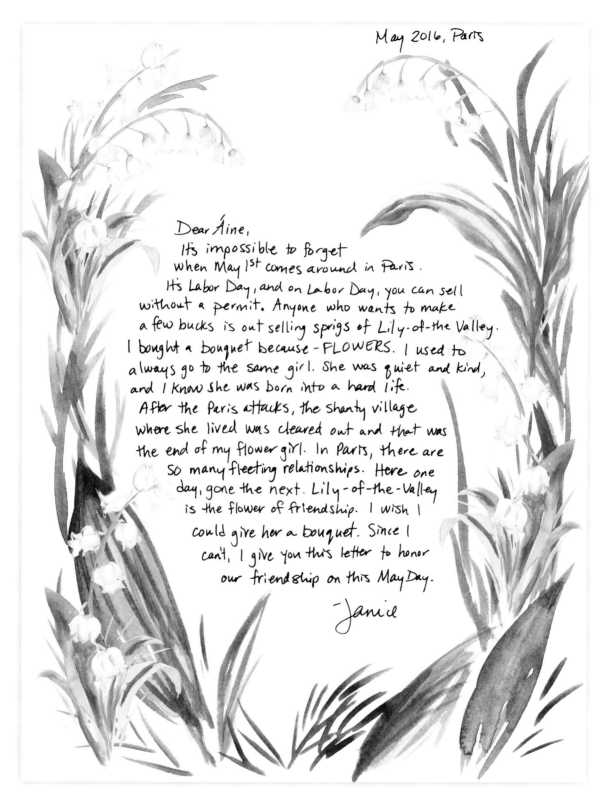

May 2016, Paris

Dear Áine,

It's impossible to forget when May 1st comes around in Paris.

It's Labor Day, and on Labor Day, you can sell without a permit. Anyone who wants to make a few bucks is out selling sprigs of Lily-of-the-Valley. I bought a bouquet because - FLOWERS. I used to always go to the same girl. She was quiet and kind, and I know she was born into a hard life.

After the Paris attacks, the shanty village where she lived was cleared out and that was the end of my flower girl. In Paris, there are so many fleeting relationships. Here one day, gone the next. Lily-of-the-Valley is the flower of friendship. I wish I could give her a bouquet. Since I can't, I give you this letter to honor our friendship on this May Day.

—Janice

161

May 2016, New York City

Dear Áine,

Look. Cities are getting warmer. Summer in New York City is no picnic. The heat gets trapped in between those skyscrapers, the cement bakes, and we begin the air-condition hop from one cold interior to the next. But in May, right before all that heat infiltrates the city, that's when you want to be in New York. Pedestrian life is in full swing. The weather is so nice that you opt to walk rather than take the train. You take a big yellow taxi a few times because you think you should when in New York, and you quietly hum Joni Mitchell's song in the back seat. I rented a tiny apartment in Manhattan, around the corner from where sweet John Lennon was shot, and I spent the week zigzagging across Central Park. First to the Met to gaze at art, then back to the Natural History Museum to explore space. And in between, rests in the park. Central Park is the park of dreams—couples in rowboats, families having picnics, cyclists, joggers, and walkers like me. Manhattan is basically Sesame Street for grown-ups. There really are street people like Oscar the Grouch and Spanish señoritas like Maria. No Big Bird though . . . unless that was the taxi.

Janice

"The true New Yorker secretly believes that people living anywhere else have to be, in some sense, kidding."

John Updike

May 2016, New York City

Dear Áine,

Look. Cities are getting warmer. Summer in New York City is no picnic. The heat gets trapped in between those skyscrapers, the cement bakes, and we begin the air-condition hop from one cold interior to the next. But in May, right before all that heat infiltrates the city, that's when you want to be in New York. Pedestrian life is in full swing. The weather is so nice that you opt to walk rather than take the train. You take a big yellow taxi a few times because you think you should when in New York, and you quietly hum Joni Mitchell's song in the back seat.

I rented a tiny apartment in Manhattan, around the corner from where sweet John Lennon was shot, and I spent the week zigzagging across Central Park. First to the Met to gaze at art, then back to the Natural History Museum to explore space. And in between, rests in the park. Central Park is the park of dreams ~ couples in row boats, families having picnics, cyclists, joggers, and walkers like me. Manhattan is basically a Sesame Street for grown-ups. There really are street people like Oscar the Grouch and Spanish señoritas like Maria. No Big Bird though... unless that was the taxi.

– Janice

Champs-Élysées

June 2016, Paris

Dear Áine,

There is always that one tourist who comes to town and insists on eating a crêpe in the shadow of the Arc de Triomphe. Locals hesitate to indulge this request as they know the reality is vastly different from the rosy soft fantasy. Our tourist wants the calm boulevard, shaded with trees—to watch people strolling by basking in the sunshine, the quaint café with the waiter who speaks English with a French accent. These tourists never assume the waiter speaks French . . . always English with a charming accent. The reality is traffic, screaming, and honking. The hordes of tourists waddling by, complaining about blisters and foot pain. The crêpes are overpriced in Euros. To convert currency would send you into panic. But stubborn tourists will not be swayed, so off you go. As you sit squished into a *terrasse* seat, you gaze off to the Arc de Triomphe. It really is an impressive war memorial. Then you smile and realize that the scene is perfect and appropriate. A different—but much preferred—kind of war.

Janice

"The pavement cafes were crowded until late at night because the boulevards still glowed with the heat of the sunlight stored up during the day. It was as if some gigantic, warm-blooded creature were hidden beneath the flagstones, breathing gently and imperceptibly."

Alex Capus, *Léon & Louise*

Dear Áine,

There is always that one tourist who comes to town and insists on eating a crêpe in the shadow of the Arc de Triomphe. Locals hesitate to indulge this request as they know the reality is vastly different from the rosy soft fantasy. Our tourist wants the calm boulevard, shaded with trees — to watch people strolling by basking in sunshine, the quaint café with the waiter who speaks English with a French accent. These tourists never assume the waiters speak French — always English with a charming accent.

The reality is traffic, screaming, and honking. The hordes of tourists waddling by, complaining about blisters and foot pain. The crêpes are overpriced in Euros. To convert currency would send you into panic. But stubborn tourists will not be swayed, so off you go. As you sit squished into a terrasse seat, you gaze off to the Arc de Triomphe. It really is an impressive war memorial. Then you smile and realize that the scene is perfect and appropriate. A different — but much preferred — kind of war.

—Janice

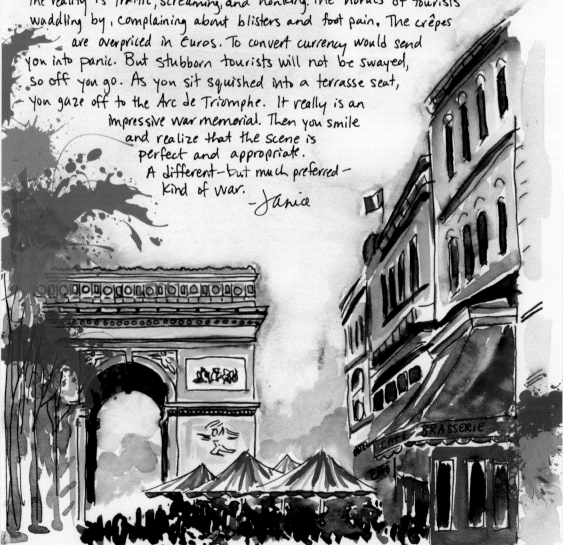

July 2016, Paris

Dear Áine,

There are two kinds of cafés in Paris these days—those with TVs showing the EuroCup and those without. Those without TVs have their chairs facing out toward the street as usual. Their clientele are calm and quiet, aiming to bask in the sunshine and watch scenes play out before them on the theatre that is the Paris street. The cafés with TVs have turned their chairs inward to face the TV—a rarity to be sure, but France is hosting this year, which means locals and hardcore fans from other countries are catching the games when they're not traveling between the 3 stadiums holding games in Paris, Lille, and Nice.

The fans amaze me. Despite train and garbage strikes, demonstrations, and the continued state of emergency with guards everywhere, these thousands of people from 24 nations get themselves from stadium to stadium—finding the trains that are running, finding last-minute accommodation based on how their team is advancing, navigating streets and the language of a new city, and being relatively calm about it (except the few hotheaded hooligan fans). It's a marvel of modern transport when you think about it. In every small group there is someone taking a quiet moment to book the next train or hotel on their phones or in the hotel at night—or maybe even taking a day in between to sit at the café <u>without</u> the TV and book the next leg of the journey.

Janice

"Paris is not a city; it's a world."

King François I

July 2016, Paris

Dear Áine,

There are two kinds of cafés in Paris these days –
those with TVs showing the Euro Cup and those without.
Those without TVs have their chairs facing out toward
the street as usual. Their clientele are calm and quiet,
aiming to bask in sunshine and watch scenes play out
before them on the theatre that is the Paris street.
The cafés with TVs have turned their chairs inward to
face the TV – a rarity to be sure, but France is hosting
this year, which means locals and hard core fans from
other countries are catching the games when they're not
traveling between the 3 stadiums holding games in Paris, Lille, and Nice.

The fans amaze me.
Despite train and garbage
strikes, demonstrations,
and the continued state of
emergency with guards everywhere,
these thousands of people
from 24 nations get themselves
from stadium to stadium –
finding the trains that are
running, finding last-minute
accommodation based on how
their team is advancing,
navigating streets and the
language of a new city, and
being relatively calm about it
(except the few hotheaded
hooligan fans). It's a marvel
of modern transport when
you think about it. In every
small group there is someone
taking a quiet moment to
book the next train or hotel
on their phones or in the
hotel at night – or maybe
even taking a day in between
to sit at the café without
the TV and book the next
leg of the journey.
– Janice

167

August 2016, Paris

Dear Áine,

When the rental agent handed me an enormous brass key, it seemed like the kind of key that unlocks a treasure chest or château. But no, she assured me. This was the key to my tiny Paris apartment. This giant antique key couldn't possibly work anymore, yet the agent reminded me "Old doors. Old keys." "Don't lose it," she said. "Very expensive to replace." The key did in fact work, and it got me thinking about how many keys are in Paris. Every door has a lock and each lock has a key. How many keys have been lost? How many have sunk to the bottom of the Seine? How many people have tucked the same key into their pocket to open the same door for the last 80 years? The key cutter on my street has been making keys in the same tiny shop for the last 50 years. He, himself, boasts that he has only used the one key to get into his shop. The cheesemonger on my street is the unofficial key keeper of the street. When someone leaves for their month-long vacation in August, they often leave their keys with him. If something should happen to them or their luggage, it's best that the key stays in Paris. I don't know how he keeps the keys straight, but he manages. There are no notes on the keys. He just seems to know. Sure enough, when I returned from a trip, I strolled up to him with my suitcase and he handed me my key. There is no payment for this service, but I assure you, I bought cheese that day.

Janice

"He had drawers of old keys, bins full of them, and sometimes rather than pick a lock he would simply try one key after another because, as he said, 'there is something delightful about helping a key find its way back to a lock, so it can do the work it was meant for.'"

Juliet Blackwell, *The Paris Key*

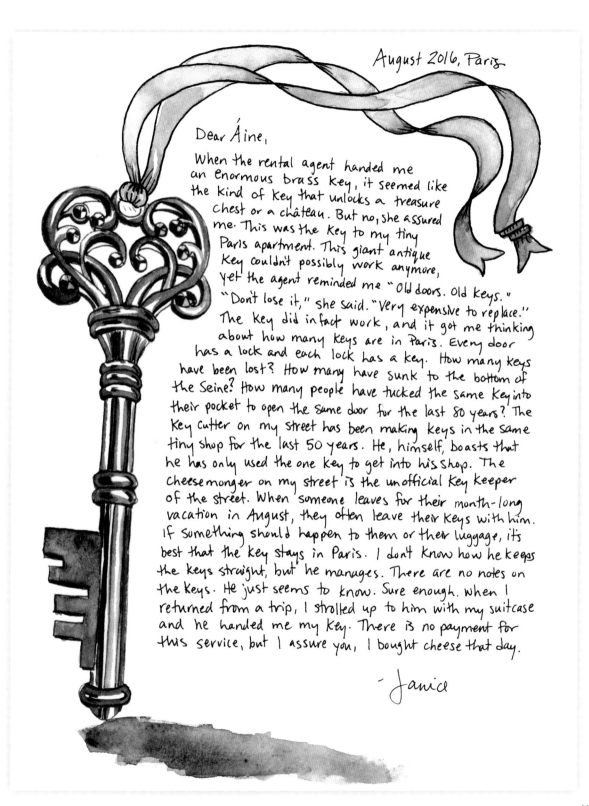

August 2016, Paris

Dear Áine,

When the rental agent handed me
an enormous brass key, it seemed like
the kind of key that unlocks a treasure
chest or a château. But no, she assured
me. This was the key to my tiny
Paris apartment. This giant antique
key couldn't possibly work anymore,
yet the agent reminded me "Old doors. Old keys."
"Don't lose it," she said. "Very expensive to replace."
The key did in fact work, and it got me thinking
about how many keys are in Paris. Every door
has a lock and each lock has a key. How many keys
have been lost? How many have sunk to the bottom of
the Seine? How many people have tucked the same key into
their pocket to open the same door for the last 80 years? The
key cutter on my street has been making keys in the same
tiny shop for the last 50 years. He, himself, boasts that
he has only used the one key to get into his shop. The
cheesemonger on my street is the unofficial key keeper
of the street. When someone leaves for their month-long
vacation in August, they often leave their keys with him.
If something should happen to them or their luggage, it's
best that the key stays in Paris. I don't know how he keeps
the keys straight, but he manages. There are no notes on
the keys. He just seems to know. Sure enough, when I
returned from a trip, I strolled up to him with my suitcase
and he handed me my key. There is no payment for
this service, but I assure you, I bought cheese that day.

— Janice

August 2016, Calgary

Dear Áine,

I finally made it to the world famous Calgary Stampede. I was curious to know what all the fuss was about, as in the days leading up to the event Calgarians start dressing up like cowboys. The cashiers at the pharmacy, at the post office, and coffee shops all dressed in their fine cowboy gear. Even people who are coming by the house for a visit are wearing cowboy hats and boots. I peered out my window at one such visit. A man parked his car, grabbed his hat, and looked at his reflection in the window to make sure it was on straight—all this for a teatime at home! A woman asked me in an elevator why I wasn't wearing my cowgirl dress. I told her the truth. It was the first day of "cowboy dress-up" and I had nothing to wear. Rookie mistake.

The stampede itself is the biggest outdoor rodeo in the world. It boasts having the "largest purse of over $2 million." The purse is a rather ladylike term for the manly event where rodeo dudes compete in bull riding, roping, chuck wagon racing, and other "home on the range" cowboy activities. It's a lot of pressure when there is so much money to be won by so few winners. Less than a second can dictate if you ride off with thousands or nothing at all. These cowboys are the real deal. They are named Chance, Colt, and Colby—likely sired by men named Wyatt and Woodrow. And they <u>look</u> like cowboys while I look like I'm going to a cowboy-themed Halloween party. These fellas are the best of the best. One can't help but wonder how many horses they fell off before they decided they had a talent for it and could enter the rodeo.

I think I'll stick to my current profession. Less bruises.

Janice

———— ≈ ————

"Mammas, don't let your babies grow up to be cowboys
'Cos they'll never stay home and they're always alone
Even with someone they love"

Waylon Jennings and Willie Nelson,
"Mammas Don't Let Your Babies Grow Up to Be Cowboys"

Calgary Stampede

Dear Áine,

I finally made it to the world famous Calgary Stampede. I was curious to know what all the fuss was about, as in the days leading up to the event Calgarians start dressing up like cowboys. The cashiers at the pharmacy, at the post office, and coffee shops all dressed in their fine cowboy gear. Even people who are coming by the house for a visit are wearing cowboy hats and boots. I peered out my window at one such visit. A man parked his car, grabbed his hat, and looked in the reflection of the window to make sure it was on straight – all this for a tea time at home! A woman asked me in an elevator why I wasn't wearing my cowgirl dress. I told her the truth. It was the first day of "cowboy dressup" and I had nothing to wear. Rookie mistake.

The Stampede itself is the biggest outdoor rodeo in the world. It boasts having the "largest purse of over $2 million." The purse is a rather ladylike term for the manly event where rodeo dudes compete in bull riding, roping, chuckwagon racing, and other "home on the range" cowboy activities. It's a lot of pressure when there is so much money to be won by so few winners. Less than a second can dictate if you ride off with thousands or nothing at all. These cowboys are the real deal. They are named Chance, Colt, and Colby – likely sired by men named Wyatt and Woodrow. And they look like cowboys while I look like I'm going to a cowboy-themed Halloween party. These fellas are the best of the best. One can't help but wonder how many horses they fell off before they decided they had a talent for it and could enter the rodeo.

I think I'll stick to my current profession. Less bruises.

– Janice

Île Saint-Louis

September 2016, Paris

Dear Áine,

September has seen the mass return of French beach bums, and for students, a return to school. September is like January in other places—when we launch it, enroll in it, and begin it. Having a long vacation seems to do what vacations are designed to do—first relax us, then reinvigorate us for the year ahead.

Early in the mornings of September, I walk to the Saint-Régis Café on Île Saint-Louis—the island in the middle of the Seine and of Paris. I sit among the bronzed locals who are revisiting projects previously abandoned for the beach. We sit together in silence, staring at our screens or notepads. One gentleman is refining a menu, another is writing an essay, another is working out math problems, which doesn't seem like a romantic notion until you see his numbers. They are so ornate, I want to frame the page. As for me, I sit with my journal and work out the next quarter—articles to be written, correspondence to organize, chapters to complete, and of course, dreams to pursue. It's a full but quiet room. The most conversation you'll get is a friendly nod of recognition. It's like a library but with clinking glasses and a buzzing espresso machine. As the brunch crowd filters in, we filter out.

I saunter down the main street of this small island town and do some window-shopping. The French call this *lèche-vitrines,* window licking, which is exactly what you want to do at the chocolatier, boulangerie, and at Berthillon—the ice cream shop. I end my stroll at the tip of the island. Here, the river splits, giving you the illusion that you are steering your own ship, which is, I suppose how September itself feels. Summer is gone and you're happy about it, delighted to get back to work.

As I turn to go, I notice the tops of the trees have begun to turn yellow. A new season has begun and I could not be more pleased. Let it begin!

Janice

"And all at once, summer collapsed into fall."

Attributed to Oscar Wilde

September 2016, Paris

Dear Áine,

September has seen the mass return of French beach bums, and for students, a return to school. September is like January in other places— when we launch it, enroll in it, and begin it. Having a long vacation seems to do what vacations are designed to do— first relax us, then reinvigorate us for the year ahead.

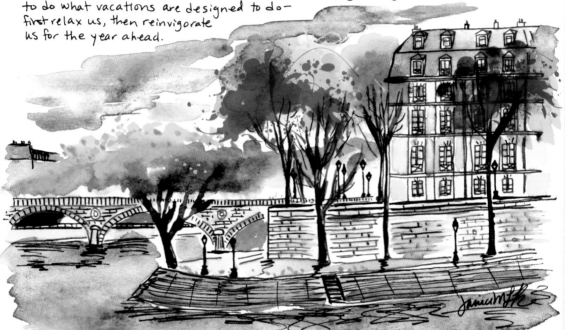

Early in the mornings of September, I walk to the Saint-Régis Café on Île Saint-Louis —the island in the middle of the Seine and of Paris. I sit among the bronzed locals who are revisiting projects previously abandonned for the beach. We sit together in silence, staring at our screens or notepads. One gentleman is refining a menu, another is writing an essay, another is working out math problems, which doesn't seem like a romantic notion until you see his numbers. They are so ornate, I want to frame the page. As for me, I sit with my journal and work out the next quarter— articles to be written, correspondence to organize, chapters to complete, and of course, dreams to pursue. It's a full but quiet room. The most conversation you'll get is a friendly nod of recognition. It's like a library but with clinking glasses and a buzzing espresso machine. As the brunch crowd filters in, we filter out.

I saunter down the main street of this small island town and do some window-shopping. The French call this "lèche-vitrines," window licking, which is exactly what you want to do at the chocolatier, boulangerie, and at Berthillon —the ice cream shop. I end my stroll at the tip of the island. Here, the river splits, giving you the illusion that you are steering your own ship, which is, I suppose, how September itself feels. Summer is gone and you're happy about it, delighted to get back to work.

As I turn to go, I notice the tops of the trees have begun to turn yellow. A new season has begun and I could not be more pleased. Let it begin!

—Janice

September 2016, Italy

Dear Áine,

Below the cliffs of the Amalfi Coast, on the edge of the Mediterranean Sea in Italy, is a small stony beach. You can hardly see it from the winding road above. You have to know to look—and look at the exact right moment—before it disappears behind a rocky hill. This beach has a snorkeling rental hut, a boat that will take you to the Island of Capri, and a small restaurant that caters to the sun worshippers who lounge along the surf. It's quieter here than at the beach next door in Positano. That's where the tourists go. The rest of us opt for a more secluded sliver of sunshine on this smaller beach of Praiano. After a few weeks of plodding through the ruins of Rome, crossing the bridges of Venice, and exploring the museums of Florence, I was happy to rest my weary self on a lounge chair by the sea.

Tired of new things, my travel companion and I opted for lunches at the beach restaurant—a ten-step walk from our lounge chairs. It was a family-run affair, and I could tell by the sour look on the face of our teenage waitress that she could not wait to fly this coop. An old fisherman would arrive each day for his noon glass of wine. He was thin and bald, and wore the same Speedo each day. He chatted with everyone, including us—having the snorkel renter translate. On our last day, when we were bronzed and had recovered, he recited a fisherman's love poem. I don't know what it meant, but I could tell by the way he spoke that it was lovely. Ah Italians!

Janice

———— ❧ ————

"There was a pleasantness to the air and a spirit about the town that did not come from its color, but from some inner, tasty citrus quality. It made Alexia wonder fancifully if cities could have souls."

Gail Carriger, *Blameless*

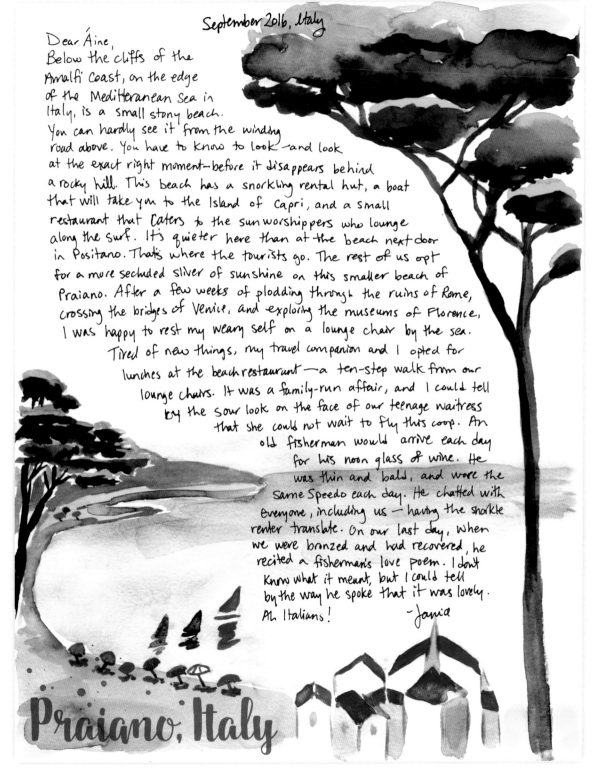

September 2016, Italy

Dear Áine,
Below the cliffs of the Amalfi Coast, on the edge of the Mediterranean Sea in Italy, is a small stony beach. You can hardly see it from the winding road above. You have to know to look—and look at the exact right moment—before it disappears behind a rocky hill. This beach has a snorkling rental hut, a boat that will take you to the Island of Capri, and a small restaurant that caters to the sun worshippers who lounge along the surf. It's quieter here than at the beach next door in Positano. That's where the tourists go. The rest of us opt for a more secluded sliver of sunshine on this smaller beach of Praiano. After a few weeks of plodding through the ruins of Rome, crossing the bridges of Venice, and exploring the museums of Florence, I was happy to rest my weary self on a lounge chair by the sea.

Tired of new things, my travel companion and I opted for lunches at the beach restaurant—a ten-step walk from our lounge chairs. It was a family-run affair, and I could tell by the sour look on the face of our teenage waitress that she could not wait to fly this coop. An old fisherman would arrive each day for his noon glass of wine. He was thin and bald, and wore the same Speedo each day. He chatted with everyone, including us—having the snorkle renter translate. On our last day, when we were bronzed and had recovered, he recited a fisherman's love poem. I don't know what it meant, but I could tell by the way he spoke that it was lovely. Ah Italians!

~Jamia

Praiano, Italy

175

Colette

October 2016, Paris

Dear Áine,

I've been hopscotching from park to park to admire the leaf-changing glory of October. The arborists who planted these trees a century ago were true artists. In Jardin du Luxembourg, the green grass lanes are now blanketed with yellow leaves. The Tuileries gardens are covered with orange. I added the Paris cemeteries to my autumn tour this year. It may sound macabre, but these cemeteries are veritable statue museums and they have a wealth of old trees that rain down the fiery tones of autumn. Some of the arborists who planted these trees are likely resting among them now, snuggled up beside great minds of Paris—Chopin, Degas, Wilde, Piaf, de Beauvoir—they are all here, as are a surprising number of cats. For some mysterious reason, these cats seem well-nourished. They eye me with mild suspicion, but when they see I won't try to approach, they get back to hunting for mice. I looked for Colette's grave. She was as known for being a writer as she was for being a cat lover. I was hoping to witness cats swarming her plot, but I never found her. I wonder if Colette fans sneak cat food to her grave to give her extra company during her eternal sleep. I also wonder if these cats hold the souls of the cemetery residence. If so, could one of these cats be Colette herself, prancing around admiring her latest incarnation? Or perhaps the arborists, who stroll around admiring their handiwork from when they lived in Paris? I do hope so, because these trees in autumn deserve admiration.

Janice

"Perhaps the only misplaced curiosity is that which persists in trying to find out here, on this side of death, what lies beyond the grave."

Colette, *The Pure and the Impure*

Dear Áine,

I've been hopscotching from park to park to admire the leaf-changing glory of October. The arborists who planted these trees a century ago were true artists. In Jardin du Luxembourg, the green grass lanes are now blanketed with yellow leaves. The Tuileries gardens are covered with orange. I added the Paris cemeteries to my autumn tour this year. It may sound macabre, but these cemeteries are veritable statue museums and they have a wealth of old trees that rain down the firey tones of autumn. Some of the arborists who planted these trees are likely resting among them now, snuggled up beside great minds of Paris — Chopin, Degas, Wilde, Piaf, de Beauvoir — they are all here, as are a surprising number of cats. For some mysterious reason, those cats seem well-nourished. They eye me with mild suspicion, but when they see I won't try to approach, they get back to hunting for mice. I looked for Colette's grave. She was as known for being a writer as she was for being a cat lover. I was hoping to witness cats swarming her plot, but I never found her. I wonder if Colette fans sneak cat food to her grave to give her extra company during her eternal sleep. I also wonder if these cats hold the souls of the cemetery residence. If so, could one of these cats be Colette herself, prancing around admiring her latest incarnation? Or perhaps the arborists, who stroll around admiring their handiwork from when they lived in Paris? I do hope so, because these trees in autumn deserve admiration.

— Janice

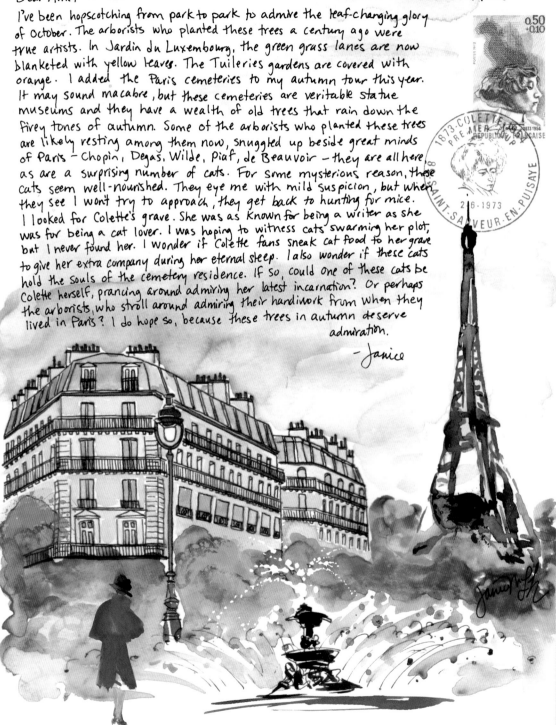

October 2016, Paris

0.50 +0.10

October 2016, Dublin, Ireland

Dear Áine,

After living in big, big cities, I had forgotten the glories of cities you can get around in a few days. Dublin is one such city. In a day of walking, I learned about the booms and busts of this Irish town. When Dublin suffers, it suffers big—statues of the 1845 Potato Famine and buildings pockmarked with bullet holes from the Easter Rising of 1916 are all next door to pubs celebrating—well, happy hour. The pubs are glorious—old wood, well-worn bars from a thousand elbows leaning in to tell a funny story or the latest gossip.

The purpose of the Easter Rising was to establish independence from British rule. It was a bloody battle and a dark time. A more cheerful monument to the separation from British rule can be found on the brightly painted doors all over the city. Apparently, back in the day, an important English royal died, so the people were ordered to paint their doors black. The feisty Irish proceeded to paint in the brightest hues they could find. Speaking of paint, I went to see the Book of Kells—this is a book of illuminated manuscripts of the four gospels of Matthew, Mark, Luke, and John. Interestingly, these gospels are really a collection of letters that were made into a manuscript. A handful of monks transcribed the manuscript and added paint—the original painted-letter writers! Who would have thought I would have something in common with old Irish monks! Besides a desire to end a long day with a tall, cold Guinness.

Cheers!

Janice

"The master says it's a glorious thing to die for the Faith and Dad says it's a glorious thing to die for Ireland and I wonder if there's anyone in the world who would like us to live."

Frank McCourt, *Angela's Ashes*

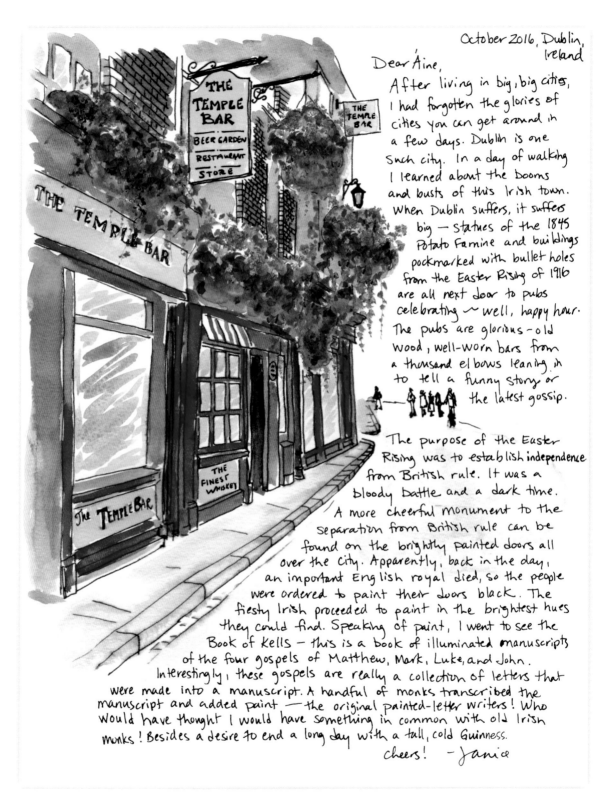

October 2016, Dublin, Ireland

Dear Áine,

After living in big, big cities, I had forgotten the glories of cities you can get around in a few days. Dublin is one such city. In a day of walking I learned about the booms and busts of this Irish town. When Dublin suffers, it suffers big — statues of the 1845 Potato Famine and buildings pockmarked with bullet holes from the Easter Rising of 1916 are all next door to pubs celebrating ~ well, happy hour. The pubs are glorious — old wood, well-worn bars from a thousand elbows leaning in to tell a funny story or the latest gossip.

The purpose of the Easter Rising was to establish independence from British rule. It was a bloody battle and a dark time. A more cheerful monument to the separation from British rule can be found on the brightly painted doors all over the city. Apparently, back in the day, an important English royal died, so the people were ordered to paint their doors black. The fiesty Irish proceeded to paint in the brightest hues they could find. Speaking of paint, I went to see the Book of Kells — this is a book of illuminated manuscripts of the four gospels of Matthew, Mark, Luke, and John. Interestingly, these gospels are really a collection of letters that were made into a manuscript. A handful of monks transcribed the manuscript and added paint — the original painted-letter writers! Who would have thought I would have something in common with old Irish monks! Besides a desire to end a long day with a tall, cold Guinness.

Cheers! — Janice

179

November 2016, Paris

Dear Áine,

There was a time I felt so cool extolling the virtues of Beaujolais Nouveau wine. This is the new wine that has just been harvested and is meant to be consumed immediately. I thought it was so lovely rolling off the tongue . . . the words, not the wine. "Beaujolais Nouveau" sounds so very sophisticated. But then I moved to Paris and discovered the truth. In November, there is a Beaujolais Nouveau Day, which includes races to get the first bottles to Paris. Bars and cafés post signs, *"Le Beaujolais Nouveau est arrivé!"* The wine has arrived! And off we trod, the great mass of Parisians, to try out the new wine. It has mixed reviews. My uneducated palate can't handle this swill. After the obligatory first glass, we move on to the wines we usually choose, and during that second glass we complain about the first. As long as you all agree, Beaujolais Nouveau Day can be quite fun. It's still quite fun to say, but with my friends, it's often followed by a complaint rather than a compliment.

C'est comme ça.

Janice

"Russians love Vladimir Putin. They seem to feel about him how New Yorkers used to feel about Giuliani: He may be a son of a bitch, but he's our son of a bitch."

Anthony Bourdain, *Parts Unknown*

November 2016, Paris

Dear Áine,

There was a time I felt so cool extolling the virtues of Beaujolais Nouveau wine. This is the new wine that has just been harvested and is meant to be consumed immediately. I thought it was so lovely rolling off the tongue... the words, not the wine. "Beaujolais Nouveau" sounds so very sophisticated. But then I moved to Paris and discovered the truth. In November, there is a Beaujolais Nouveau Day, which includes races to get the first bottles to Paris. Bars and cafés post signs, "Le Beaujolais Nouveau est arrivé!" The wine has arrived! And off we trod, the great mass of Parisians, to try out the new wine. It has mixed reviews. My uneducated palate can't handle this swill. After the obligatory first glass, we move on to the wines we usually choose, and during that second glass we often complain about the first. As long as you all agree, Beaujolais Nouveau Day can be quite fun. It's still fun to say, but with my friends, it's often followed by a complaint rather than a compliment.

C'est comme ça.

—Janice

November 2016, Toronto, Canada

Dear Áine,

I just returned from Toronto, my old stomping ground. This marvelous Canadian city has inspiration seeping up from the sidewalks. I think this is because it's a great walking town—all those people thinking up thoughts on their way to work, home, and a thousand places in between. Back when I lived in Toronto, I lived on Gerrard Street and could hear the streetcar rumble by every 20 minutes. Some people may think this is a detriment, but I loved it. I felt like I was definitely somewhere. When I moved on to even bigger cities, I kept a transit token in my wallet. This is your ticket to ride the transit system, but for me, it was a symbolic ticket home. After 12 years of shuffling that token around in my wallet, I finally used it. Toronto is phasing out the token and I'm a practical lady. This was a now or never situation. I chose a rainy moment to ride the streetcar and the gods rewarded me by making it pour once I stepped on. The rumble and sway of the ride, the swish swish of the windshield wipers, and the patter of the rain hitting the roof made for a satisfying symphony. I revisited places where ghosts of my former self lived. I wished I could reach out to her and tell her that so many of life's questions will be answered so try not to be consumed with wondering. That there will be a point when you either grow up or get fed up and take action to make it better. And that's when life changes from being one long wet commute to a fun ride in the rain.

Janice

———————※———————

"Don't search for the answers, which could not be given to you now, because you would not be able to live them. And the point is, to live everything. Live the questions now. Perhaps then, someday far in the future, you will gradually, without even noticing it, live your way into the answer."

Rainer Maria Rilke

Dear Áine,

I just returned from Toronto, my old stomping ground. This marvelous Canadian city has inspiration seeping up from the sidewalks. I think this is because it's a great walking town — all those people thinking up thoughts on their way to work, home, and a thousand places in between. Back when I lived in Toronto, I lived on Gerrard Street and could hear the streetcar rumble by every 20 minutes. Some people may think this a detriment, but I loved it. I felt like I was definitely somewhere. When I moved on to even bigger cities, I kept a transit token in my wallet. This is your ticket to ride the transit system, but for me, it was a symbolic ticket home. After 12 years of shuffling that token around in my wallet, I finally used it. Toronto is phasing out the token and I'm a practical lady. This was a now or never situation. I chose a rainy moment to ride the streetcar and the gods rewarded me by making it pour once I stepped on. The rumble and sway of the ride, the swish swish of the windshield wipers, and the patter of the rain hitting the roof made for a satisfying symphony. I revisited places where ghosts of my former self lived. I wished I could reach out to her and tell her that so many of life's questions will be answered so try to not be consumed with wondering. That there will be a point when you either grow up or get fed up and take action to make it better. And that's when life changes from being one long wet commute to a fun ride in the rain.

— Janice

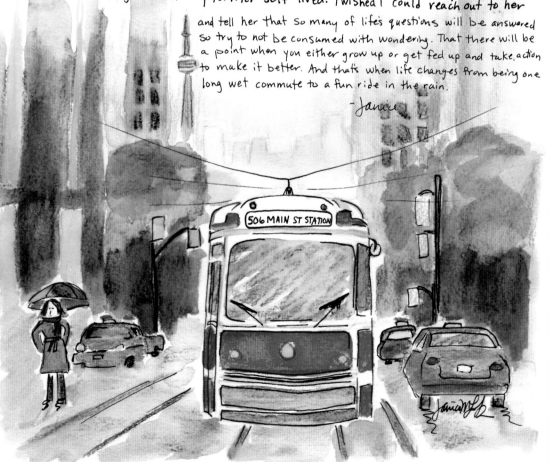

Le Bon Marché

December 2016, Paris

Dear Áine,

All of Paris is like a jewelry store in December. Streets are draped with Christmas lights, the stores have filled their windows with their most dazzling gifts, and if it snows, the flakes seem to fill the air with glitter. This Christmas I spent much of my time at Le Bon Marché department store. First, they created an entire wing just for Christmas ornaments; second, it's less crowded than other department stores, so I could avoid the tourists (when you're on a mission, you don't want extra crowds slowing you down); third, they have a spectacular papeterie full of fancy stationery, daybooks, journals, and pens. Why on earth am I so very attracted to a blank page? All this paper, ready to record plans, ideas, sketches, lists, stories—I suppose it's the potential of this pure paper, mixed with a new year on the horizon and the hypnotics of all those holiday lights that makes a person want to spend, spend, spend. I was not alone. The place was crowded with quiet locals, also mesmerized by the selection. I could tell that many people weren't buying gifts for other people. They seemed too serious about their deliberations. The French take letter writing and journal keeping seriously. No slap-dash scrap paper for them. It's all textures and fountain pens, pretty stamps and embellishments. In short, I believe I have found my people in the middle of a sparkly department store in Paris.

Joyeux Noël!

Janice

"*Each and every church, boulevard, lamppost, monument, department store, bridge, pastry shop, park bench, café table, sewer cover, hospital, and garbage can— everything in the city is carefully placed where it is, as a result of much thought and reflection. A team of thirty people moves about under the cover of darkness each night, constantly adjusting, focusing, and softening the lights to give Paris and its monuments that extraspecial glow.*"

David Lebovitz, *The Sweet Life in Paris*

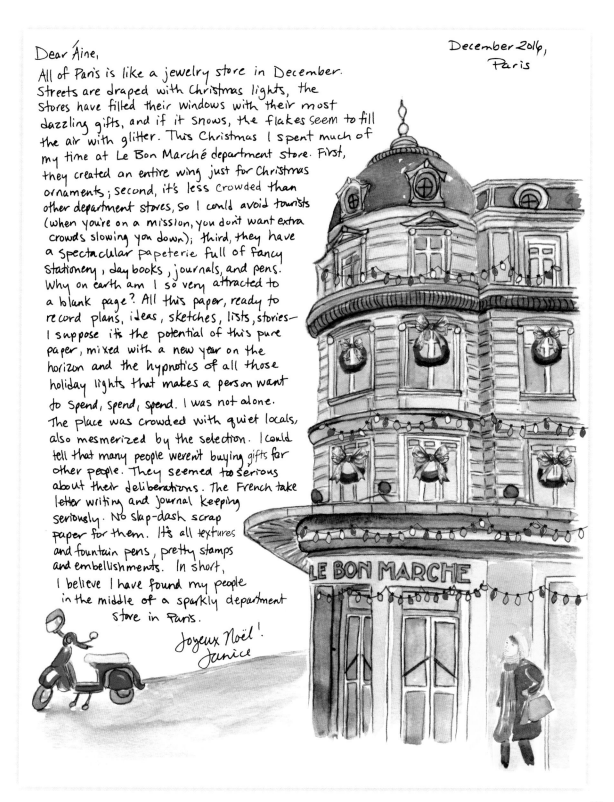

Dear Áine,

December 2016,
Paris

All of Paris is like a jewelry store in December. Streets are draped with Christmas lights, the stores have filled their windows with their most dazzling gifts, and if it snows, the flakes seem to fill the air with glitter. This Christmas I spent much of my time at Le Bon Marché department store. First, they created an entire wing just for Christmas ornaments; second, it's less crowded than other department stores, so I could avoid tourists (when you're on a mission, you don't want extra crowds slowing you down); third, they have a spectacular papeterie full of fancy stationery, day books, journals, and pens. Why on earth am I so very attracted to a blank page? All this paper, ready to record plans, ideas, sketches, lists, stories— I suppose it's the potential of this pure paper, mixed with a new year on the horizon and the hypnotics of all those holiday lights that makes a person want to spend, spend, spend. I was not alone. The place was crowded with quiet locals, also mesmerized by the selection. I could tell that many people weren't buying gifts for other people. They seemed too serious about their deliberations. The French take letter writing and journal keeping seriously. No slap-dash scrap paper for them. It's all textures and fountain pens, pretty stamps and embellishments. In short, I believe I have found my people in the middle of a sparkly department store in Paris.

Joyeux Noël!
Janice

LE BON MARCHE

185

December 2016, Verona

Dear Áine,

I was extolling the virtues of beautiful European cities to the lovely Christophe as I am wont to do whenever wanderlust strikes. He, being European, replied, "Beautiful?! Pshaw! It depends on what you see and a lot of what you DON'T see." His life in Europe was very different than mine. His was a working-class world, and when I arrived on European soil, I had a firm foot in the land of tourists. I was shown the welcome mat, the one rolled out to entice visitors to relieve themselves of Euros one meal and admission fee at a time. "Look harder," Christophe says. And that got me thinking about balconies. In the larger cities, people live in apartments and their only private outdoor space is their balconies. Only from the clues they reveal to onlookers below can you guess what lives live beyond the shuttered windows. Naples and its laundry strung up across streets reveals clues of residents—baby sleepers vs aprons, dresses vs jerseys. In Paris, where hanging laundry is forbidden, you look for other clues—the type of bike stored on the balcony, for example. Or you see the residents themselves—a young girl drying her painted toenails in the sun, or the old lady who smokes ciggies all day long. She only comes down once a week to buy groceries. It's her knees, she says. "My lungs are fine," she defends. So she peers down to the street like a cat—seen but also unseen. Then there is the famous balcony of Juliet in Verona. This Capulet of Shakespearean lore is said to have lived behind this balcony. The lovelorn visit and write letters to Juliet, posting them on the wall—their own romantic version of a weeping wall. These letters are answered by the Club di Giulietta, financed by the city, which is grateful for the tourism Juliet-oh-Juliet brings to Verona.

Of course, my ponderings of the unseen in European cities weren't exactly what Christophe meant. He was referring to the difficulties to stay afloat—of the hours they work just to break even, of the beggars, the pickpockets, the smells of confined populations. All this is true, and it's all there once you step off the welcome mat, or I suppose, when you look beyond the balcony.

Janice

"Parting is such sweet sorrow, that I shall say good night till it be morrow."

William Shakespeare, *Romeo and Juliet*

December 2016, Verona

Dear Áine,

I was extolling the virtues of beautiful European cities to the lovely Christophe
as I am wont to do whenever wanderlust strikes. He, being European, replied
"Beautiful?! Pshaw! It depends on what you see and a lot on what you don't see."
His life in Europe was very different than mine. His was a working-class world,
and when I arrived on European soil, I had a firm foot in the land of tourists. I was
shown the welcome mat, the one rolled out to entice visitors to relieve themselves
of Euros one meal and admission fee at a time. "Look harder," Christophe says.
And that got me thinking about balconies. In the larger cities, people live in apartments
and their only private outdoor space is their balconies. Only from the clues they
reveal to onlookers below can you guess what lives live beyond the
shuttered windows. Naples and its laundry strung up across streets
reveals clues of residents - baby sleepers vs aprons, dresses vs jerseys.
In Paris, where hanging laundry is forbidden, you look for other clues -
the type of bike stored on the balcony, for example. Or you see the
residents themselves — a young girl drying her painted toenails in the
sun, or the old lady who smokes ciggies all day. She only comes
down once a week for groceries. It's her knees, she says.
"My lungs are fine" she defends. So she peers down to the
street like a cat — seen but also unseen. Then there is
the famous balcony of Juliet in Verona. This Capulet
of Shakespearean lore is said to have lived behind this
balcony. The lovelorn visit and write letters to Juliet,
posting them on the wall— their own romantic
version of a weeping wall. These letters are
answered by the "Club di Giulietta," financed
by the city, which is grateful for the tourism
Juliet -oh- Juliet brings to Verona.

Of course, my ponderings of the unseen
in European cities weren't exactly what Christophe
meant. He was referring to the difficulties to stay
afloat —of the hours they work just to break even, of
the beggars, the pickpockets, the smells of confined populations.
All this is true, and it's all there once you step off the
welcome mat, or I suppose, when you look beyond the balcony.

—Janice

L. 170
ITALIA

VERONA C.P.
10·10 1987

Giorno di emissione
PIAZZA DEI SIGNORI

January 2017, Paris

Dear Áine,

Paris is colder than a lot of other cities known for their wintery wonderlands of snow. This is partly because the humidity in Paris makes the city feel colder and partly because Parisians do much of their living outside, not inside, their apartments . . . And this is partly because heating in the apartments is lousy. I swear, Paris apartments are made up of stone and layers of old wallpaper. The administration also recommends airing out your apartment when you leave for the day, adding to the lack of coziness upon your return. On a particularly cold day, I ventured out to explore the covered passages of Paris. These are streets covered by glass roofs so you can shop in warmth on the most frigid of days. There, you'll find antique stores, artisanal bakeries, and even a store dedicated entirely to walking canes. You'll also find a healthy handful of stores for stamp collectors. That's where you'll usually find me. The proprietors appreciate my enthusiasm but are mystified by my purchases. I don't seek the collector editions of stamps, nor do I care how much the stamps are worth. Instead, I sift through boxes of philatelic odds and ends nobody else seems to want. I find these most useful in the collage art I create. It's all about the beauty of the stamp to me. That's its worth. And because the French love to collect bits of paper and ephemera (they never toss anything), after decades these collections eventually end up in quirky shops in Paris awaiting a second life in an art piece by an enthusiastic expat. Anyone can find a treasure in the covered passages—even if it's just a hot chocolate to stay warm on a cool winter day.

Janice

―――――◆―――――

" Miss Petitfour loved the little pictures, each in its own serrated frame, and each seeming to tell its own little story."

Anne Michaels, *The Adventures of Miss Petitfour*

Dear Áine, January 2017, Paris

Paris is colder than a lot of other cities known for their wintery wonderlands of snow. This is partly because the humidity in Paris makes the city feel colder and partly because Parisians do most of their living outside, not inside, their apartments... And this is partly because heating in the apartments is lousy. I swear, Paris apartments are made up of stone and layers of old wallpaper. The administration also recommends airing out your apartment when you leave for the day, adding to the lack of coziness upon your return. On a particularly cold day, I ventured out to explore the covered passages of Paris. These are streets covered by glass roofs so you can shop in warmth on the most frigid of days. There you'll find antique stores, artisanal bakeries, and even a store dedicated entirely to walking canes. You'll also find a healthy handful of stores for stamp collectors. That's where you'll usually find me. The proprietors appreciate my enthusiasm but are mystified by my purchases. I don't seek the collector editions of stamps, nor do I care how much any of the stamps are worth. Instead, I sift through boxes of philatelic odds and ends nobody else seems to want. I find these most useful in the collage art I create. It's all about the beauty of the stamp to me. That's its worth. And because the French love to collect bits of paper and ephemera (they never toss anything), after decades these collections eventually end up in quirky shops in Paris awaiting a second life in an art piece by an enthusiastic expat. Anyone can find a treasure in the covered passages — even if it's just a hot chocolate to stay warm on a cool winter day. — Janice

189

January 2017, Flanders, Belgium

Dear Áine,

The toughest train ride in my European travels was from Paris to Flanders, Belgium. And that's saying something after multiple snafus in Italy (notorious for difficult train travel). The big train from Paris to Lille was easy. Big trains have big signs in big stations. The next train was smaller, with no English, just French. Difficult but doable. The next train was smaller still and it crossed the border into full-on Flemish in Flanders. Platform signs were miniscule and the overhead speaker announcing the stops was crackly at best. I was scared and stressed as I was being hurled through an unknown land. Oddly, the view out the window was familiar. I realized it was familiar because of all the war footage I've seen on TV and in the classroom. This was the same place, but in person. The bones were still there. It was on these trains where soldiers were sent to front lines, these lines where locals escaped capture, these platforms where languages mingled—first French and Flemish, then German, then back to French and Flemish. Not too much English, but some. I calmed down. I wasn't going to war. If I got lost, I got lost. It actually wouldn't be the end of the world as it must have seemed to many who rode these tracks into war. In Ypres, a town in Flanders surrounded by battlefields, there has been a memorial service for soldiers with no known grave every night at 8 pm since 1928 (except during German occupation during WWII). Sometimes there is a marching band and many poppy wreathes are presented. Other times, it's a lone soldier playing a mournful bugle ballad. Either way, it's worth the journey to get there, as challenging as it might be.

Janice

"Many times the wrong train took me to the right place."

Paulo Coelho

January 2017, Flanders, Belgium

Dear Áine,

The toughest train ride in my European travels was from Paris to Flanders, Belgium. And that's saying something after multiple snafus in Italy (notorious for difficult train travel). The big train from Paris to Lille was easy. Big trains have big signs in big stations. The next train was smaller, with no English, just French. Difficult but doable. The next train was smaller still and it crossed the border into full-on Flemish in Flanders. Platform signs were miniscule and the overhead speaker announcing the stops was crackly at best. I was scared and stressed as I was being hurled through an unknown land. Oddly, the view out the window was familiar. I realized it was familiar because of all the war footage I've seen on TV and in the classroom. This was the same place, but in person. The bones were still there. It was on these trains where soldiers were sent to the front lines, these lines where locals escaped capture, these platforms where languages mingled — first French and Flemish, then German, then back to French and Flemish. Not too much English, but some. I calmed down. I wasn't going to war. If I got lost, I got lost. It actually wouldn't be the end of the world as it must have seemed to many who rode these tracks into war. In Ypres, a town in Flanders surrounded by battlefields, there has been a memorial service for soldiers with no known grave every night at 8pm since 1928 (except during German occupation during WWII). Sometimes there is a marching band and many poppy wreaths are presented. Other times, it's a lone soldier playing a mournful bugle ballad. Either way, it's worth the journey to get there, as challenging as it might be.

— Janice

191

Crêpes

February 2017, Paris

Dear Áine,

On February 2nd, we celebrated *la Fête de la Chandeleur*, which is a fancy way of saying it was crêpe day. The French are experts at turning a religious day into a reason to celebrate food. Originally, this day marked 40 days since Jesus' birthday when he was presented at the temple. It's also the day Mary had finished her 40 days of semi-seclusion after giving birth. I can relate to this as I gave birth two weeks ago and could use at least another couple weeks of semi-seclusion. Baby Amélie is doing well and is chunking up nicely. The pagans made crêpes to represent the coming spring—we are out of the darkest days of winter. A crêpe looks like a sun, and I suppose this is the French version of a Groundhog Day. For me, this day reminds me of my first days in Paris—two years before I moved to Paris and strolled down rue Mouffetard to lock eyes on the man who would be Amélie's daddy. I was in Paris for a long weekend in February. It was so cold. Because I was only there for three days, I was on one of my marathon all-day urban hikes, therefore starving. I stopped at a crêpe stand and had my first crêpe. It was filled with Nutella. The hot crêpe on that cold day awakened something within. Up until now I had worked worked worked, and forgotten to take time to indulge. I wasn't even sure I knew how to indulge without guilt. But here, on this cobblestone street in Paris (a 10-minute walk and two years from Christophe), I relearned the art of indulgence. Life has been sweeter ever since.

Janice

"If there's a sexier sound on this planet than the person you're in love with cooing over the crêpes you made for him, I don't know what it is."

Julie Powell, *Julie & Julia*

Dear Áine,

On February 2nd we celebrated la Fête de la Chandeleur, which is a fancy way of saying it was crêpe day. The French are experts at turning a religious day into a reason to celebrate food. Originally, this day marked 40 days since Jesus' birthday when he was presented at the temple. It's also the day Mary had finished her 40 days of semi-seclusion after giving birth. I can relate to this as I gave birth two weeks ago and could use at least another couple weeks of semi-seclusion. Baby Amélie is doing well and is chunking up nicely. The pagans made crêpes to represent the coming spring — we are out of the darkest days of winter. A crêpe looks like a sun, and I suppose this is the French version of a Groundhog Day. For me, this day reminds me of my first days in Paris — Two years before I moved to Paris and strolled down rue Mouffetard to lock eyes on the man who would be Amélie's daddy. I was in Paris for a long weekend in February. It was so cold. Because I was only there for three days, I was on one of my marathon all-day urban hikes, therefore starving. I stopped at a crêpe stand and had my first crêpe. It was filled with Nutella. The hot crêpe on that cold day awakened something within. Up until now I had worked worked worked, and forgotten to take time to indulge. I wasn't even sure I knew how to indulge without guilt. But here, on this cobblestone street in Paris (10 minutes and two years from Christophe) I relearned the art of indulgence. Life has been sweeter ever since.

♡ Janice

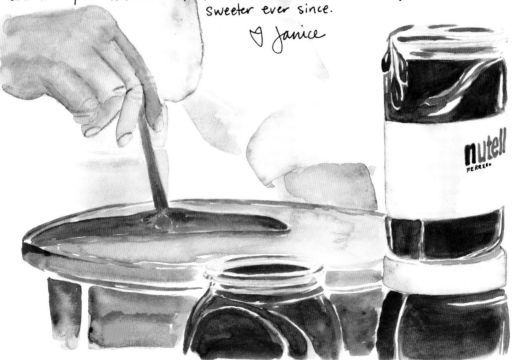

Fromage

March 2017, Paris

Dear Áine,

There is a subtle season in Paris in early spring. Some might even call it a subliminal season. It is the French Tourism Campaign season. It begins when the Salon de l'Agriculture comes to town. This massive farm show features the best of every region of France. Parisians flock to the show to sample oysters from the sea, smell sachets of lavender from Provence, and to see the prize animals that will be responsible for future foie gras, confits, and cheese. Once you've ate and drank your way through the show, and gathered a hefty sum of tourist brochures, you come home, dump your tourist loot on the floor, and turn on the TV to discover a wealth of shows about France—The Prettiest Villages, The Grandest Castles, The Best Beaches, The Top Hotels, etc. . . . All showcasing different regions of France. These shows inevitably feature someone making their regional cheese. There is something hypnotic about watching the gathering of milk, the separation of curds and whey, the pressing of the curds into molds, and the moment in the dark cave when the proprietor pulls a round of cheese off the shelf, then marvels at the magic and aliveness of fungus and fermentation. I've seen it a hundred times and never tire of it. Quite the opposite. I start plotting my French vacation—usually based on cheese! I'm not the only one. The French are notorious for spending their holidays in France. I like to imagine the whole city dropping their dripping umbrellas at the door and beginning a deep study of sunnier days ahead.

Janice

———— ≈ ————

"You will always struggle with not feeling productive until you accept that your own joy can be something you produce. It is not the only thing you will make, nor should it be, but it is something valuable and beautiful."

Hank Green, *A Beautifully Foolish Endeavor*

March 2017, Paris

Dear Áine,

There is a subtle season in Paris in early spring. Some might even call it a subliminal season. It is the French Tourism campaign season. It begins when the Salon de l'Agriculture comes to town. This massive farm show features the best of every region of France. Parisians flock to the show to sample oysters from the sea, smell sachets of lavender from Provence, and see the prize animals that will be responsible for future foie gras, confits, and cheese. Once you've ate and drank your way through the show, and gathered a hefty sum of tourist brochures, you come home, dump your tourist loot on the floor, and turn on the TV to discover a wealth of shows about France — The Prettiest Villages, The Grandest Castles, The Best Beaches, The Top Hotels, etc... All showcasing different regions of France. These shows inevitably feature someone making their regional cheese.

There is something hypnotic about watching the gathering of milk, the separation of curds and whey, the pressing of the curds into molds, and the moment in the dark cave when the proprietor pulls a round of cheese off the shelf, then marvels at the magic and aliveness of fungus and fermentation. I've seen it a hundred times and never tire of it. Quite the opposite. I start plotting my French vacation — usually based on cheese! I'm not the only one. The French are notorious for spending their holidays in France. I like to imagine the whole city dropping their dripping umbrellas at the door and beginning a deep study of summer days ahead.

—Janice

Roquefort

Neufchâtel

Saint-Agur

Burrata

Chèvre

Valençay

Morbier

Brie

Comté

Camembert

195

Macaron Secrets

April 2017, Paris

Dear Áine,

The macaron craze is a little out of control in Paris. Not so long ago this pretty pastel pastry came in typical *vanille, chocolat*, and if you were feeling wild, *pistache*—and you only ordered it because it was fun to say *"Pistache!"* But now, it seems you need a minor in French language studies to order your macaron: *cassis violette, cédrat, épices et fruit moelleux*. When did it all get so complicated? I think a pastry chef along the way discovered a cold hard truth and decided to exploit it, and that is that the appeal of the macaron isn't so much taste or texture. It's in the collecting of them all—the patisserie version of trading cards. I'll admit I fell for it, stopping at various shops around Paris for a spontaneous sample of the latest or prettiest macaron of the day. You know what I discovered? That *réglisse* is black licorice (yuck) and *vanille* is pure perfection.

Who would have guessed that the plain Jane vanilla would win out over hotshots like *chocolat griotte* (chocolate with cherry) and *fleur d'oranger* (orange blossom)? So now when I stop by a patisserie, I boldly order *"Vanille!"* Other customers look at me oddly, but not the pastry chef. He gives me a smile and a wink, like I discovered the best-kept secret of this curious confection.

Janice

<div align="center">✦ ──── ✦</div>

"In the dark beside me, she smelled of sweat and sunshine and vanilla . . ."

John Green, *Looking for Alaska*

Dear Áine, April 2017, Paris

The macaron craze is a little out
of control in Paris. Not so long ago
this pretty pastel pastry came in
typical Vanille, Chocolat, and if you
were feeling wild, Pistache — and you only ordered it because
it was fun to say "Pistache!" But now, it seems you need a
minor in French language studies to order your macaron:
Cassis Violette, Cédrat, Épices et Fruit Moelleux. When did
it all get so complicated? I think a pastry chef along the way
discovered a cold hard truth and decided to exploit it, and that
is that the appeal of the macaron isn't so much taste or texture.
It's in the collecting of them all — the patisserie version of
trading cards. I'll admit I fell for it, stopping at various shops
around Paris for a spontaneous sample of the latest or
prettiest macaron of the day. You know what I discovered?
That Réglisse is Black Licorice (yuck) and Vanille
is pure perfection.

Who would have guessed that the plain Jane Vanilla
would win out over hotshots like Chocolat Griotte (chocolate
with cherry) and Fleur d'Oranger (orange blossom). So now when
I stop by a patisserie, I boldly order "Vanille!" Other customers
look at me oddly, but not the pastry chef. He gives me a smile and
a wink, like I discovered the best-kept secret of this curious confection.

 - Janice

Café Tabac

May 2017, Paris

Dear Áine,

By the time you read this, the French elections will have likely been decided and we will have a new president of the Fifth Republic of France. What I find fascinating about this election is that one candidate is basically wanting things to stay the same (stay with the European Union) and one candidate wants things to go back in time (leave the Union and bring back the franc). There are other promises made as well, but TO STAY or TO GO BACK are the big themes. No one seems eager to vote for NEW or CHANGE, which is so French. The French have never been big on change. Why should they? They know the glories of what happens when you leave things alone to sit, simmer, and stew—cheese and wine are two great examples of this.

As an expat, I have no say in the matter as I don't have the right to vote. The only side I can choose is which side of the street to sit on so I can sketch the café opposite me. On these warm May days, lingering on *la terrasse* can turn a coffee break into a painted letter.

Au revoir!

Janice

"One wanders to the left, another to the right. Both are equally in error, but, are seduced by different delusions."

Horace

Dear Áine,

By the time you read this, the French elections will have likely been decided and we will have a new president of the Fifth Republic of France. What I find fascinating about this election is that one candidate is basically wanting things to stay the same (stay with the European Union) and one candidate wants things to go back in time (leave the Union and bring back the franc). There are other promises made as well, but TO STAY or TO GO BACK are the big themes. No one seems eager to vote for NEW or CHANGE, which is so French. The French have never been big on change. Why should they? They know the glories of what happens when you leave things alone to sit, simmer, and stew — cheese and wine are two great examples of this.

As an expat, I have no say in the matter as I don't have the right to vote. The only side I can choose is which side of the street to sit on so I can sketch the café opposite me. On these warm May days, lingering on la terrasse can turn a coffee break into a painted letter.

Au Revoir!
Janice

199

Berthillon

June 2017, Paris

Dear Áine,

It's summer, which means I must get to the ice cream shop before it closes for the season. Yes, Berthillon, the famous ice cream shop in Paris, closes its doors in July and August. The owner figures his staff needs a summer holiday just like everyone else. Plus, they make plenty of ice cream in anticipation of a hot Paris summer. They have vendors sell it in other shops while they themselves likely sample other *crème glacée* along the beaches of the Mediterranean. Berthillon is on Île Saint-Louis, an island in the middle of Paris. This island has a parade of shops down the middle vein, each more lovely than the last.

There is an olive oil shop, an art gallery, a perfume shop, a stationery shop, a clock shop, an old-fashioned hat shop, and a soap store with soaps so beautiful you want them all—not to use, but to display. Walking along, one can't help but feel like these stores are tipped over treasure chests, chocked full of sparkly loot. Sure, they are designed to mesmerize tourists and relieve them of their discretionary fund, but that's fine. I prefer window-shopping, or as the French say, *lèche-vitrine*, window licking, as I lick the latest tasty treat from Berthillon *glacier*.

Janice

*"If your arteries are good, eat more ice cream. If they
are bad, drink more red wine. Proceed thusly."*

Sandra Byrd, *Bon Appetit*

Dear Áine, June 2017, Paris

It's summer, which means I must get to the ice cream shop before it
closes for the season. Yes, Berthillon, the famous ice cream shop in Paris,
closes its doors in July and August. The owner figures his staff needs a
summer holiday just like everyone else. Plus, they make plenty of ice cream
in anticipation of a hot Paris summer. They have vendors sell it in other shops
while they themselves likey sample other crème glacée along the beaches
of the Mediterranean. Berthillon is on Île Saint-Louis, an island in the
middle of Paris. This island has a parade of shops down the middle vein,
each more lovely than the last.

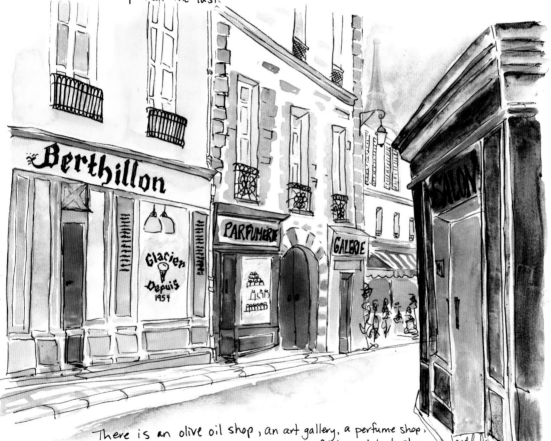

 There is an olive oil shop, an art gallery, a perfume shop,
 a stationery shop, a clock shop, an old-fashioned hat shop,
 and a soap store with soaps so beautiful you want them all—
not to use, but to display. Walking along, one can't help but feel like these
stores are tipped over treasure chests, chocked full of sparkly loot. Sure, they
are designed to mesmerize tourists and relieve them of their discretionary
fund, but that's fine. I prefer window-shopping, or as the French say, lèche-vitrine,
window licking, as I lick the latest tasty treat from Berthillon glacier.
 —Janice

Shakespeare and Company Café

July 2017, Paris

Dear Áine,

Shakespeare and Company is one of those magical places in Paris that feel like a closely guarded secret, even though everyone knows about it. This English bookstore across the river from Notre Dame has been my go-to literary haunt since the day I arrived in Paris. Recently, the proprietor, Sylvia, opened a café next to the bookshop. I was eager to merge my two loves—books and coffee. I envisioned finding a corner table and reading a new book purchased next door while sipping a creamy coffee. Ha! NOT SO. Evidently, I wasn't the only expat in town with this plan. When I arrived, the place was crammed with clients slouching over grub, being all hip and supportive of this new business venture. There was even a long line! What a letdown.

The Japanese have a term for this disappointment—*Pari Shōkōgun*—literally Paris Syndrome. It's a mental disorder brought on by extreme shock by Japanese tourists who discover Paris isn't what they expected it to be. Extreme disappointment is a <u>condition</u>! The Japanese are known to be especially susceptible—a mix of language barriers, cultural differences, exhaustion, and especially an idealized image of Paris—like, for instance, expecting a quiet coffee at a café and instead getting hordes of tourists who couldn't shove a cheek even if they wanted to! Oh well. C'est la vie.

Janice

"It is clear that the books owned the shop rather than the other way about. Everywhere they had run wild and taken possession of their habitat, breeding and multiplying, and clearly lacking any strong hand to keep them down."

Agatha Christie, *The Clocks*

Dear Áine,

Shakespeare and Company is one of those magical places in Paris that feel like a closely guarded secret, even though everyone knows about it. This English bookstore across the river from Notre Dame has been my go-to literary haunt since the day I arrived in Paris. Recently, the Propietor, Sylvia, opened a café next to the bookshop. I was eager to merge my two loves — books and coffee. I envisioned finding a corner table and reading a new book purchased next door while sipping a creamy coffee. Ha! NOT SO. Evidently, I wasn't the only expat in town with this plan. When I arrived, the place was crammed with clients slouching over grub, being all hip and supportive of this new business venture. There was even a long line! What a let down.

The Japanese have a term for this disappointment — Pari shōkōgun — literally Paris Syndrome. It's a mental disorder brought on by extreme shock by Japanese tourists who discover Paris isn't what they expected it to be. Extreme disappointment is a condition! The Japanese are known to be especially suseptible — a mix of language barriers, cultural differences, exhaustion, and especially an idealized image of Paris — like, for instance, expecting a quiet coffee at a café and instead getting hordes of tourists who couldn't shove a cheek even if they wanted to! Oh well. C'est la vie.

— Jania

Place des Vosges

August 2017, Paris

Dear Áine,

Greetings from Place des Vosges—a lovely little park in the middle of the hip Marais in the 4th arrondissement. People tend to go on about this picturesque park—so much so that it's a bit of a letdown upon arrival. It's thick with history—built by one king on the site where another king died in a jousting tournament, and more recently, the residence of Victor Hugo. I like it for the big trees, and therefore, generous shade. Paris is thick with heat and humidity at this time of the year, so those who choose to stay in August tend to hop from one shade to the next. Most people leave for a long vacation by the sea, so Paris is quiet—a perfect time for reading books and writing letters—and being lulled by the sound of babbling fountains. *C'est parfait, n'est-ce pas?*

Janice

"He never went out without a book under
his arm, and he often came back with two."

Victor Hugo, *Les Misérables*

Dear Áine,

August 2017, Paris

Greetings from Place des Vosges ~ a lovely little park in the middle of the hip Marais in the 4th arrondissement. People tend to go on about this picturesque park ~ so much so that it's a bit of a let down upon arrival. It's thick with history — built by one king on the site where another king died in a jousting tournament, and more recently, the residence of Victor Hugo. I like it for the big trees, and therefore, generous shade. Paris is thick with heat and humidity at this time of the year, so those who choose to stay in August tend to hop from one shade to the next. Most people leave for a long vacation by the sea, so Paris is quiet ~ a perfect time for reading books and writing letters —and being lulled by the sound of babbling fountains. C'est parfait, n'est-ce pas?

—Janice

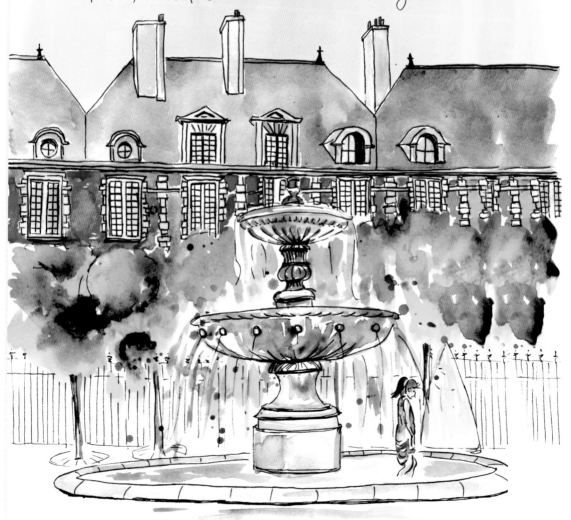

Petit Écolier

September 2017, Paris

Dear Áine,

I think, secretly, September is the best time of the year for most Parisians. Everyone is feeling rejuvenated after a month of sunny beach days in the south of France. It's the best feeling until boredom sets in and the family is getting on your nerves. Then it's time to pack the bags and return to usefulness and purpose. Each morning the *fromager* walks his children up the street to school. They stop at the boulangerie for a croissant, then stop at the *boucherie* to say hello to Christophe. He has been greeting them each school morning for six years, which is a long time to a child. The *fromager* returns to the shop to start his day, and at the end of the school day he does a reverse commute to fetch the children. They return home for *le goûter*. This is the afternoon meal. French children have four meals. Somehow calling snack time a meal gives it more importance. Often these meals include cookies, most notably *le petit écolier*—a shortbread cookie topped with a layer of chocolate stamped with the image of a schoolboy. Personally, I don't miss many afternoon teas without one of these cookies. Perhaps they were the subconscious reason I decided to take a cooking class at École de Cuisine from famed chef Alain Ducasse. If you learn anything while sunning in Saint-Tropez, it's that fish first swim in the sea, then in olive oil, then in wine. I figured it was time to learn the second swim. I'm already well-versed at the third. After class, I received a certificate and came home beaming with pride—and a bit peckish for something sweet. You know exactly what cookie I had in mind.

Janice

"I envy the table its scars, the scorch marks caused by the hot bread tins. I envy its calm sense of time, and I wish I could say: I did this five years ago. I made this mark, this ring caused by a wet coffee cup, this cigarette burn, this ladder of cuts against the wood's coarse grain . . . I did this on a warm day seven summers ago with the carving knife . . . I envy the table's calm sense of place. It has been here a long time. It belongs."

Joanne Harris, *Chocolat*

September 2017, Paris

Dear Áine,

I think, secretly, September is the best time of year for most Parisians. Everyone is feeling rejuvenated after a month of sunny beach days in the south of France. It's the best feeling until boredom sets in and the family is getting on your nerves. Then it's time to pack the bags and return to usefulness and purpose. Each morning the fromager walks his children up the street to school. They stop at the boulangerie for a croissant, then stop at the boucherie to say hello to Christophe. He has been greeting them each school morning for six years, which is a long time to a child. The fromager returns to the shop to start his day, and at the end of the school day he does a reverse commute to fetch the children. They return home for le goûter. This is the afternoon meal.

French children have four meals. Somehow calling snack time a meal gives it more importance. Often these meals include cookies, most notably le petit écolier — a shortbread cookie topped with a layer of chocolate stamped with the image of a school boy.

Personally, I don't miss many afternoon teas without one of these cookies. Perhaps they were the subconscious reason I decided to take a cooking class at École de Cuisine from famed chef Alain Ducasse. If you learn anything while sunning in Saint-Tropez, it's that fish first swim in the sea, then in olive oil, then in wine. I figured it was time to learn the second swim. I'm already well-versed at the third. After class, I received a certificate and came home beaming with pride — and a bit peckish for something sweet. You know exactly what cookie I had in mind.

— Janice

Le Boucher

October 2017, Paris

Dear Áine,

The old butcher is back in Paris. He owned the butcher shop in front of my building for more years than anyone can remember—that is, until July when he put it up for sale, slapped a FERMÉ sign on the door, and took off to the coast to bask in his newfound freedom. The last time I saw him he was straddling his motorcycle, arms crossed, leaning back and telling Christophe his retirement plans.

I remember marveling at the butcher's moustache. It was so bushy it seemed to do all the talking for him, and his matching brows seem to agree emphatically with his opinion. Anyway, he's back. Retirement didn't work. He missed his clients and his daily workout of hauling meat around the store all day. He took a job up the street at the other butcher shop. All the glory and none of the pressure of ownership. He is so very reflective of Paris itself—it changes, but ever so slowly. So slowly you hardly notice time go by. Were it not for nature stepping in and showing off autumn hues, then winter wind and rain, spring and the flowers, summer and heat, we'd feel we were in a time capsule. Then again, if you're going to live in a time capsule, Paris is a pretty good choice.

Janice

"Paris, I believe, is a man in his twenties in love with an older woman."

John Berger

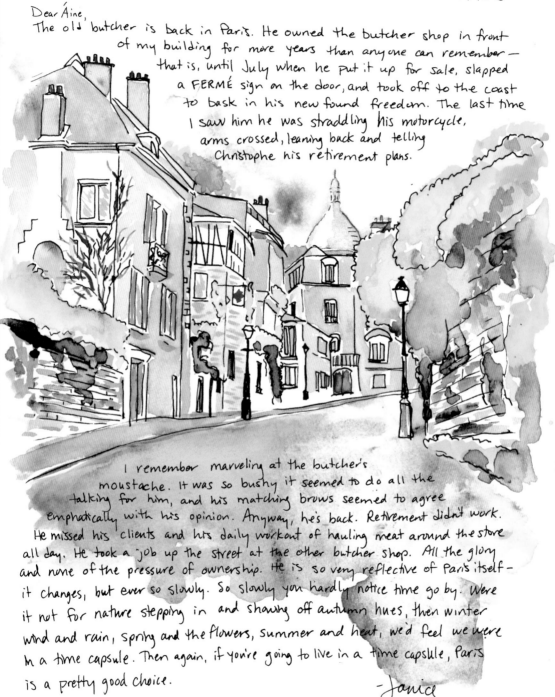

October 2017, Paris

Dear Áine,

The old butcher is back in Paris. He owned the butcher shop in front of my building for more years than anyone can remember — that is, until July when he put it up for sale, slapped a FERMÉ sign on the door, and took off to the coast to bask in his new found freedom. The last time I saw him he was straddling his motorcycle, arms crossed, leaning back and telling Christophe his retirement plans.

I remember marveling at the butcher's moustache. It was so bushy it seemed to do all the talking for him, and his matching brows seemed to agree emphatically with his opinion. Anyway, he's back. Retirement didn't work. He missed his clients and his daily workout of hauling meat around the store all day. He took a job up the street at the other butcher shop. All the glory and none of the pressure of ownership. He is so very reflective of Paris itself — it changes, but ever so slowly. So slowly you hardly notice time go by. Were it not for nature stepping in and showing off autumn hues, then winter wind and rain, spring and the flowers, summer and heat, we'd feel we were in a time capsule. Then again, if you're going to live in a time capsule, Paris is a pretty good choice.

—Janice

Sorbonne

November 2017, Paris

Dear Áine,

I have wanted to be a student at the Sorbonne ever since I heard about this artsy
university in the book *Little Women* by Louisa May Alcott. In the book, the youngest
sister travels to Paris to take painting classes. I thought that would be the best life I
could ever imagine for myself. So, when through luck and lust, I ended up living in
Paris, I investigated classes. To my shock and horror, one must be fluent in French to
understand the professors. In my fantasy, I would understand everything and charm
them with my cute English accent. So I investigated French classes but was scared
off when a friend of mine (now bilingual) told me of the vigorous curriculum. *Non
merci*. Instead, I opted for an education via osmosis. I sauntered through museums
and galleries, soaking up inspiration and techniques along the way. I also sat in cafés
outside the Sorbonne to watch students sketch and chat. Some of their sketches left me
breathless and seething with jealousy at their seemingly natural (or supernatural) talent.
It was in these cafés where I also realized that the little women of the Sorbonne spoke
French so quickly and with so many expressions and slang that I'm sure I would have
been lost and lonely had I enrolled. So that's it then. This little woman will continue
painting her own little paintings and writing her letters on them—IN ENGLISH.

Janice

≈

*"I'm not afraid of storms, for I'm learning
how to sail my ship."*

Louisa May Alcott, *Little Women*

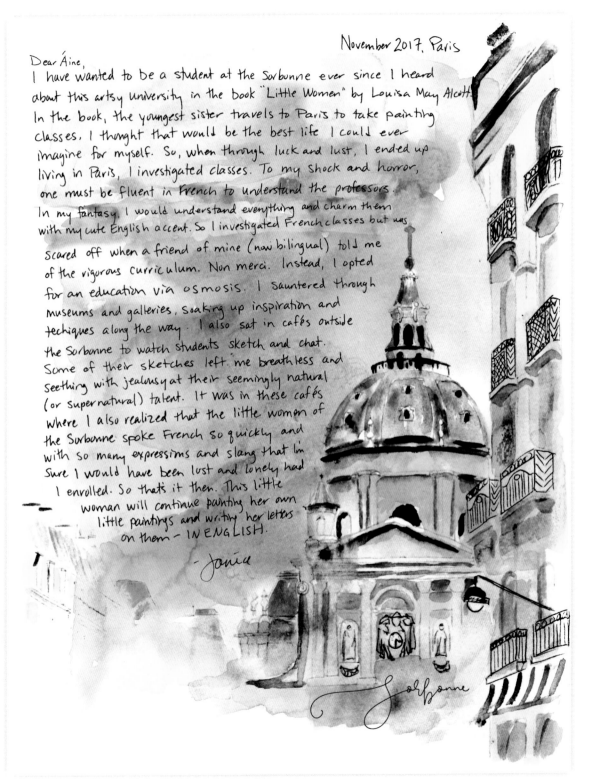

November 2017, Paris

Dear Áine,

I have wanted to be a student at the Sorbonne ever since I heard about this artsy university in the book "Little Women" by Louisa May Alcott. In the book, the youngest sister travels to Paris to take painting classes. I thought that would be the best life I could ever imagine for myself. So, when through luck and lust, I ended up living in Paris, I investigated classes. To my shock and horror, one must be fluent in French to understand the professors. In my fantasy, I would understand everything and charm them with my cute English accent. So I investigated French classes but was scared off when a friend of mine (now bilingual) told me of the rigorous curriculum. Non merci. Instead, I opted for an education via osmosis. I sauntered through museums and galleries, soaking up inspiration and techiques along the way. I also sat in cafés outside the Sorbonne to watch students sketch and chat. Some of their sketches left me breathless and seething with jealousy at their seemingly natural (or supernatural) talent. It was in these cafés where I also realized that the little women of the Sorbonne spoke French so quickly and with so many expressions and slang that I'm sure I would have been lost and lonely had I enrolled. So that's it then. This little woman will continue painting her own little paintings and writing her letters on them — IN ENGLISH.

— Janice

Bar de la Croix Rouge

December 2017, Paris

Dear Áine,

I'm writing to you from Bar de la Croix Rouge—the Red Cross Bar—which is fitting as I think I've done irreparable damage to my feet and may be in need of First Aid. The medicine this bar doles out comes in the form of wine, a big meal, and comfy chairs to rest my weary self. I've been Christmas shopping. Though I have walked many miles—zigzagging from side to side of the twinkling streets—my Christmas list hasn't shrunk and my list of desires has grown much longer. Just admiring the ornaments in one store had me on my feet for an hour, and the handcrafted leather journal store, another hour. And don't get me started on the dazzling EVERYTHING in the department stores. They sure know how to woo a girl. I'm spent, have spent, and still have more spending to do. Generally, I'm a minimalist, but Paris at Christmas has me drunk on the delights of the material world. It *might* be the wine.

I wish you a very *Joyeux Noël*. May your year ahead be filled with beauty, culinary delights, and very comfy shoes.

Janice

"The lamp is burning low upon my tabletop
The snow is softly falling
The air is still in the silence of my room
I hear your voice softly calling
If I could only have you near
To breathe a sigh or two
I would be happy just to hold the hands I love
On this winter night with you"

Gordon Lightfoot, "Song for a Winter's Night"

Dear Áine,

I'm writing to you from Bar de la Croix Rouge - the Red Cross Bar - which is fitting as I think I've done irreparable damage to my feet and may be in need of First Aid. The medicine this bar doles out comes in the form of wine, a big meal, and comfy chairs to rest my weary self. I've been Christmas shopping. Though I have walked many miles — zigzagging from side to side of the twinkling streets — my Christmas list hasn't shrunk and my list of desires has grown much longer. Just admiring the ornaments in one store had me on my feet for an hour, and the handcrafted leather journal store, another hour. And don't get me started on the dazzling EVERYTHING in the department stores. They sure know how to woo a girl. I'm spent. have spent, and still have more spending to do. Generally, I'm a minimalist, but Paris at Christmas has me drunk on the delights of the material world. It *might* be the wine.

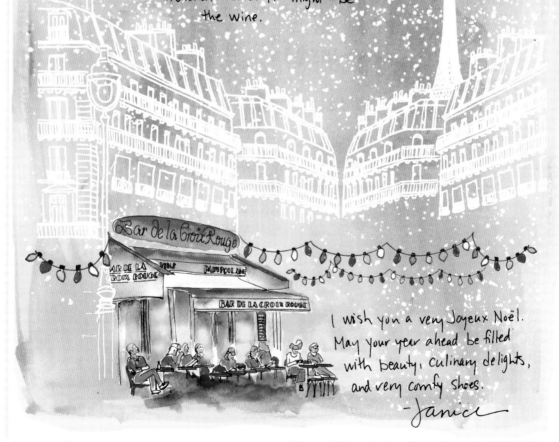

I wish you a very Joyeux Noël. May your year ahead be filled with beauty, culinary delights, and very comfy shoes.

—Janice

213

Les Amis

January 2018, Paris

Dear Áine,

The first year in Paris for an expat isn't always smooth. There is the language, local customs, and notoriously difficult paperwork—all challenging in their own way. But it's the loneliness that suffocates—always a table for one, holidays in front of the TV in a drafty apartment, the awkwardness of seemingly endless small talk until bonds are formed. In the moment, it feels like an expat problem and that all French people know each other and spend endless evenings talking together behind glass walls we can't penetrate.

But this isn't the case. There are many lonely French in Paris, too. On New Year's Eve, a handful of Christophe's colleagues meet at the local bar—a motley crew of single young people who don't have the time or money to visit family over the holidays. The baker shows up with bread and dessert; the cheese guy arrives with a selection of cheeses; Christophe, who roasts the chickens at the butcher shop, arrives with roasted chicken; and the rest of us round out the meal with olives, crackers, foie gras, and other vittles collected in the day. A feast!

One would think we've known each other for years, but in some cases, only the face is familiar and has been invited by someone who was once the new face on the street. It is a beautiful way to ring in the new year, and often is the turning point from a life of loneliness to a life of friendships. And so I wish you a Happy New Year filled with those you can eat, drink, and laugh with all year long.

Janice

———————— ❖ ————————

"To be fully seen by somebody, then, and be loved anyhow—
this is a human offering that can border on miraculous."

Elizabeth Gilbert, *Committed*

Dear Áine,

The first year in Paris for an expat isn't always smooth. There is the language, local customs, and notoriously difficult paperwork — all challenging in their own way. But it's the loneliness that suffocates — always a table for one, holidays in front of the TV in a drafty apartment, the awkwardness of seemingly endless small talk until bonds are formed. In the moment, it feels like an expat problem and that all French people know each other and spend endless evenings talking together behind glass walls we can't penetrate.

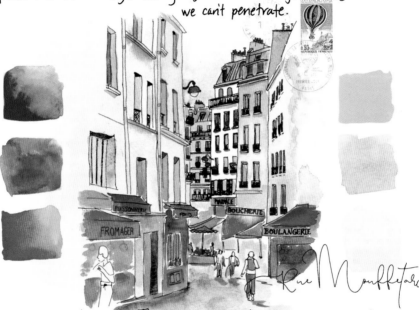

Rue Mouffetard

But this isn't the case. There are many lonely French in Paris, too. On New Year's Eve, a handful of Christophe's colleagues meet at the local bar — a motley crew of single young people who don't have the time or money to visit family over the holidays. The baker shows up with bread and dessert; the cheese guy arrives with a selection of cheeses; Christophe, who roasts the chickens at the butcher shop, arrives with roasted chicken; and the rest of us round out the meal with olives, crackers, foie gras, and other vittles collected in the day. A feast!

One would think we've known each other for years, but in some cases, only the face is familiar and has been invited by someone who was once the new face on the street. It is a beautiful way to ring in the new year, and often is the turning point from a life of loneliness to a life of friendships. And so I wish you a Happy New Year filled with those you can eat, drink, and laugh with all year long.

—Janice

February 2018, Paris

Dear Áine,

A writer in Paris needs three things: A good pen, good shoes, and a good view. I was discussing the pen thing with another pen nut in front of the pen wall at our local stationery shop. I told her I can't write, nor hardly even think, without a good pen. She nodded. *"Poubelle immédiatement!"* and gestured tossing substandard pens in the trash. As for the good shoes, every writer worth his salt knows walking is a great way to avoid the blank page and let ideas marinate so he doesn't return to another blank page, which is infinitely worse than the first. And the good view, it doesn't have to be some breathtaking vista overlooking a valley of blossoms. A café with a decent hum of activity will do. However, writers can be extremely persnickety about which café and when. For instance, on a sunny day, I'll sit on the terrace of Café de Flore. The tables are spaced out and I find the elbow room agreeable. However, when the crazy lady is squawking on the street outside the bookstore to the left, I choose Les Deux Magots to the right, but inside. The chairs outside are too close together and I feel people looking over my shoulder. If it's too late for coffee I'll walk a hundred paces further for wine at Le Bonaparte. Seems more festive there in the evening. The waiters all over Paris generally let you sit wherever you want, likely because we all have weird preferences based on temperature, ambiance, or whoever might be squawking nearby.

Janice

"'No thank you,' I said. 'I don't want to accept a drink from you, because then I would be obliged to purchase one for you in return, and I'm afraid I'm simply not interested in spending two drinks' worth of time with you.'"

Gail Honeyman, *Eleanor Oliphant Is Completely Fine*

literati café

Dear Áine,

A writer in Paris needs three things: A good pen, good shoes, and a good view. I was discussing the pen thing with another pen nut in front of the pen wall at our local stationery shop. I told her I can't write, nor hardly even think, without a good pen. She nodded. "Poubelle immédiatement!" and gestured tossing substandard pens in the trash. As for the good shoes, every writer worth his salt knows walking is a great way to avoid the blank page and let ideas marinate so he doesn't return to another blank page, which is infinitely worse than the first. And the good view, it doesn't have to be some breathtaking vista overlooking a valley of blossoms. A café with a decent hum of activity will do. However, writers can be extremely persnickity about which café and when. For instance, on a sunny day, I'll sit on the terrace of Café de Flore. The tables are spaced out and I find the elbow room agreeable. However, when the crazy lady is squawking on the street outside the bookstore to the left, I choose Les Deux Magots to the right, but inside. The chairs outside are too close together and I feel people looking over my shoulder. If it's too late for coffee I'll walk a hundred paces further for wine at Le Bonaparte. Seems more festive there in the evening. The waiters all over Paris generally let you sit wherever you want, likely because we all have weird preferences based on temperature, ambiance, or whoever might or might not be squawking nearby.

Janice

217

March 2018, Paris

Dear Áine,

The big news this month in Paris was the flood. The Seine rose, rose, rose due to excessive rains. I'd like to think it was France crying over the loss of the great French chef Paul Bocuse and the great French crooner Johnny Hallyday. Much was made of the flood on TV, but locals know it wasn't such a big deal. First, flooding happens more often than not. Second, the city plans for it. Oh how I shook my head at the many Before and After pictures of the flood. What you need to see is the Before, After, and After the After picture to see the genius of French horticulturalists.

For instance, there is a lovely little park at the base of Île de la Cité—the island in the middle of Paris. It was submerged during the flood and foreigners gasped at the tragedy of it all. But here's what happens after the water recedes: Gardeners come in and hose off the benches (which must be bolted to the earth's core because they never float away), they fluff up the grass with rakes and give it a good dose of fertilizer, then they plant flowers. The flowers are planted in full bloom. You see, they were born and bred in a nearby greenhouse. When you arrive at the park a few weeks after the flood, it not only looks undamaged, but it looks like it's positively flourishing! You then realize the park is really just a big plant box. And when you've lived in Paris long enough, you discover even more of these situations and see that, in fact, the entire city is one big plant box. *Incroyable!*

Janice

―――― ≈ ――――

"Sometimes you're swimming in unwept tears
and you'll go under if you store them up inside."

Nina George, *The Little Paris Bookshop*

March 2018, Paris

Dear Áine,

The big news this month in Paris was the flood. The Seine rose, rose, rose due to excessive rains. I'd like to think it was France crying over the loss of the great French chef Paul Bocuse and the great French crooner Johnny Hallyday. Much was made of the flood on TV, but locals know it wasn't such a big deal. First, flooding happens more often than not. Second, the city plans for it. Oh how I shook my head at the many Before and After pictures of the flood. What you need to see is the Before, After, and After the After picture to see the genius of French horticulturalists.

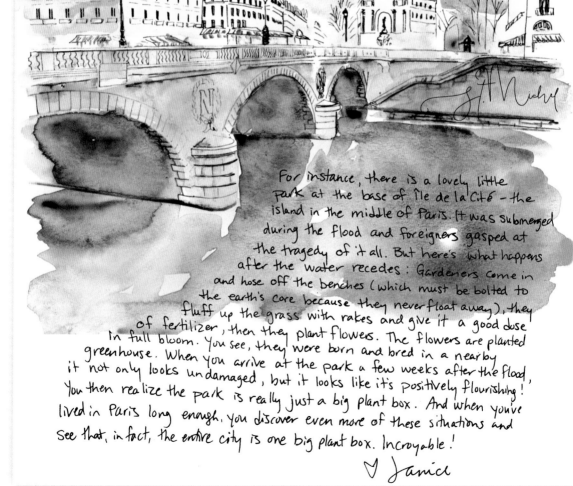

For instance, there is a lovely little park at the base of Île de la Cité – the island in the middle of Paris. It was submerged during the flood and foreigners gasped at the tragedy of it all. But here's what happens after the water recedes: Gardeners come in and hose off the benches (which must be bolted to the earth's core because they never float away), they fluff up the grass with rakes and give it a good dose of fertilizer, then they plant flowers. The flowers are planted in full bloom. You see, they were born and bred in a nearby greenhouse. When you arrive at the park a few weeks after the flood, it not only looks undamaged, but it looks like it's positively flourishing! You then realize the park is really just a big plant box. And when you've lived in Paris long enough, you discover even more of these situations and see that, in fact, the entire city is one big plant box. Incroyable!

♡ Janice

219

Jardin du Luxembourg

April 2018, Paris

Dear Áine,

No matter how many springs you experience in Paris, you're always struck by the dazzle of the hundreds of blooming trees. Just this morning I stood beneath a canopy of white blooms and listened to the hum of a thousand bees happily floating from bloom to bloom. One doesn't need to fear being stung—they are too preoccupied to even notice my eavesdropping. Then I continued on my annual Macaron Day urban hike. Each year a handful of patisseries give away macarons for a donation to charity. After floating from patisserie to patisserie . . . let's just say I'm practically a philanthropist. Now I'm nursing weary feet and a sugar crash in the park. As I gaze out over the greens and the profusely pillared palace, I notice they've pulled the hot weather plants out of the orangerie and placed them around the garden. Soon the orangerie will be transformed into an art gallery for the season. A brilliant idea. Another brilliant idea is the apiary on the edge of the garden. When the bees are full, they'll head over to transform nectar into honey—right here in the middle of this bustling metropolis.

Paris is full of examples of inspired thought that becomes reality—the park design, Macaron Day, and in my case, my brilliantly designed urban hikes (if I may be so bold). It is great fun to create themed urban hikes for self. I suppose I should market them—make a thing of it—but why ruin a good walk with small talk with strangers? I'd much rather converse with my inner self, listen to bees, and at the end of the walk, write a letter to you.

Janice

———✦———

"The only thing that could spoil a day was people and if you could keep from making engagements, each day had no limits."

Ernest Hemingway, *A Moveable Feast*

Dear Áine, April 2018, Paris

No matter how many springs you experience in Paris, you're always struck by the
dazzle of the hundreds of blooming trees. Just this morning I stood beneath a
canopy of white blooms and listened to the hum of a thousand bees happily floating
from bloom to bloom. One doesn't need to fear being stung — they are too preoccupied
to even notice my eavesdropping. Then I continued on my annual Macaron Day urban
hike. Each year a handful of patisseries give away macarons for a donation to charity.
After floating from patisserie to patisserie... let's just say I'm practically a philanthropist.
Now I'm nursing weary feet and a sugar crash in the park. As I gaze out over the
greens and the profusely pillared palace, I notice they've pulled the hot weather
plants out of the orangerie and placed them around the garden. Soon the orangerie
will be transformed into an art gallery for the season. A brilliant idea. Another
brilliant idea is the apiary on the edge of the garden. When the bees are full,
they'll head over to transform nectar into honey— right here
In the middle of this bustling metropolis.

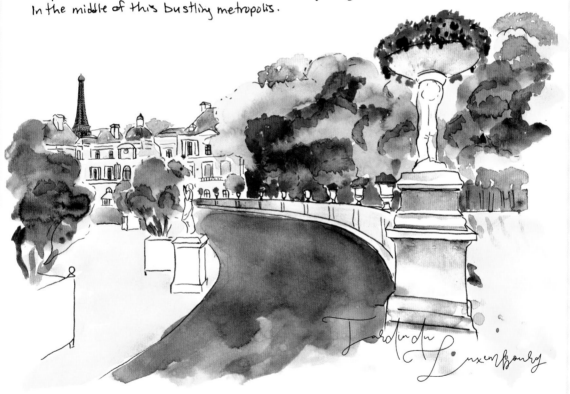

Jardin du Luxembourg

Paris is full of examples of inspired thought that becomes reality— the park design,
Macaron Day, and in my case, my brilliantly designed urban hikes (if I may be so bold).
It is great fun to create themed urban hikes for self. I suppose I should market them—make
a thing of it— but why ruin a good walk with small talk with strangers? I'd much rather
converse with my inner self, listen to bees, and at the end of the walk, write a letter to you.

 —Janice

May 2018, Paris

Dear Áine,

If the French can complicate matters, they will. They are notorious for being difficult with the general administration required of living in France. It seems they want to make it difficult for you to live here, even if you're FROM here. Even getting a package delivered becomes a scavenger hunt around Paris. Recently, I received a delivery slip in the mail. It had an address scratched on it. This was where I would find my package. My Amazon packages usually get delivered to a small fruit market. My photos are delivered to an eyeglass boutique. And my recent purchase of comfy ballerina flats was delivered to a chocolate shop. The proprietor of the shop seemed shocked to see me. I handed her the slip. She listlessly glanced at the pile of boxes in the corner and said, *"Non."* My package wasn't there. As luck . . . (luck?) would have it, my package was on top. I saw my name clearly marked on the box. She almost didn't believe me, and she seemed reluctant to hand it over. With the package still in her hand, she asked if I'd like a sample of her lemon chocolate. Sure, and the package please. The chocolate was lovely—truly the great mix of tart lemon and sweet chocolate. She proceeded to tell me how it took days to make. Many steps. Precise timing. Curing was involved. It had a shiny glaze. I nodded and pretended to savor the chocolate that already went down the hatch. How much for this ONE chocolate? 7 Euros! *Oh la la la la la la! Non merci!* It was my turn to look shocked. She handed me my package and offered me another version of this treat. Tasted the same. Didn't have the shiny glaze. How much? Same price as all the other chocolates in the shop . . . about 50 centimes. Same chocolate, but that glaze must have been imported from a great distance. Perhaps she, like me, had to spend half the day traipsing around Paris to track down the shipment. *Qui sait?*

Janice

"Working from home has its obvious advantages; namely, you don't have to brave the crowds on the morning métro to get to work, and you're home to accept packages, a boon in Paris, where getting deliveries can turn into a second full-time job."

David Lebovitz, *L'appart: The Delights and Disasters of Making My Paris Home*

Dear Áme, May 2018, Paris

If the French can complicate matters, they will. They are notorious for being difficult
with the general administration required of living in France. It seems they want to
make it difficult for you to live there — even if you're FROM here. Even getting a
package delivered becomes a scavenger hunt around Paris. Recently, I received
a delivery slip in the mail. It had an address scratched on it. This was where
I would find my package. My Amazon packages usually get delivered to a small
fruit market. My photos are delivered to an eyeglass boutique. And my recent
purchase of comfy ballerina flats was delivered to a chocolate shop. The proprietor
of the shop seemed shocked to see me. I handed her the slip. She listlessly
glanced at the pile of boxes in the corner and said "Non." My package wasn't there.
As luck... (luck?) would have it, my package was on top. I saw my name clearly
marked on the box. She almost didn't believe me, and she seemed reluctant to
hand it over. With the package still in her hand, she asked if I'd like a sample of
her lemon chocolate. Sure, and the package please. The chocolate was lovely — truly
a great mix of tart lemon and sweet chocolate. She proceeded to tell me how it
took days to make. Many steps. Precise timing. Curing was involved. It had a shiny
glaze. I nodded and pretended to savor the chocolate that already went down
the hatch. How much for this ONE chocolate? 7 Euros! Oh la la la la la la aa. Non merci!
It was my turn to look shocked. She handed me my package and offered
another version of this treat. Tasted the same. Didn't have the shiny glaze.
How much? Same price as all the other chocolates in the shop... about 50 centimes
Same chocolate, but that glaze must have been imported from a great distance.
Perhaps she, like me, had to spend half the day traipsing around Paris to track
down the shipment. Qui sait?
 — Janice

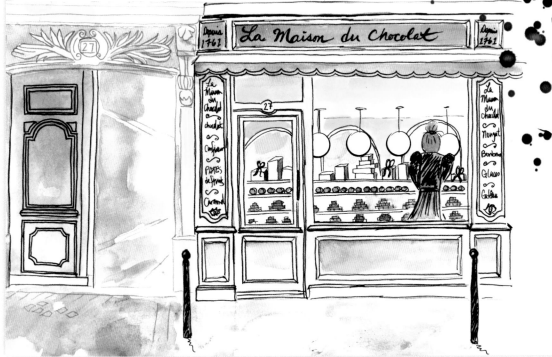

Le Select

June 2018, Paris

Dear Áine,

Greetings from Montparnasse. This is one of the areas of Paris known for its literary cafés. You've got Le Dôme Café, La Coupole, and Le Select all within a stone's throw of each other—all lovely eateries featured in a slew of novels written around the 1920s by Hemingway, Fitzgerald, Joyce, and the like. I showed up with pen in hand to see if I could conjure any literary snippets from these ghosts. Plus, I'm a sucker for a neon sign and the area is chocked full of such eye candy. I chose to sit at Le Select—the least hoity-toity of the three. I waited for inspiration to arrive as I nibbled at my croque monsieur and washed it down with a light rosé. The café had a nice hustle-bustle. The waiters were kind and efficient. The manager surveyed the floor and stopped by tables of regulars to make sure all is as it should be. All good, but no ghosts. That part is over. Those books have been written. That magical time in history is gone and can't be re-created. Back then, they weren't writing about these cafés because someone else had written about them before. I suppose the writers of today must find their own cafés and make them theirs in new books. So I let these ghosts go. I paid my bill and headed back to my usual café where writing comes more easily to me and where the manager stops by to see if everything is as it should be. Yes, I believe it is.

Janice

"You're an expatriate. You've lost touch with the soil. You get precious. Fake European standards have ruined you. You drink yourself to death . . . You spend all your time talking, not working. You are an expatriate, see? You hang around cafés."

Ernest Hemingway, *The Sun Also Rises*

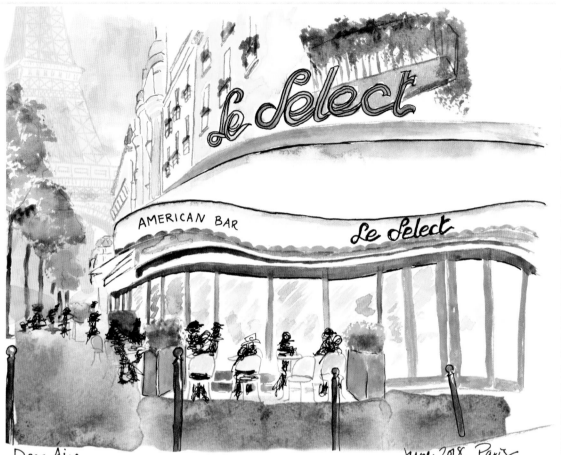

Dear Aine, June 2018, Paris

Greetings from Montparnasse. This is one of the areas of Paris known for
its literary cafés. You've got Le Dôme Café, La Coupole, and Le Select all within a
stone's throw of each other — all lovely eateries featured in a slew of novels
written around the 1920s by Hemingway, Fitzgerald, Joyce, and the like. I showed
up with pen in hand to see if I could conjure any literary snippits from these ghosts.
Plus, I'm a sucker for a neon sign and the area is chocked full of such eye candy.
I chose to sit at Le Select — the least hoity-toity of the three. I waited for inspiration
to arrive as I nibbled at my croque monsieur and washed it down with a light rosé.
The café had a nice hustle-bustle. The waiters were kind and efficient. The manager
surveyed the floor and stopped by tables of regulars to make sure all is as it
should be. All good, but no ghosts. That party is over. Those books have been written.
That magical time in history is gone and can't be recreated. Back then, they
weren't writing about these cafés because some one else had written about them
before. I suppose the writers of today must find their own cafés and make
them theirs in new books. So I let these ghosts go. I paid my bill and headed
back to my usual café where writing comes more easily to me and where the manager
stops by to see if everything is as it should be. Yes, I believe it is. —Jania

225

July 2018, Hôtel de Sens, Paris

Dear Áine,

The July heat is coming at us from all angles. The sun beats down and heats the buildings and streets, so the city is one beautiful but unbearable oven. Most apartments don't have air conditioning, so there is a mass exodus to cool places—the cinema, department stores, and hotel restaurants are all hot spots, so to speak, but the Seine is by far the hottest spot in town to cool off. The Seine-side picnic has almost become a religion and the worshippers are devout. Parisians have perfected the riverside picnic. First, they pack ZERO food. They only pack wine glasses, a corkscrew, cutlery, and napkins. Second, they mentally map out a walking route to the Seine. There are many delectable vittles to be purchased at the plentitude of boutiques along the way and no one wants to carry a heavy pack far in this heat. By the time your bags are full, you're near your destination. Third, one must find a spot in the shade with a great view. On my last picnic, I didn't even make it down to the Seine. I spotted a shaded garden outside Hôtel de Sens—a castle above the river that is now a library. I guess that's the final picnic tip. Be spontaneous because Paris loves to show off. And she's so good at it.

Janice

———≈———

"'Never plan a picnic,' Father said. 'Plan a dinner, yes, or a house, or a budget, or an appointment with the dentist, but never, never plan a picnic.'"

Elizabeth Enright, *The Four-Story Mistake*

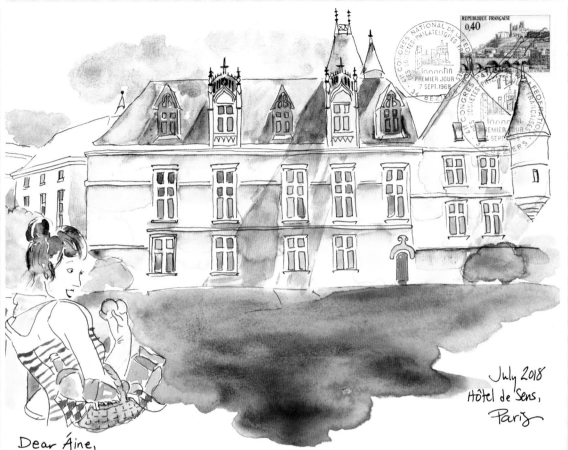

July 2018
Hôtel de Sens,
Paris

Dear Áine,

The July heat is coming at us from all angles. The sun beats down and heats the buildings and streets, so the city is one beautiful but unbearable oven. Most apartments don't have air conditioning, so there is a mass exodus to cool places— the cinema, department stores, and hotel restaurants are hot spots, so to speak, but the Seine is by far the hottest spot in town to cool off. The Seine-side picnic has almost become a religion and the worshippers are devout. Parisians have perfected the riverside picnic. First, they pack ZERO food. They only pack wine glasses, a corkscrew, cutlery, and napkins. Second, they mentally map out a walking route to the Seine. There are many delectible vittles to be purchased at the plentitude of boutiques along the way and no one wants to carry a heavy pack far in this heat. By the time your bags are full, you're near your destination. Third, one must find a spot in the shade with a great view. On my last picnic, I didn't even make it down to the Seine. I spotted a shaded garden outside Hôtel de Sens - a castle above the river that is now a library. I guess that's the final picnic tip. Be spontaneous because Paris loves to show off. And she's so good at it.

—Janice

August 2018, Paris

Dear Áine,

It catches me by surprise every August. I walk out the door and it is quiet. So eerily quiet. No traffic hum. Nothing open. It feels like everyone hopped on the train and left without you. This year, August feels especially quiet after the back-to-back celebrations with Bastille Day, then winning the World Cup. But now the party is definitely over, or more accurately, the party has moved south to beaches dotting the coast. I'm sweltering in the shade, so I don't know how anyone manages to WANT to sit in the sun. For me, Paris in August is a peaceful world filled with available seats on the Métro, short lines for the museums, and shaded park benches where I linger longer with a cold Orangina.

August is for artists. We can sit and actually finish a painting, poem, or in my case, a letter, without people peering over our shoulders. This is also my museum season. They are still open, unlike my preferred *boulangeries, fromageries*, and *boucheries*. The Mona Lisa is always busy. Poor girl doesn't get time off. But the rest of the treasures, well, one gets a front row seat for gazing and gawking in August.

Cashiers seem different in August. To me, they seem kinder or serene . . . sad? One doesn't have to fight so much with the city in August . . . though finding a good dessert is a challenge with so many closed patisseries. But even a bad dessert in Paris is a pretty good dessert anywhere else. You can say the same for this city in August. Even a deserted Paris is a lovelier city than most cities on their best days.

Janice

"He who contemplates the depths of Paris is seized with vertigo. Nothing is more fantastic. Nothing is more tragic."

Victor Hugo

August 2018, Paris

Dear Áine,

It catches me by surprise every August. I walk out the door and it is quiet. So eerily quiet. No traffic hum. Nothing open. It feels like everyone hopped on the train and left without you. This year, August feels especially quiet after the back-to-back celebrations with Bastille Day, then winning the World Cup. But now the party is definitely over, or more accurately, the party has moved south to beaches dotting the coast. I'm sweltering in the shade, so I don't know how anyone manages to WANT to sit in the sun. For me, Paris in August is a peaceful world filled with available seats on the Métro, short lines for the museums, and shaded park benches where I linger longer with a cold Orangina.

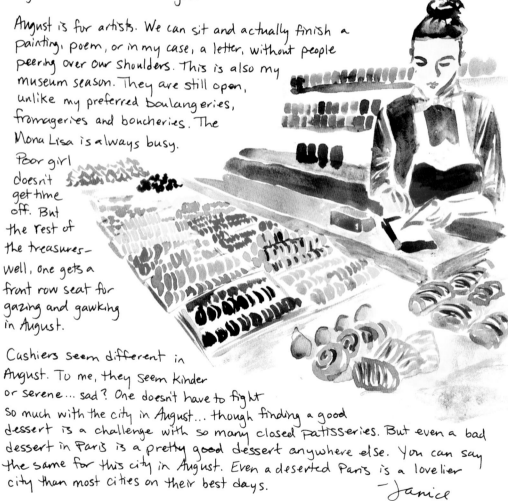

August is for artists. We can sit and actually finish a painting, poem, or in my case, a letter, without people peering over our shoulders. This is also my museum season. They are still open, unlike my preferred boulangeries, fromageries and boucheries. The Mona Lisa is always busy. Poor girl doesn't get time off. But the rest of the treasures— well, one gets a front row seat for gazing and gawking in August.

Cashiers seem different in August. To me, they seem kinder or serene... sad? One doesn't have to fight so much with the city in August... though finding a good dessert is a challenge with so many closed patisseries. But even a bad dessert in Paris is a pretty good dessert anywhere else. You can say the same for this city in August. Even a deserted Paris is a lovelier city than most cities on their best days.

—Janice

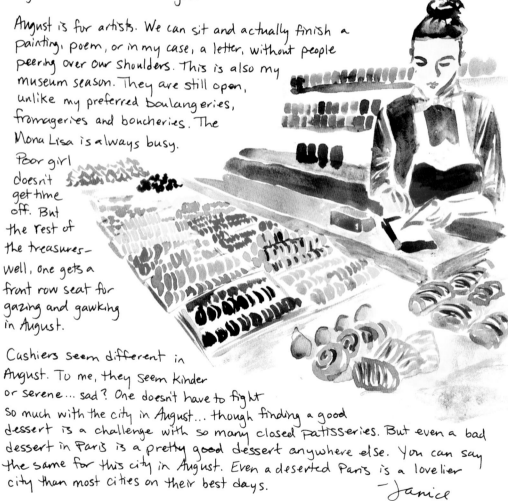

229

Jardin des Plantes

September 2018, Paris

Dear Áine,

This is secretly the preferred month of the year for Parisians. They'd never admit it as they revel in boasting about their famously long vacation time to the rest of the world. Most have been gone all of August, sunning themselves at seaside resorts. Now those resorts are breathing a sigh of relief that the onslaught has left. And the onslaught are back in Paris happy to get back to the daily routine. Any quarrels that rose with colleagues and friends in July are long forgotten, or at least cooled off with daily dips in the sea, and people are generously doling out handshakes and kisses for familiar faces.

For me, getting back to it, called *rentrée,* is to reenter the routine of jogging in Jardin des Plantes. This horticultural paradise has shaded lanes for joggers, perfect for hot September. Plus, the firemen jog here as a group each morning. They have a jogging uniform, of course, and their cute red shorts are very motivating for anyone jogging behind them. After my laps, I cool down in the flower garden . . . FULL of blooms. This place was once a medicinal garden to the king. It's all flowers now, but it still cures what ails. And it makes the *rentrée* even more delightful.

Janice

"But when fall comes, kicking summer out on its treacherous ass as it always does one day sometime after the midpoint of September, it stays awhile like an old friend that you have missed. It settles in the way an old friend will settle into your favorite chair and take out his pipe and light it and then fill the afternoon with stories of places he has been and things he has done since last he saw you."

Stephen King, *Salem's Lot*

Dear Áine,

This is secretly the preferred month of the year for Parisians. They'd never admit it as they revel in boasting about their famously long vacation time to the rest of the world. Most have been gone all of August, sunning themselves at seaside resorts. Now those resorts are breathing a sigh of relief that the onslaught has left. And the onslaught are back in Paris happy to get back to the daily routine. Any quarrels that rose with colleagues and friends in July are long forgotten, or at least cooled off with daily dips in the sea, and people are generously doling out handshakes and kisses for familiar faces.

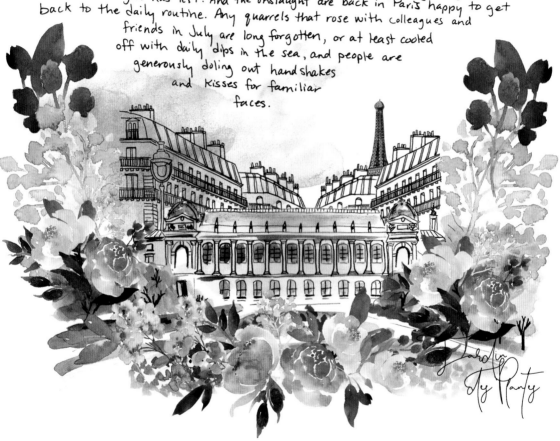

Jardin des Plantes

For me, getting back to it, called "rentrée", is to "reenter" the routine of jogging in Jardin des Plantes. This horticultural paradise has long shaded lanes for joggers, perfect for hot September. Plus, the firemen jog here as a group each morning. They have a jogging uniform, of course, and their cute red shorts are very motivating for anyone jogging behind them. After my laps, I cool down in the flower garden... FULL of blooms. This place was once a medicinal garden to the king. It's all flowers now, but it still cures what ails. And it makes the "rentrée" even more delightful.

— Janice

October 2018, Paris

Dear Áine,

My daily constitutional walk usually starts with a sharp left out my front door, which leads to the Seine and all the glorious activities on the right bank. But in October, I take a sharp right and head directly for the Medici Fountain in Jardin du Luxembourg. There is always at least one magical leaf-changing day when the leaves fall into the fountain and those still on the trees are reflected in the water. It's a dizzying display of orange and yellow, much like the postage stamps that came out recently. This fountain was built under the watchful eye of Marie de' Medici, who lived here back in the 1600s. I wonder how she would feel with strangers like me lurking in her backyard. In a way, I imagine she would be offended. Then again, it's so breathtaking in autumn that it would be a challenge to not want to share the scene with whoever happened by. I'd be waving people in!

Janice

"October, baptize me with leaves! Swaddle me in corduroy and nurse me with split pea soup. October, tuck tiny candy bars in my pockets and carve my smile into a thousand pumpkins. O autumn! O teakettle! O grace!"

Rainbow Rowell, *Attachments*

October 2018, Paris

Dear Áine,

My daily constitutional walk usually starts with a sharp
left out my front door, which leads to the Seine and all
the glorious activities on the right bank. But in October,
I take a sharp right and head directly for the Medici
Fountain in Jardin du Luxembourg. There is always at
least one magical leaf-changing day when the leaves
fall into the fountain and those still on the trees are
reflected in the water. It's a dizzying display of orange
and yellow, much like the postage stamps that came out
recently. This fountain was built under the watchful eye
of Marie de' Medici, who lived here back in the 1600s. I wonder
how she would feel with strangers like me lurking in her backyard.
In a way, I imagine she would be offended. Then again, it's so
breathtaking in autumn that it would be a challenge to not want
to share the scene with whoever happened by. I'd be
 waving people in!
 —Janice

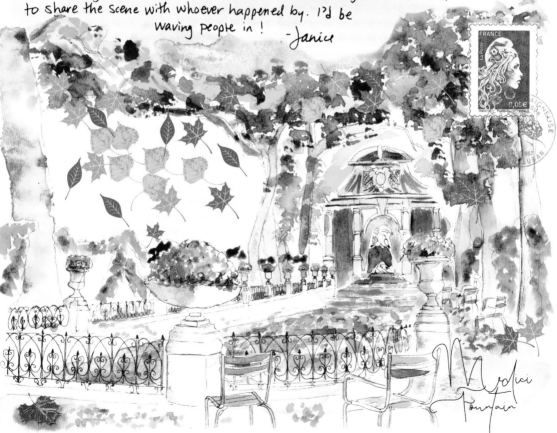

Medici
Fountain

233

Marie Curie

November 2018, Paris

Dear Áine,

The blustery winds are bringing out the hypochondriac nature of my French compatriots. And that means a pilgrimage—or ten—to the pharmacy. Most people will go to the pharmacy instead of the doctor's office, and for good reason. The pharmacists are very well educated in France—in both real and imagined ailments. They are even able to identify poisonous from edible mushrooms. So if you go on any forest excursions, you can rest assured that what you serve up at the table does not result in a murder mystery. In my French language classes, I was taught how to converse with the pharmacist. You know I was excited when I was *mal à la gorge* and could show off my latest linguistic feat to the pharmacist, who promptly gathered all the necessary ingredients to concoct the ultimate antidote for my sore throat. She was like a kid in a candy store, except with lozenges, tinctures, and tonics.

Another time, I went in for burn cream. The pharmacist leaned over the counter, raised a brow, and in a hushed tone, said that this cream was a special order. Sounded expensive, but *pas du tout*. It was the size and price of a tube of toothpaste. And it worked amazingly well. Now I understand why all the fuss over the pharmacist. When the cool winds begin to blow and I walk by the iconic green cross outside a pharmacy, I know I'll be taken care of—my throat, burns, and even sometimes with dinner.

Janice

———— ≈ ————

Marie Curie discovered radium and polonium, two highly radioactive elements. Her remains are so radioactive that she is interred in thick lead in the Panthéon in Paris to prevent the radiation from harming those who visit her.

Dear Áine, November 2018, Paris

The blustery winds are bringing out the hypochondriac nature of my French compatriots.
And that means a pilgrimage — or ten — to the pharmacy. Most people will go to the
pharmacy instead of the doctor's office, and for good reason. The pharmacists are very
well educated in France — in both real and imagined ailments. They are even able
to identify poisonous from edible mushrooms. So if you go on any forest excursions,
you can rest assured that what you serve up at the table does not result in a
murder mystery. In my French language classes, I was taught how to converse with
the pharmacist. You know I was excited when I was "mal à la gorge" and could
show off my latest linguistic feat to the pharmacist, who promptly gathered
all the necessary ingredients to concoct the ultimate antidote for my sore throat.
She was like a kid in a candy store,
except with lozenges, tinctures
and tonics.

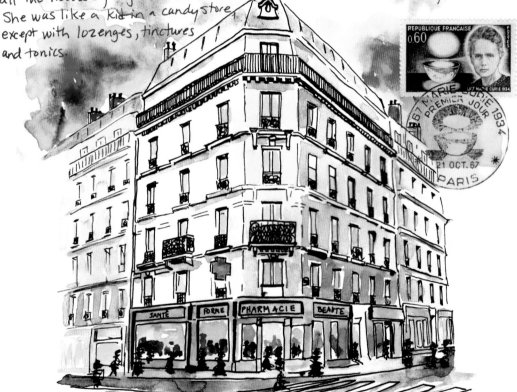

Another time, I went in for burn cream. The pharmacist leaned over the
counter, raised a brow and, in a hushed tone, said that this cream was a
special order. Sounded expensive, but pas du tout. It was the size and price
of a tube of toothpaste. And it worked amazingly well. Now I understand why
all the fuss over the pharmacist. When the cool winds begin to blow and I walk
by the iconic green cross outside a pharmacy, I know I'll be taken care of —
my throat, burns, and even sometimes with dinner.
 — Janice

235

December 2018, Paris

Dear Áine,

'Tis that time of the year again. The city is twinkling with lights and chocked full of delights. It's also time for the annual holiday meal with friends. The email goes out a few weeks early. Basically, a Who-Is-Bringing-What message. Responses happen quickly— one has the wine, another dessert, another cheese, and so on until all the major food groups are covered—except meat and vegetables. That's up to the host. No one says they'll bring baguettes, but the person who shows up with them at the last minute is hailed as the hero of the evening. The baguette is a necessary ingredient, but everyone is focused on bringing some amazing treat they discovered during the year—like the wine they tasted on a bike trip through Burgundy, or the mango caramels from Jacques Genin, or the triple cream Brie from—well, I don't know where, but it tasted like it was from heaven. We all arrive with our treats and talk about the same old things, and marvel at our good fortune—that we get to live together in this place, this treasure chest of a city. This—our Paris.

Joyeux Noël

Janice

"Sin ought to be something exquisite."

Émile Zola, *The Kill*

Dear Áine,

'Tis that time of the year again. The city is twinkling with lights
and choked full of delights. It's also time for the annual holiday meal
with friends. The email goes out a few weeks early. Basically, a
Who-Is-Bringing-What message. Responses happen quickly—one has the
wine, another dessert, another cheese, and so on until all the major
food groups are covered—except meat and vegetables. That's up to the host.
No one says they'll bring baguettes, but the person who shows up with
them at the last minute is hailed as the hero of the evening. The
baguette is a necessary ingredient, but everyone is focused on
bringing some amazing treat they discovered during the year—like
the wine they tasted on a bike trip through Burgundy, or the mango
caramels from Jacques Genin, or the triple cream Brie from—well,
I don't know from where, but it tasted like it was from heaven.
We all arrive with our treats and talk about the same old things,
and marvel at our good fortune—that we get to live together
in this place, this treasure chest of a city. This—our Paris.

Joyeux Noël —Janice

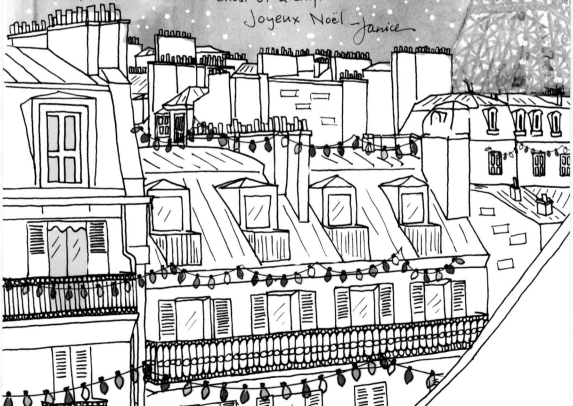

237

January 2019, Paris

Dear Áine,

I've never really liked the Arc de Triomphe. I've looked at it from all the angles, painting it a handful of times, walked up it and through it, viewed it up close and from afar, and still can't find the love. It's bulky, blocky, and busy. It heads the Champs-Élysées, a street I find to be a loud salute to commerce, crowds, and overpriced crêpes. But as I spent Saturday watching another round of protests from the Yellow Vests, I thought I'd give it another go. Like the Arc de Triomphe, the Yellow Vest Movement has a lot of ugly angles. It started as a protest against a new fuel tax. Since every car in France must include a reflective yellow vest to wear in an emergency situation, the uniform of the protest was genius . . . thematically appropriate. Bravo!

Two months later, the protest has morphed into a protest against the high cost of living in France. They have a point. A person with an average salary has a hard time getting by. There is often a lot of month left at the end of the money. And that's for someone with an <u>average</u> salary. Small business has already been taxed to the max by the previous government. If you tax big business, they simply pick up and move to a country nearby. It's tricky. I also feel for the riot police. I've seen the fear in their eyes as a protest marches toward them. It's the riot police who take the blows. No one is throwing rocks at or pushing the president. Plus, many police agree with the Yellow Vest Movement, but their job isn't to join, it's to contain. Tricky *encore*.

Janice

"I've looked at clouds from both sides now
From up and down, and still somehow
It's cloud illusions I recall
I really don't know clouds at all"

Joni Mitchell, "Both Sides Now"

Dear Áine,

I've never really liked the Arc de Triomphe. I've looked at it from all the angles, painting it a handful of times, walked up it and and through it, viewed it up close and from afar, and still can't find the love. It's bulky, blocky, and busy. It heads the Champs-Élysées, a street I find to be a loud salute to commerce, crowds, and overpriced crêpes. But as I spent Saturday watching another round of protests from the Yellow Vests, I thought I'd give it another go. Like the Arc de Triomphe, the Yellow Vest Movement has a lot of ugly angles. It started as a protest against a new fuel tax. Since every car in France must include a reflective yellow vest to wear in an emergency situation, the uniform of the protest was genius... thematically appropriate.

Bravo!

Two months later, the protest has morphed into a protest against the high cost of living in France. They have a point. A person with an average salary has a hard time getting by. There is often a lot of month left at the end of the money. And that's for someone with an average salary. Small business has already been taxed to the max by the previous government. If you tax big business, they simply pick up and move to a country nearby. It's tricky. I also feel for the riot police. I've seen the fear in their eyes as a protest marches toward them. It's the riot police who take the blows. No one is throwing rocks at or pushing the president. Plus, many police agree with the Yellow Vest Movement, but their job isn't to join, it's to contain. Tricky encore.

—Janice

February 2019, Paris

Dear Áine,

La Chandeleur was February 2nd—a holiday when the French eat crêpes. The crêpe either represents candlelight and hope during dark winter days, or the return of the spring sun, or gold coins and prosperity. It's one of those holidays that oscillates between religion and paganism, but either way, everyone ends up at the table. What amazed me on this particular day was not the feast on my plate but rather a feast for my eyes upon arrival at the *crêperie*. Above the entrance was a large ornate iron sign featuring a jolly chef flipping crêpes. The proprietor inside explained that the sign had been there long before he arrived on the scene, and likely before the previous proprietor. "It's Paris. If it's pretty, it stays. No one has the heart to take these old signs down."

This metal sign inspired further research and a great hike all over Paris to find more old signs. Ages ago, when illiteracy was common, the signs explained the business within. These days, sometimes the signs are accurate (like at our *crêperie*), but often the business is long gone yet the sign remains. My hike culminated at the Musée Carnavalet where they have a permanent collection of these old signs on display. I wonder if our old crêpe chef will end up here one day. My romantic heart hopes not. I hope he continues to hold court above the *crêperie*, bestowing prosperity, hope, and a warm spring sun on all who enter.

Janice

"Beyond the edge of the world there's a space where emptiness and substance neatly overlap, where past and future form a continuous, endless loop. And, hovering about, there are signs no one has ever read, chords no one has ever heard."

Haruki Murakami, *Kafka on the Shore*

Dear Áine,

La Chandeleur was February 2nd — a holiday when the French eat crêpes. The crêpe either represents candlelight and hope during dark winter days, or the return of the spring sun, or gold coins and prosperity. It's one of those holidays that oscillates between religion and paganism, but either way, everyone ends up at the table. What amazed me on this particular day was not the feast on my plate but rather a feast for my eyes upon arrival at the crêperie. Above the entrance was a large ornate iron sign featuring a jolly chef flipping crêpes. The proprietor inside explained that the sign had been there long before he arrived on the scene, and likely before the previous proprietor. " It's Paris. If it's pretty, it stays. No one has the heart to take these old signs down."

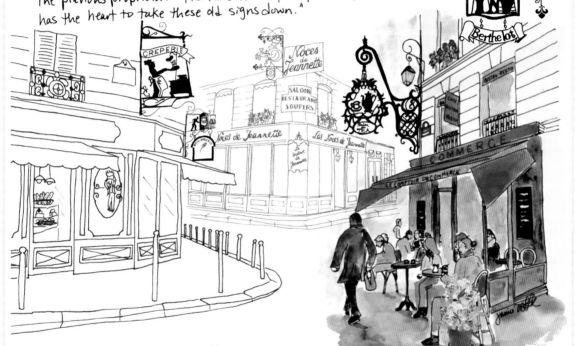

This metal sign inspired further research and a great hike all over Paris to find more old signs. Ages ago, when illiteracy was common, the signs explained the business within. These days, sometimes the signs are accurate (like at our crêperie), but often the business is long gone yet the sign remains. My hike culminated at the Musée Carnavalet where they have a permanent collection of these old signs on display. I wonder if our old crêpe chef will end up here one day. My romantic heart hopes not. I hope he continues to hold court above the crêperie, bestowing prosperity, hope, and a warm spring sun on all who enter. — Janice

March 2019, Paris

Dear Áine,

Did heaven get another angel or did the Chanel boutique get another ghost? The recent death of our white-haired sunglassed icon, Karl Lagerfeld, has been the big news fluttering by on the breeze in Paris. The legacy of his work has been everywhere. I had no idea how much of a machine he was. He revitalized the aging Chanel brand by keeping her signature style (tweed, chains, gold), but adding so much more. We are talking 10 new collections a year. I was always hoping to catch a glimpse of him over at the Chanel boutique at 31 rue Cambon, but never did. And now I know why. He was BUSY. His death coincides with the start of a new hobby for me—sewing. I was gifted a sewing machine, and after much trepidation, I started small with a few minor alterations. These early simple edits got me interested in revisiting my wardrobe to turn everything inside out and see how it was all put together. Fashion is a <u>marvel</u>. I hadn't paid too much attention before Karl's news and my sewing machine came along. I was watching this documentary on Karl. It was in French, so I couldn't catch it all, but I understood one particular scene. He walks into his atelier with new sketches. The crew crowds around and everyone nods Yes! Yes! Yes! He leaves and they look at each other How? How? How? A two-dimensional sketch must now face the challenges of three-dimensional space—gravity, movement, and fabric. They haul out the mannequins and start draping, cutting, pinning, repinning, ripping, and repinning until they get it right. And I thought I was a genius for being able to fix the hem on my skirt! I don't think I'll be opening a fashion house anytime soon, but I have a deeper appreciation for the art. Well done, Karl!

Janice

"I took piano for a year and then my mother said I had no talent whatsoever and she shut the piano. . . . She said, 'Why don't you draw instead. That's not so noisy.'"

Karl Lagerfeld

March 2019, Paris

Dear Áine,

Did heaven get another angel or did the Chanel boutique get another ghost? The recent death of our white-haired sunglassed icon, Karl Lagerfeld, has been the big news fluttering by on the breeze in Paris. The legacy of his work has been everywhere. I had no idea how much of a machine he was. He revitalized the aging Chanel brand by keeping her signature style (tweed, chains, gold), but adding so much more. We are talking 10 new collections a year. I was always hoping to catch a glimpse of him over at the Chanel boutique at 31 rue Cambon, but never did. And now I know why. He was BUSY. His death coincides with the start of a new hobby for me — sewing. I was gifted a sewing machine, and after much trepidation, I started small with a few minor alterations. These early simple edits got me interested in revisiting my wardrobe to turn everything inside out and see how it was all put together. Fashion is a <u>marvel</u>. I hadn't paid too much attention before Karl's news and my sewing machine came along. I was watching this documentary on Karl. It was in French, so I couldn't catch it all, but I understood one particular scene. He walks into his atelier with new sketches. The crew crowds around and everyone nods Yes! Yes! Yes! He leaves and they look at each other How? How? How?

A two-dimensional sketch must now face the challenges of three-dimensional space — gravity, movement, and fabric. They haul out the mannequins and start draping, cutting, pinning, repinning, ripping, and repinning until they get it right. And I thought I was a genius for being able to fix the hem on my skirt! I don't think I'll be opening a fashion house any time soon, but I have a deeper appreciation for the art. Well done, Karl!

— Jamie

Ferris Wheel

April 2019, Paris

Dear Áine,

I'd like to think I'm an observant person on my urban hikes around Paris, which is why I am astounded that I never noticed that the giant Ferris wheel in the Tuileries Garden moves around the city. You'd think you'd notice that a massive structure like that isn't always in the same place.

I only noticed it in a different location because of the blooming trees it was nestled in at the end of the garden. Had it not been for the trees, I might have walked right by it, assuming it was delighting tourists at the base of the Champs-Élysées, where it sat over Christmas. Paris itself is like that Ferris wheel. You'd think it doesn't change, that it will always look the same, but it's a sneaky town. It likes to keep you guessing. I suppose so you'll keep up with the urban hikes. It works!

Janice

"Every time I look down on this timeless town
Whether blue or gray be her skies
Whether loud be her cheers or whether soft be her tears
More and more do I realize that
I love Paris in the springtime"

Cole Porter, "I Love Paris"

April 2019, Paris

Dear Áine,

I'd like to think I'm an observant person on my urban hikes around Paris, which is why I am astounded that I never noticed that the giant Ferris wheel in the Tuileries Garden moves around the city. You'd think you'd notice that a massive structure like that isn't always in the same place.

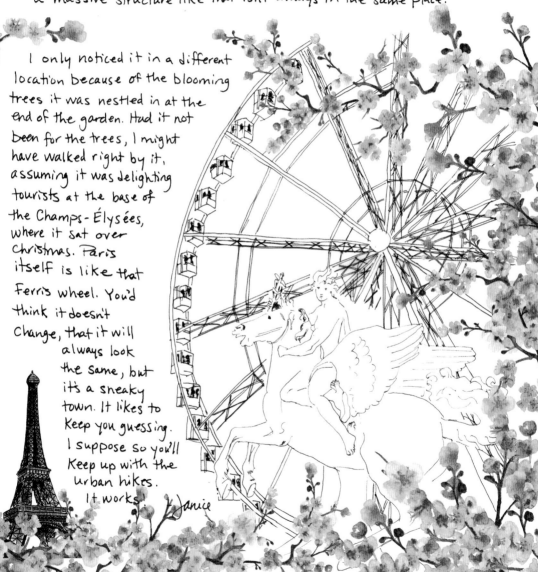

I only noticed it in a different location because of the blooming trees it was nestled in at the end of the garden. Had it not been for the trees, I might have walked right by it, assuming it was delighting tourists at the base of the Champs-Élysées, where it sat over Christmas. Paris itself is like that Ferris wheel. You'd think it doesn't change, that it will always look the same, but it's a sneaky town. It likes to keep you guessing. I suppose so you'll keep up with the urban hikes. It works!

Janice

May 2019, Paris

Dear Áine,

The first time I saw Notre Dame, I was so very lovesick. I was in Paris on vacation with a friend—also lovesick. We were discussing our flailing love lives when we came upon those bellowing buttresses and that soaring spire. We gasped. Just seeing it helped soothe my heart. A few years later I returned alone. Still lovesick. On my first evening in Paris, not knowing where to go or what to do, I walked to Notre Dame. She is situated at the heart of Paris—the site where Paris began. And though I didn't know it at the time, the exact beginning of my new life in Paris. I walked in, sat down, and listened to the music. The space felt thick with calm. That's the best way I can describe it. Peace? Tranquility? Definitely something beyond words. The effect of thousands of prayers over hundreds of years. Since that day, I've been to Notre Dame hundreds of times. It became my church. My beginning of everything. And where I healed my lovesick heart. To see it burning now hurts, but it's not the same kind of lovesickness. That's gone, thanks to her. This event brings you to your knees—but more in thanks than anything. Notre Dame is still there. The roof might be gone, spire crumbled, but she's still there.

Janice

"I love her and that's the beginning and end of everything."

F. Scott Fitzgerald

Dear Áine, May 2019, Paris

The first time I saw Notre Dame, I was so very lovesick. I was in Paris
on vacation with a friend —also lovesick. We were discussing our flailing
love lives when we came upon those bellowing buttresses and that soaring spire.
We gasped. Just seeing it helped soothe my heart. A few years later I returned
alone. Still lovesick. On my first evening in Paris, not knowing where to go or
what to do, I walked to Notre Dame. She is situated at the heart of Paris—
the site where Paris began. And though I didn't know it at the time, the exact
beginning of my new life in Paris. I walked in, sat down, and listened to the
music. The space felt thick with calm.

That's the best way I can describe it.
Peace? Tranquility? Definitely
something beyond words.
The effect of thousands of
prayers over hundreds
of years. Since that day,
I've been to Notre Dame
hundreds of times.

It became my
church. My beginning
of everything. And
where I healed
my lovesick heart.
To see it burning
now hurts, but
it's not the same
kind of love-
sickness. That's
gone, thanks to
her. This event
brings you to your
knees — but more in
thanks than anything.
Notre Dame is still there. The roof
might be gone. Spire crumbled.
But she's still there.

— Janice

247

White Asparagus

June 2019, Paris

Dear Áine,

There continues to be an emotional dark cloud in Paris. Notre Dame's rooftop still looks bleak. The Gilets Jaunes still protest at major sites on the weekends. And a recent report reveals that Paris tied for 1st place as the priciest place to live, thereby fueling the Gilets Jaunes and making locals feel like they are being had. Even I discovered it can be cheaper to fly to nearby countries and shop than to stay and buy in Paris (but not as much fun). Despite all this, the fruit markets are cheering up locals. There is great relief to see the local strawberries, cherries, and radishes. I don't know how many varieties of radishes there are in this world, but I think they are all at the Paris markets in June. And then there is the arrival of the white asparagus. It's actually just green asparagus that is covered with more soil so it can never reach daylight and perform its chlorophyll magic trick and turn green. Ta daaa! It tastes a little like green asparagus (but not as much) and a little like artichoke (but not as much). Beware of the word "delicate" when food is described. In the case of white asparagus, this translates to "bland." Plus, it's pricey . . . 15 Euros for a small bunch. You don't need to convert currencies to know this is nuts. After I handed back a bunch to the vendor with a startled *"Non merci,"* I furtively lurked around our market stall to see if he charged others the same as he did me. Was there a secret local price? If so, did it have something to do with accents, or lack thereof? But no, that's the price everyone must pay. I think if you understand why white asparagus exists, you understand why the Gilets Jaunes are protesting. Tonight at the bistro, I'll be ordering a side of green asparagus as part of my own silent protest.

Janice

"Our vegetable garden is coming along well, with radishes and beans up, and we are less worried about revolution than we used to be."

E. B. White

Dear Áine, June 2019, Paris

There continues to be an emotional dark cloud in Paris. Notre Dame's rooftop
still looks bleak. The Gilets Jaunes still protest at major sites on the weekends.
And a recent report reveals that Paris tied for 1st place as the priciest place to live,
thereby fueling the Gilets Jaunes and making locals feel like they are being had.
Even I discovered it can be cheaper to fly to nearby countries and shop than to
stay and buy in Paris (but not as much fun). Despite all this, the fruit markets
are cheering up locals. There is great relief to see the local strawberries, cherries,
and radishes. I don't know how many varieties of radishes there are in this
world, but I think they are all at the Paris markets in June. And then there
is the arrival of the white asparagus. No other vegetable drives me to want to
protest like the white asparagus. It's actually just green asparagus that is
covered with more soil so it can never reach daylight and perform its
chlorophyll magic trick and turn green. Ta daaa! It tastes a little like green
asparagus (but not as much) and a little like artichoke (but not as much). Beware
of the word "delicate" when food is described. In the case of white asparagus,
this translates to "bland." Plus, it's pricey... 15 Euros for a small bunch. You don't
need to convert currencies to know this is nuts. After I handed back a bunch
to the vendor with a startled "Non merci," I furtively lurked around our
market stall to see if he charged others the same as he did me. Was there
a secret local price? If so, did it have something to do with accents, or lack thereof?
But no, that's the price everyone must pay. I think if you understand why
white asparagus exists, you understand why the Gilets Jaunes are protesting.
Tonight at the bistro, I'll be ordering a side of green asparagus as part of
 my own silent protest. — Janice

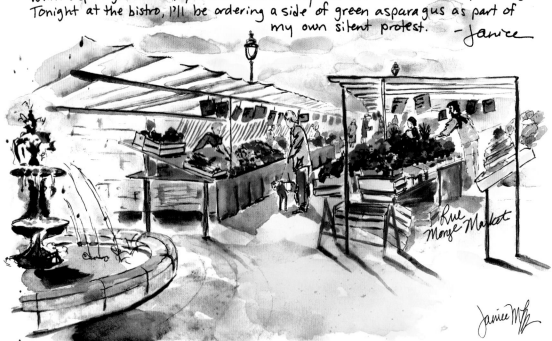

Rue
Monge Market

Janice M

Summer Heat

July 2019, Paris

Dear Áine,

The heat is on in Paris, and I don't just mean the weather. I've noticed a lot more canoodling in the shade of trees. Christophe says it's too hot to touch each other in sweltering apartments so the amorous among us must find alternatives. Even he and I have been holding hands pinky-*à*-pinky. The mayor announced that the city would be planting more trees to cool down the sizzling sidewalks . . . actually removing some stones and replacing them with mini verdant forests. Some of these stones were actually from the Bastille—repurposed as bridges and walkways—removed again to free the people—this time from a stifling heat. While they are making improvements, I'd like them to install ice machines. There is a serious lack of ice in Paris and I could use a cold drink.

Cheers!

Janice

"The summer sun was not meant for boys
like me. Boys like me belonged to the rain."

Benjamin Alire Sáenz, *Aristotle and Dante
Discover the Secrets of the Universe*

July 2019, Paris

Dear Áine,
The heat is on in Paris, and I don't just
mean the weather. I've noticed a lot more
canoodling in the shade of trees. Christophe
says it's too hot to touch each other in sweltering apartments so the amorous
among us must find alternatives. Even he and I have been holding hands pinky-à-pinky.
The mayor announced that the city would be planting more trees to cool down the
sizzling sidewalks... actually removing some stones and replacing them with
mini verdant forests. Some of these stones were actually from the Bastille – repurposed
as bridges and walkways – removed again to free the people – this time from a
stifling heat. While they are making improvements, I'd like them to install ice machines.
There is a serious lack of ice in Paris and I could use a cold drink. Cheers! Janice

August 2019, Paris

Dear Áine,

I love a Paris flea market. It's an outdoor museum of the culture. In Paris flea markets, you'll always find ornate cutlery, feathers, and books. You will also, inevitably, come across a booth that is absolutely 100% off the mark. And that booth is usually filled with Buddha statues. I imagine the hierarchy of steps that led to the creation of this booth. First, our salesman travels abroad and falls in love with the local souvenir. In Paris, this is the Eiffel Tower keychain until you see it everywhere. Then the spell is broken and you buy yourself a scarf instead. But our salesman falls in love with the Buddha statues—and the low price—especially when converted into Euro. He fills his bags and dreams of the profits to be had in Paris. He invests in his table, tent, and permit; small expenses when he's already mentally rolling in dough. Locals have NO IDEA how cheap these Buddha statues are in the foreign land and currency. He sets out his wares and stands back, preparing for the buzz. Instead, he gets silence and bored glances by passersby who can't even be bothered to step inside the booth. Next door is a vintage sunglass salesman who doesn't even need to haggle. People are lapping up his offerings—giggling in the wee mirrors he has slapped up around his booth. A selfie station. It dawns on our entrepreneurial salesman that he has committed a pricey faux pas.

Janice

"A woman can always get some practical use from a torn-up life . . . She likes mending and patching it, making sure the edges are straight. She spreads the last shred out and takes its measure: 'What can I do with this remnant? How long does it need to last?' A man puts on his life ready-made. If it doesn't fit, he will try to exchange it for another. Only a fool of a man will try to adjust the sleeves or move the buttons; he doesn't know how."

Mavis Gallant, *Paris Stories*

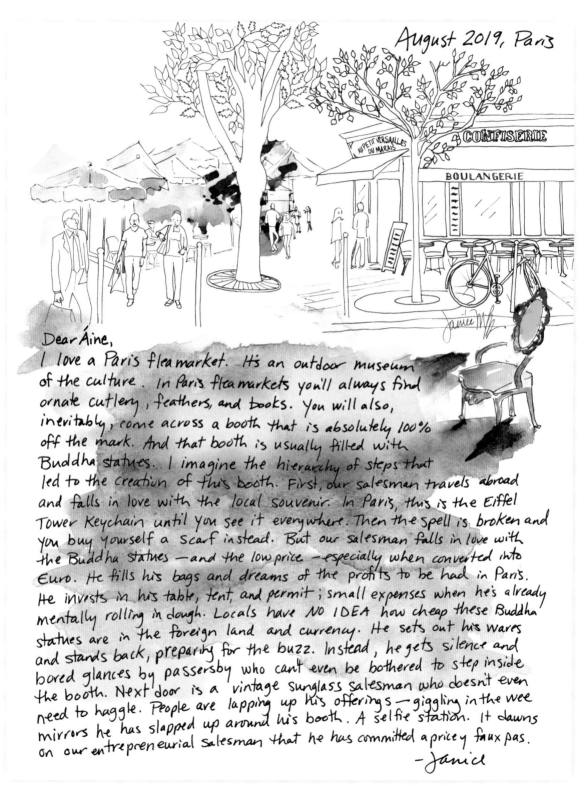

August 2019, Paris

Dear Áine,

I love a Paris flea market. It's an outdoor museum of the culture. In Paris flea markets you'll always find ornate cutlery, feathers, and books. You will also, inevitably, come across a booth that is absolutely 100% off the mark. And that booth is usually filled with Buddha statues. I imagine the hierarchy of steps that led to the creation of this booth. First, our salesman travels abroad and falls in love with the local souvenir. In Paris, this is the Eiffel Tower Keychain until you see it everywhere. Then the spell is broken and you buy yourself a scarf instead. But our salesman falls in love with the Buddha statues — and the low price — especially when converted into Euro. He fills his bags and dreams of the profits to be had in Paris. He invests in his table, tent, and permit; small expenses when he's already mentally rolling in dough. Locals have NO IDEA how cheap these Buddha statues are in the foreign land and currency. He sets out his wares and stands back, preparing for the buzz. Instead, he gets silence and bored glances by passersby who can't even be bothered to step inside the booth. Next door is a vintage sunglass salesman who doesn't even need to haggle. People are lapping up his offerings — giggling in the wee mirrors he has slapped up around his booth. A selfie station. It dawns on our entrepreneurial salesman that he has committed a pricey faux pas.

— Janice

253

September 2019, Paris

Dear Áine,

When little Amélie arrived on the scene, Paris became a whole city of places I couldn't go with a stroller. Overnight, my world was smaller as the city became a jungle gym of stairs. At first, we kept close to our own *quartier*—the little park by the church and up and down our street, rue Mouffetard, to do the shopping. On our first visit to the grocery store, the man first in line at the cashier offered to let me go ahead of him in line. *"Non, no, ça va."* "That's okay," I said. "We can wait." He looked visibly pained. "It is your right," he said. What he didn't add, but what showed on his face, was that he was obligated to insist that I cut ahead of him in line lest he offend the rest of the line who would, turn by turn, have to insist I go to the front of the line. I changed my answer and stepped ahead with a nod and a smile. Generally, the French LOVE to push ahead of you in line. The older ladies at the post office are particularly pushy, but now when I have *bébé* on board, Back up, ladies! When Amélie was older and we could venture sans stroller, I took her to the front car of Line 1 on the Métro. This Métro line has a driverless train. I don't know how it works, but everyone seems comfortable with this fact, so I fall in line with the consensus. Since this train has no driver, you can sit at the front of the first car and get the sense that you're driving the train. It's packed with kids—and adults smile and gladly sit back a few seats. Even here on the Métro, it is the unofficial right of children to go to the front of the line.

Janice

"At some point in life the world's beauty becomes enough."

Toni Morrison, *Tar Baby*

Dear Áine,

When little Amélie arrived on the scene, Paris became a whole city of places I couldn't go with a stroller. Overnight, my world was smaller as the city became a jungle gym of stairs. At first, we kept close to our own quartier — the little park by the church and up and down our street, rue Mouffetard, to do the shopping. On our first visit to the grocery store, the man first in line at the cashier offered to let me go ahead of him in line. "Non, non, ça, va." "That's okay," I said. "We can wait." He looked visibly pained. "It is your right," he said. What he didn't add, but what showed on his face, was that he was obligated to insist that I cut ahead of him in line lest he offend the rest of the line who would, turn by turn, have to insist I go to the front of the line. I changed my answer and stepped ahead with a nod and a smile.

Generally, the French LOVE to push ahead of you in line. The older ladies at the post office are particularily pushy, but not when I have bébé on board. Back up, ladies! When Amélie was older and we could venture sans stroller, I took her to the front car of Line 1 on the Métro. This Métro line has a driverless train. I don't know how it works, but everyone seems comfortable with this fact, so I fall in line with the consensus. Since this train has no driver, you can sit at the front of the first car and get the sense that you're driving the train. It's packed with kids — and adults smile and gladly sit back a few seats. Even here on the Métro, it is the unofficial right of children to go to the front of the line.

— Jania

October 2019, Paris

Dear Áine,

I was on a walk when I came upon so many interesting fashion choices that I thought Halloween came early. No. Just haute couture. A fashion show was underway. It's Fashion Week here in Paris—a very serious business. A parade of faces devoid of expression staring off in the middle distance. The only smile is that of the designer who pops out at the end, looking physically pained to smile and wave. To think, all these clothes started as a thought, then a scribble, a sketch, a discussion, and eventually something sewn and draped and worn.

Later, I reviewed the shows. There were long coats with buttons and bows, short coats with sashes and zippers, some vibrant and some muted, paired with heels or flats. All the designers were doing something different and contrary to each other. Now we as the audience wait and see what will become a trend and what will be seen as an interesting exercise. I spotted one person wearing athletic gear but with a shirt that had sort of tentacles hanging off it. Now that <u>would</u> be an interesting exercise.

Janice

"It's always about timing. If it's too soon, no one understands. If it's too late, everyone's forgotten."

Anna Wintour, editor-in-chief, *Vogue*

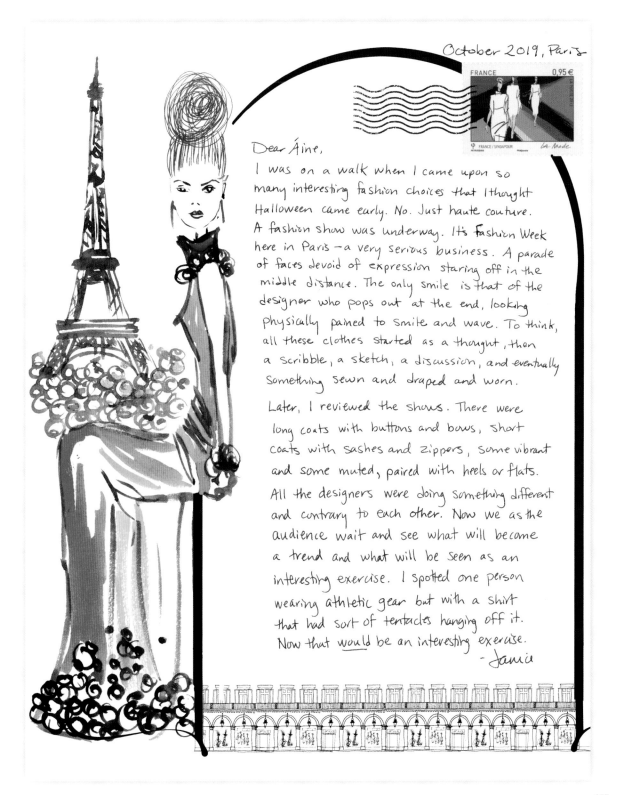

October 2019, Paris

FRANCE 0,95 €
FRANCE / SINGAPOUR
La Mode

Dear Áine,

I was on a walk when I came upon so many interesting fashion choices that I thought Halloween came early. No. Just haute couture. A fashion show was underway. It's Fashion Week here in Paris — a very serious business. A parade of faces devoid of expression staring off in the middle distance. The only smile is that of the designer who pops out at the end, looking physically pained to smile and wave. To think, all these clothes started as a thought, then a scribble, a sketch, a discussion, and eventually something sewn and draped and worn.

Later, I reviewed the shows. There were long coats with buttons and bows, short coats with sashes and zippers, some vibrant and some muted, paired with heels or flats. All the designers were doing something different and contrary to each other. Now we as the audience wait and see what will become a trend and what will be seen as an interesting exercise. I spotted one person wearing athletic gear but with a shirt that had sort of tentacles hanging off it. Now that would be an interesting exercise.

-Jamie

257

November 2019, Paris

Dear Áine,

Just when I thought I knew all I could know about this fantastic French city, I discover a whole other city inside. This town is full of curious tall Roman arches. They frame big doorways, are part of exterior walls of bistros, and can even be found in the middle of restaurant interiors. For a long time I didn't even <u>notice</u> the arches. Then when I did, I thought they were an odd design choice, or even a decorative load-bearing post. *Mais non.* Many of these arched zones were stables for a city of horses. The original car parks!

Less than 100 years ago, Paris still ran on horses. Homes were equipped to house horses and carriages (and had central squares where they could turn around), and department stores had horse parking lots, which are now cleverly disguised as parking lots—still filled with horsepower, but alas, no horses. The Louvre stables now display statues, but in its heyday it could accommodate 150 horses and carriages. I've walked through the room a dozen times and never recognized it as a stable. Hidden in plain sight! But now it's all so obvious. You spot a tall archway and can easily imagine how horse travel fit in Paris. Some doors still have low metal bars across them that were once packed with hay for hungry horses. So now I will walk all over Paris again with the fresh eyes of education to find these equine artifacts. The horses were here less than 100 years ago, and in less than 100 years from now, driverless vehicles will likely be cruising these streets. What will become of our parking lots or even traffic signals? Will some writer in the future see the scars of an old gas station and find it as charming as I find the Roman arches? Astoundingly likely.

Janice

———— ≈ ————

"Everybody has a secret world inside of them. I mean everybody . . . no matter how dull and boring they are on the outside. Inside them they've all got unimaginable, magnificent, wonderful, stupid, amazing worlds . . . Hundreds of them. Thousands, maybe."

Neil Gaiman, *The Sandman: A Game of You*

Dear Áine, November 2019, Paris

Just when I thought I knew all I could know about this fantastic French city,
I discover a whole other city inside. This town is full of curious tall Roman
arches. They frame big doorways, are part of exterior walls of bistros, and
can even be found in the middle of restaurant interiors. For a long time I
didn't even <u>notice</u> the arches. Then when I did, I thought they were an odd
design choice, or even a decorative load-bearing post. Mais non. Many of
these arched zones were stables for a city of horses. The original car parks!

Less than 100 years ago, Paris still ran on horses. Homes were equipped
to house horses and carriages (and had central squares where they could
turn around), and department stores had horse parking lots, which are
now cleverly disguised as parking lots — still filled with horse power,
but alas, no horses. The Louvre stables now display statues, but in its
heyday it could accomodate 150 horses and carriages. I've walked through
the room a dozen times and never recognized it as a stable. Hidden in
plain sight! But now it's all so obvious. You spot a tall archway and
can easily imagine how horse travel fit in Paris. Some doors still have low
metal bars across them that were once packed with hay for hungry horses.
So now I will walk all over Paris again with the fresh eyes of education
to find these equine artifacts. The horses were here less than 100 years
ago, and in less than 100 years from now, driverless vehicles will likely
be cruising these streets. What will become of our parking lots or even
traffic signals? Will some writer in the future see the scars of an old
gas station and find it as charming as I find the Roman arches? Astoundingly likely.

 —Janice

BHV

December 2019, Paris

Dear Áine,

I think I kind of had a romantic encounter with an older gentleman today. I was on my usual holiday outing to BHV (pronounced Bay-Ahsh-Vay) department store to pretend to shop for those on my Christmas list but really scout for pressies for myself. I was in the kitchen department when I came upon a wall of pepper grinders from Peugeot. Yes, before Peugeot was making cars, the family was turning out these massive chess-piece-like mills to add a little spice to the French table. These grinders are virtually indestructible, they are ergonomically pleasing to hold, and they even sound great when in use—a nice smooth grind. I have spent much time and money on substandard grinders and left many a–busted contraption in my wake. This wall of grinders offered a rainbow of hues. I scanned the lot and feasted my eyes on a bright poppy red mill so perfect in design and shade that I gasped audibly. Astonishingly, mine wasn't the only gasp. The older gentleman had come around the other side and discovered the red one at the same time. We both giggled at each other as we reached for the answer to our pepper grinder woes. Thankfully there were two. He looked at me. I looked at him. He held out his grinder. I held out mine. We clinked our grinders together. Cheers! And bid each other a *Joyeux Noël*. Now my little grinder will stand like a soldier at most meals, happy to serve. Seeing it will likely bring to mind my encounter with the gentleman. I wonder if I will come to mind when he sprinkles some spice on his steak. I sure hope so.

Joyeux Noël!

Janice

> "'Like I said, I'm fine. I don't ever think of her.' And
> I didn't ever think of her, except from time to time."
>
> David Nicholls, *Sweet Sorrow*

Dear Áine, December 2019, Paris

I think I kind of had a romantic encounter with an older gentleman today.
I was on my usual holiday outting to BHV (pronounced Bay-Ahsh-Vay) department
store to pretend to shop for those on my Christmas list but really scout for
pressies for myself. I was in the kitchen department when I came upon
a wall of pepper grinders from Peugeot. Yes, before Peugeot was making cars,
the family was turning out these massive chess-piece-like mills to add a little
spice to the French table. These grinders are virtually indestructible, they are
ergonomically pleasing to hold, and they even sound great when in use — a nice
smooth grind. I have spent much time and money on substandard grinders and
left many a-busted contraption in my wake. This wall of grinders offered a rainbow
of hues. I scanned the lot and feasted my eyes on a bright poppy red mill
so perfect in design and shade that I gasped audibly.
Astonishingly, mine wasn't the only gasp. The older
gentleman had come around the other side and discovered
the red one at the same time. We both giggled at each
other as we reached for the answer to our pepper
grinder woes. Thankfully there were two. He looked
at me. I looked at him. He held out his grinder.
I held out mine. We clinked our grinders together.
Cheers! And bid each other a Joyeux Noël.
Now my little grinder will stand like a
soldier at most meals, happy to serve.
Seeing it will likely bring to mind
my encounter with the gentleman.
I wonder if I will come to
mind when he sprinkles
some spice on his
steak. I sure hope so.
Joyeux Noël!
– Janice

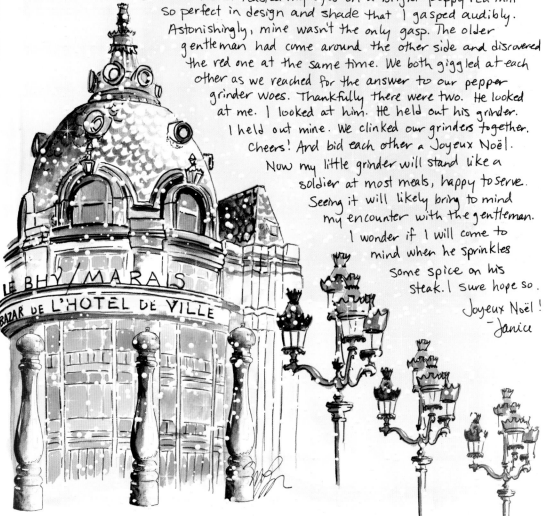

LE BHV/MARAIS
BAZAR DE L'HÔTEL DE VILLE

January 2020, Paris

Dear Áine,

Greetings from the café at Galeries Lafayette in Paris. Something stinks in Paris and it's not the perfume left over from sluggish holiday sales. It's the stench of the transit strike that has left too many too stranded for too long. This strike is in protest to a new pension reform plan that, if not implemented soon, will also leave too many too stranded for too long in another way. In brief, soon there will be many pensioners and fewer contributors. Simple math. Back when Jacques Chirac tried this, the transit strike was so debilitating that he scrapped the plan altogether. Now President Macron is faced with even more dire numbers. I would not want to be a French president during pension reform—not for all the best baguettes in France. I was pondering all this as I gazed at the perfumes sparkling in this glittery department store. The fashion designers added perfume to their collections as a way to boost the bottom line. In fact, perfume sales have bankrolled the fashion houses since Chanel sniffed bottle number five. More people are willing and able to dish out for a luxury perfume than a handbag. The trick is to create a scent (and bottle and marketing campaign) that appeals to the widest possible audience. I'm not saying the government should create a perfume to fund the pension—though I wonder about the fragrance of that eau de toilette. They just need to design something that doesn't stink to most people. While they figure it out, I think I'll visit the perfume counter and daub a little French ingenuity behind my ears. I'll smell like sunshine as I weave around pedestrians and protesters on the long walk home.

Janice

"I kept walking. Have you ever done that? Just walk. Just walk and have no idea where you're going? It wasn't a good feeling, but not a bad one either. I felt caged and free at the same time."

Markus Zusak, *Underdogs*

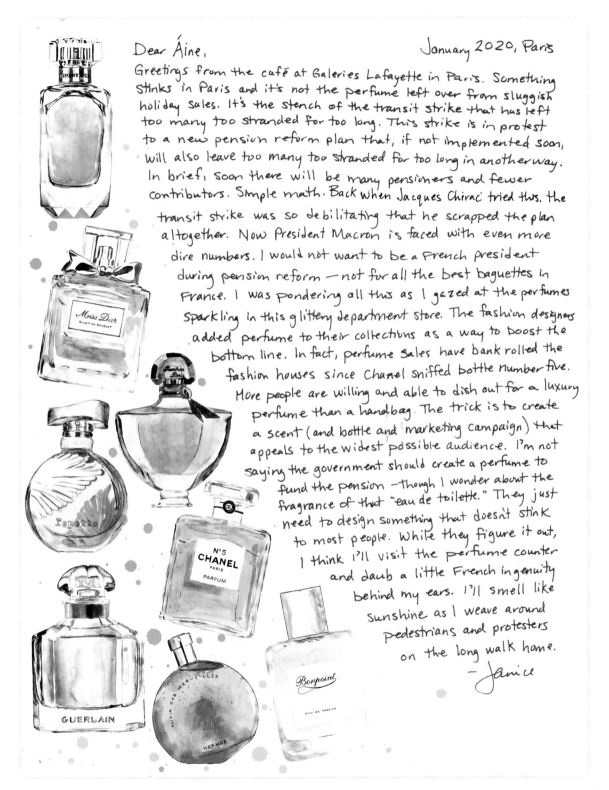

Dear Áine, January 2020, Paris

Greetings from the café at Galeries Lafayette in Paris. Something
stinks in Paris and it's not the perfume left over from sluggish
holiday sales. It's the stench of the transit strike that has left
too many too stranded for too long. This strike is in protest
to a new pension reform plan that, if not implemented soon,
will also leave too many too stranded for too long in another way.
In brief, soon there will be many pensioners and fewer
contributors. Simple math. Back when Jacques Chirac tried this, the
transit strike was so debilitating that he scrapped the plan
altogether. Now President Macron is faced with even more
dire numbers. I would not want to be a French president
during pension reform — not for all the best baguettes in
France. I was pondering all this as I gazed at the perfumes
sparkling in this glittery department store. The fashion designers
added perfume to their collections as a way to boost the
bottom line. In fact, perfume sales have bank rolled the
fashion houses since Chanel sniffed bottle number five.
More people are willing and able to dish out for a luxury
perfume than a handbag. The trick is to create
a scent (and bottle and marketing campaign) that
appeals to the widest possible audience. I'm not
saying the government should create a perfume to
fund the pension — though I wonder about the
fragrance of that "eau de toilette." They just
need to design something that doesn't stink
to most people. While they figure it out,
I think I'll visit the perfume counter
and daub a little French ingenuity
behind my ears. I'll smell like
sunshine as I weave around
pedestrians and protesters
on the long walk home.
 — Janice

Vincent

February 2020, Paris

Dear Áine,

Recently, we celebrated St. Vincent, the patron saint of winemakers. But for me, it's a
celebration of my bartender pal Vincent. He speaks elegant English and seems to take
great pride in being able to volley between French and English when conversing with
Christophe and I. When we sat down at his bar, I was startled to see how old and thin
he had become. When he saw us, his whole face smiled. "A surprise and a pleasure."
He kissed my hand, then both cheeks. How long has it been? "At least a year," he
informed me. The last time I saw him, he had finished his shift and was a few bars into
his evening, in that wobbly state between drunk and oblivion.

"I am older now, yes?" He touched his face. Paris is a *"ville de vielle,"* meaning an old
town but also a city of old people. "Now I fit in," he laughed. He quit drinking about
the time I, or anyone, stopped running into him. It was a challenge requiring great
concentration. I asked if it was hard to still be a bartender. *"Pas du tout."* Not at all. How
else would he see his friends? And he pointed to the bottles. "Some people look behind
the bar and see a wall of bottles. Me? I see a bookshelf full of family albums. Each bottle
is a memory—some good, some not good—just like a family album. The bottles are a
comfort. It's nice to know they are there." Our talk got me thinking about St. Vincent
and winemakers. I've known winemakers who don't drink, tobacco farmers who don't
smoke, and PLENTY of writers who don't write. (Paris is full of wishful authors.) So a
bartender who doesn't drink isn't so odd. We wished him a *"Bonne Année."* He took
a deep breath. "It will be a long year for me. Time is slower without the drink." Then
he shook his head, as if disagreeing with someone he couldn't see. "That's not such a
bad thing."

Janice

————

*"There's something fascinating about seeing something you
don't like at first but directly know you will love—in time."*

Vincent Price, *I Like What I Know*

Dear Áine, February 2020, Paris

Recently, we celebrated St. Vincent, the patron saint of wine makers.
But for me, it's a celebration of my bartender pal Vincent. He speaks elegant
English and seems to take great pride in being able to volley between French
and English when conversing with Christophe and I. When we sat down at his
bar, I was startled to see how old and thin he had become. When he saw
us, his whole face smiled. "A surprise and a pleasure."
He kissed my hand, then both cheeks.
How long has it been? "At least a year,"
he informed me. The last time I saw
him, he had finished his shift and was
a few bars into his evening, in that
wobbly state between drunk
and oblivion.

"I am older now, yes?" He touched his face. Paris is a "ville de vielle," meaning
an old town but also a city of old people. "Now I fit in," he laughed. He quit
drinking about the time I, or anyone, stopped running into him. It was a challenge
requiring great concentration. I asked if it was hard to still be a bartender. "Pas du tout."
Not at all. How else would he see his friends? And he pointed to the bottles.
"Some people look behind the bar and see a wall of bottles. Me? I see a bookshelf
full of family albums. Each bottle is a memory — some good, some not good —
just like a family album. The bottles are a comfort. It's nice to know they are there."
Our talk got me thinking about St. Vincent and wine makers. I've known wine-
makers who don't drink, tobacco farmers who don't smoke, and PLENTY of writers
who don't write. (Paris is full of wishful authors.) So a bartender who doesn't
drink isn't so odd. We wished him a "Bonne Année." He took a deep breath.
"It will be a long year for me. Time is slower without the drink." Then he
shook his head, as if disagreeing with someone I couldn't see. "That's not
such a bad thing." — Janice

March 2020, Paris

Dear Áine,

Yesterday I spent a rainy afternoon at the stamp store. My philatelic friend sells and trades all manner of postage stamps. He regards me with kind indifference. He knows I'm there for lovely stamps that don't hold much value, monetarily speaking. Still, my purchase will fund a midafternoon coffee so he puts up with me digging in his bins. A colleague of his came in while I was inspecting various versions of the most common French stamp—the Marianne. The colleague leaned in on the counter, our Monsieur put down his copy of *Le Monde*, and hushed tones of excited jibber jabber commenced. Monsieur pulled out a box from under the counter and opened it gingerly. Angels sang. Sunshine beamed in. *Non*. Not really. It was a stamp. Some rare expensive stamp I know nothing about but they fawned over and discussed at length. Then they both stood back from the counter, delighted that the search was over. This rare stamp existed and it was here. Then the colleague tapped the counter, nodded, and left. He didn't buy it. I said as much to Monsieur. He laughed. "Some people support your passions." He tapped the cash register. "And some people support your passions." He put his hand to his heart. Then he peered over to my pile of stamps. "I'm not sure which person you are yet."

Janice

———— ≈ ————

"*I am excessively diverted.*"

Jane Austen, *Pride and Prejudice*

March 2020,
Paris

Dear Áine,

Yesterday I spent a rainy afternoon at the stamp store. My philatelic friend sells and trades all manner of postage stamps. He regards me with kind indifference.

He knows I'm there for lovely stamps that don't hold much value, monetarily speaking. Still, my purchase will fund a midafternoon coffee so he puts up with me digging in his bins. A colleague of his came in while I was inspecting various versions of the most common French stamp—the Marianne. The colleague leaned in on the counter, our Monsieur put down his copy of "Le Monde," and hushed tones of excited jibber jabber commenced. Monsieur pulled out a box from under the counter and opened it gingerly. Angels sang. Sunshine beamed in. Non. Not really. It was a stamp. Some rare expensive stamp I know nothing about but they fawned over and discussed at length. Then they both stood back from the counter, delighted that the search was over. This rare stamp existed and it was here. Then the colleague tapped the counter, nodded, and left. He didn't buy it. I said as much to Monsieur. He laughed. "Some people support your passions." He tapped the cash register. "And some people support your passions." He put his hand to his heart. Then he peered over to my pile of stamps. "I'm not sure which person you are yet."

—Janice

Fleuriste

April 2020, Paris

Dear Áine,

The French pride themselves on being a careful, cautious people. If you have any paperwork that needs to be approved, their careful caution often means delays and frustration. In fact, when our dossier of paperwork was approved at city hall and we were permitted to marry (!!!), more people congratulated us on the approval of paperwork than the actual marriage. So their slow pace ways can irritate people like me who hail from faster pace cultures. This snail's pace has its place—in cheese and wine—and, as I recently learned, in flower shops. I popped in to see my local *fleuriste* for a fresh something to brighten up my windowsill. She was in the middle of creating a bouquet of 60 roses. She said she would be a few minutes as I could see her hands were occupied. Would I mind waiting? In this case, I wouldn't mind at all. She held the first stem in one hand, then added stem after stem alongside the previous, making sure the blooms were even. In the end, she would tie the bundle, then trim the stems to make them as even as the blooms on top. Watching her, I realized I have been putting bouquets together all wrong—jamming stems into vases, taking them out, trimming stems, and jamming them back in. Nothing looking quite right. Something always askew or a stem not bending to my will. And there you go. This was my French lesson for today—paperwork, cheese, flowers—it's all the same: Sometimes you might get a better result if you take one step, or in this case, stem, at a time.

Janice

"Nobody sees a flower—really—it is so small it takes time—we haven't time—and to see takes time, like to have a friend takes time."

Georgia O'Keeffe

Dear Áine,

The French pride themselves on being a careful, cautious people. If you have any paperwork that needs to be approved, their careful caution often means delays and frustration. In fact, when our "dossier" of paperwork was approved at city hall and we were permitted to marry (!!!), more people congratulated us on the approval of paperwork than the actual marriage. So their slow pace ways can irritate people like me who hail from faster pace cultures. This snail's pace has its place — in cheese and wine — and, as I recently learned, in flower shops. I popped in to see my local fleuriste for a fresh something to brighten up my windowsill. She was in the middle of creating a bouquet of 60 roses. She said she would be a few minutes as I could see her hands were occupied. Would I mind waiting? In this case, I wouldn't mind at all. She held the first stem in one hand, then added stem after stem alongside the previous, making sure the blooms were even. In the end, she would tie the bundle, then trim the stems to make them as even as the blooms on the top. Watching her, I realized I have been putting bouquets together all wrong — jamming stems into vases, taking them out, trimming stems, and jamming them back in. Nothing looking quite right. Something always askew or a stem not bending to my will. And there you go.

This was my French lesson for today — paperwork, cheese, flowers — it's all the same: Sometimes you might get a better result if you take one step, or in this case, stem, at a time.

— Janice

L'artisan Fleuriste

269

May 2020, Paris

Dear Áine,

Paris was kind of a bummer this year with Notre Dame all boarded up after her run-in with an old flame last May. She is strategically located between where I live and where I roam, so I popped in often for a silent reprieve and to rest my aching feet. But now, I have needed to reroute my rests, so I've been spending more time in other churches. Paris is kind in letting all these great churches stay open to weary urban hikers such as myself.

The churches offer stunning architecture, statues, paintings, and—I learned recently, sundials. Paris has more sundials than any French city—120 of them! They've been used to track the sun so they could determine the exact date of Easter. This is all reminiscent of a Dan Brown novel and positively reeks of intrigue. Naturally, I set out to find these sundials all over Paris. The faded lines were etched on a wall of a church or in a courtyard out front. Some still work, others are shaded from overgrown trees or are half covered in vines. Most, I wouldn't have noticed unless I was looking for them. I suppose this is true for the churches themselves. Had it not been for Notre Dame's fire, I would have missed these delightful romps around town. It was hard on my feet though. On one sunny day, when I had walked a bit beyond my limit, I stopped to rest in a park. People had arranged their chairs to face the sun. After one person would leave, another would arrive to take his place, adjusting the chair slightly toward the moving sun. And there was the final sundial, this one made of a collection of strangers who were, unknowingly, announcing that spring had arrived.

Janice

"She turned to the sunlight
And shook her yellow head
And whispered to her neighbour
'Winter is dead'"

A.A. Milne, "Daffodowndilly," *When We Were Very Young*

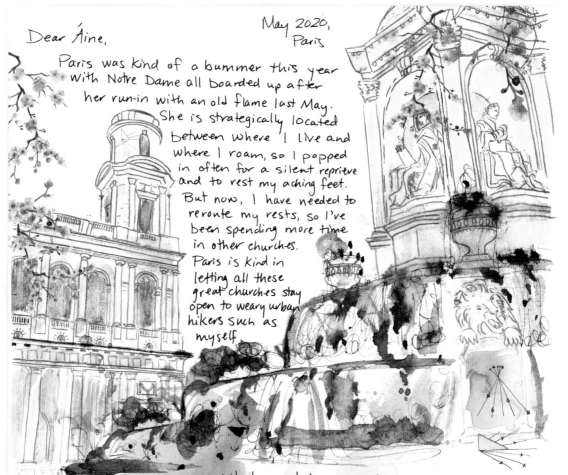

Dear Áine,

May 2020,
Paris

Paris was kind of a bummer this year with Notre Dame all boarded up after her run-in with an old flame last May. She is strategically located between where I live and where I roam, so I popped in often for a silent reprieve and to rest my aching feet. But now, I have needed to reroute my rests, so I've been spending more time in other churches. Paris is kind in letting all these great churches stay open to weary urban hikers such as myself.

The churches offer stunning architecture, statues, paintings, and — I learned recently, sundials. Paris has more sundials than any French city — 120 of them! They've been used to track the sun so they could determine the exact date of Easter. This is all reminescent of a Dan Brown novel and positively reeks of intrigue. Naturally, I set out to find these sundials all over Paris. The faded lines were etched on a wall of a church or in a courtyard out front. Some still work, others are shaded from overgrown trees or are half covered in vines. Most, I wouldn't have noticed unless I was looking for them. I suppose this is true for the churches themselves. Had it not been for Notre Dame's fire, I would have missed these delightful romps around town. It was hard on my feet though. On one sunny day, when I had walked a bit beyond my limit, I stopped to rest in a park. People had arranged their chairs to face the sun. After one person would leave, another would arrive to take his place, adjusting the chair slightly toward the moving sun. And there was the final sundial, this one made of a collection of strangers who were, unknowingly, announcing that spring had arrived. — Janice

June 2020, Paris

Dear Áine,

I'm at the train station awaiting the arrival of a friend who is visiting me in Paris for the week. As I look around, I see so many emotions—mainly negative emotions. Seeing these faces reminds me that it's often so much easier to stay home than travel. Travel, at its root, is a verb. To move. The familiar comforts are gone. Tempers flare after sleeping upright all night—even a sleeper car is jarring and stiff. There is weird food, terrible coffee, confusing money exchange, thieves lurking. You actually start to crave a McDonald's and an hour with fast WiFi to bask in an acre of cyberspace . . . a little embassy of you. Hemingway said you should never travel with someone you don't love. You should also never travel with someone who is very attached to their routine. Travel could be considered the opposite of routine. You can't re-create your perfect day in L.A. when you're in Paris. The city won't let you. "You're under my roof, you'll go by my rules." This happened to me and a friend of mine. A day into exploring a city and we were already exasperated by each other's desires. I suggested we split up—me to see the new, her to see the old. Go! Me to find who I was in this new place, her to find her old ways in this new place. In the end, there were train tickets exchanged for earlier dates and in opposite directions—and a crack in a friendship neither of us recovered from, not that we even wanted to. The stakes are higher with travel. Having a day ruined at home is one thing, but having it ruined abroad after hotels and tickets have been saved up for and purchased—well, that's quite another. I wonder, as I watch all the travelers at this station, who is coming, who is going, and why. So many stories walking about—some beginning . . . and some ending. What I wouldn't give to read their thoughts today.

Janice

"Like some wines, our love could neither mature nor travel."

Graham Greene, *The Comedians*

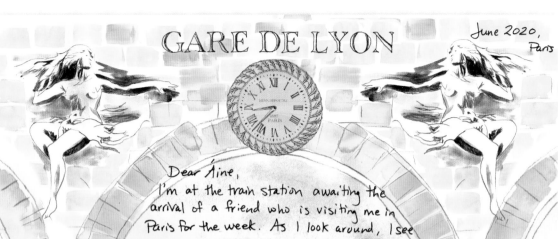

GARE DE LYON

Dear Áine,

I'm at the train station awaiting the arrival of a friend who is visiting me in Paris for the week. As I look around, I see so many emotions — mainly negative emotions. Seeing these faces reminds me that it's often so much easier to stay home than travel. Travel, at its root, is a verb. To move. The familiar comforts are gone. Tempers flare after sleeping upright all night — even a sleeper car is jarring and stiff. There is weird food, terrible coffee, confusing money exchange, thieves lurking. You actually start to crave a McDonald's and an hour with fast WiFi to bask in an acre of cyberspace... a little embassy of you. Hemingway said you should never travel with someone you don't love. You should also never travel with someone who is very attached to their routine. Travel could be considered the opposite of routine. You can't re-create your perfect day in L.A. when you're in Paris. The city won't let you. "You're under my roof. You'll go by my rules." This happened to me and a friend of mine. A day into exploring a city and we were already exasperated by each other's desires. I suggested we split up — me to see the new, her to see the old. Go! Me to find who I was in this new place, her to find her old ways in this new place. In the end, there were train tickets exchanged for earlier dates and in opposite directions — and a crack in a friendship neither of us recovered from, not that we wanted to. The stakes are higher with travel. Having a day ruined at home is one thing, but having it ruined abroad after hotels and tickets have been saved up for and purchased — well, that's quite another. I wonder, as I watch all the travelers at this station, who is coming, who is going, and why. So many stories walking about — some beginning... and some ending. What I wouldn't give to read their thoughts today.

— Jenice

June 2020, Vienna, Austria

Dear Áine,

The trip to Vienna started off anticlimactic. When you've lived in big cities like Paris and Los Angeles, it's easy to forget that one can get around most European cities in a couple of days. After we ate the cheese-filled street hotdogs, meandered through the cathedrals, and tried the schnitzel from the alleged "world famous" schnitzel house, we were at a bit of a loss. We revisited our tourist map to see what we could, well, revisit. There we spotted the Schönbrunn Palace, home of the Hapsburgs. Off we went. We were delighted to discover it was a self-guided audio tour, available in many languages including English and Polish. Christophe's first language is Polish and mine is English. It was nice to take a break from French and walk along in the relaxing lull of our own languages. With our earphones on, we learned the usual facts—who lived there and when, and why they aren't there anymore. We also learned Mozart played at court when he was young. There is even a painting commemorating the event. Strangely, it was painted before he was born. The artist added him later. That's how much they loved Mozart. After the tour, we took another walk around Vienna. By then the churches had begun their evening concerts. Familiar melodies poured out to the street—a sonnet soup—and those of us walking by swished and swayed to the tune.

Janice

———— ≈ ————

"The music is not in the notes, but in the silence between."

Wolfgang Amadeus Mozart

Dear Áine,

The trip to Vienna started off anticlimactic. When you've lived in big cities like Paris and Los Angeles, it's easy to forget that one can get around most European cities in a couple of days. After we ate the cheese-filled street hotdogs, meandered through the cathedrals, and tried the schnitzel from the alleged "world famous" schnitzel house, we were at a bit of a loss. We revisited

our tourist map to see what we could, well, revisit. There we spotted the Schönbrunn Palace, home of the Hapsburgs. Off we went. We were delighted to discover it was a self-guided audio tour, available in many languages including English and Polish. Christophe's first language is Polish and mine is English. It was nice to take a break from French and walk along in the relaxing lull of our own languages. With our earphones on, we learned the usual facts — who lived there and when, and why they weren't there anymore. We also learned Mozart played at court when he was young. There is even a painting commemorating the event. Strangely, it was painted before he was born. The artist added him later. That's how much they loved Mozart. After the tour, we took another walk around Vienna. By then the churches had begun their evening concerts. Familiar melodies poured out to the street — a sonnet soup — and those of us walking by swished and swayed to the tune.

— Janice

July 2020, Paris

Dear Áine,

People often say that so much writing is done in Paris because of the cafés. While it's true that a great many thinkers have taken pen to paper while tucked into a corner of a bustling eatery, I think that's only half the story. Any writer who truly writes knows one simple truth: You cannot write while walking. Just try to write a quick list on the way to the grocer and you'll know what I mean. Pulling out a paper and pen mid-stride isn't worth the trouble. So writers, in order to avoid the page, walk away from it. Walking, you see, must be done anyway for good health. The greatest, most widely accepted and encouraged act of procrastination is to walk. And Paris is the greatest walking city.

Paris was designed to be done in stride—all the sidewalks, stairways, drinking fountains, and benches have been placed "just so" so that you can get in a good walk. The idea has been built up over the centuries with ornate doors, statues, and monuments to amuse the eye en route. The city of Paris is the perfect place for writers to avoid writing. Look at the bottom of any writer's shoes and you will see a well-worn heel. We must tire ourselves out, you see, run ourselves to weariness and thirst before we will finally sit down to write. And once we are at that point, well looky-loo, a café. So we sit, order a coffee and water, and address the page. I don't know how other writers begin their pages, but today, after a very long walk, I addressed this one with your name.

Janice

*"You never have to change anything you
got up in the middle of the night to write."*

Saul Bellow

Dear Áine,

People often say that so much writing is done in Paris because of the cafés. While it's true that a great many thinkers have taken pen to paper while tucked into a corner of a bustling eatery, I think that's only half the story. Any writer who truly writes knows one simple truth: you cannot write while walking. Just try to write a quick list on the way to the grocer and you'll know what I mean. Pulling out a paper and pen mid-stride isn't worth the trouble. So writers, in order to avoid the page, walk away from it. Walking, you see, must be done anyway for good health. The greatest, most widely accepted and encouraged act of procrastination is to walk. And Paris is the greatest walking city.

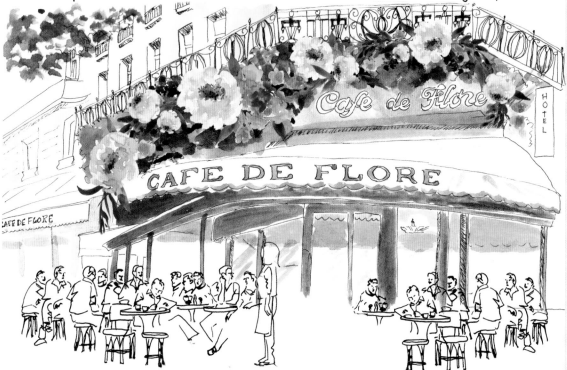

Paris was designed to be done in stride —all the sidewalks, stairways, drinking fountains, and benches have been placed "just so" so that you can get in a good walk. The idea has been built upon over the centuries with ornate doors, statues, and monuments to amuse the eye en route. The city of Paris is the perfect place for writers to avoid writing. Look at the bottom of any writer's shoes and you will see a well-worn heel. We must tire ourselves out, you see, run ourselves to weariness and thirst before we will finally sit down to write. And once we are at that point, well looky-loo, a café. So we sit, order a coffee and water, and address the page. I don't know how other writers begin their pages, but today, after a very long walk, I addressed this one with your name.

— Jania

August 2020, Paris

Dear Áine,

I've been tracking The Lady. Her window faces my window. Our courtyards are divided by an ivy-covered stone wall so that we cannot see into each other's courtyards, but we can talk to each other from the windows. She calls out for her cat, I peer into my courtyard and report if the cat is on my side. She is a good mouser—the cat, not The Lady. I don't know her name and by now it's too late to ask. She's ancient and wears a pillbox hat wherever she goes. I spoke with her on the street and asked if she was going on vacation like most of Paris in August. "Too old," she said. "Don't want to spend the money to struggle on stairs by the sea. I have my own stairs in Paris for free. I just hope I don't die in August. No one will be here for the party. All on holiday!" I asked about her health. "Same! But at my age I could 'expire' at any moment." Then she went "Pouff" with her hands.

So I've been keeping an eye out for both her and her cat. I have also recruited Christophe to report when he sees her on the street. Today I saw her dancing at the Sunday market. Every Sunday on rue Mouffetard there is music, dancing, and a sing-a-long. She was dancing with a handsome man. She had a sparkle in her eye that led me to believe there might be other reasons she's not interested in going anywhere anytime soon.

Janice

"The screen door slams
Mary's dress waves
Like a vision she dances
Across the porch
As the radio plays"

Bruce Springsteen, "Thunder Road"

August 2020, Paris

Dear Áine,

I've been tracking The Lady. Her window faces my window. Our courtyards are divided by an ivy-covered stone wall so that we cannot see into each other's courtyards, but we can talk to each other from the windows. She calls out for her cat, I peer into my courtyard and report if the cat is on my side. She's a good mouser — the cat, not The Lady. I don't know her name and by now it's too late to ask. She's ancient and wears a pill box hat wherever she goes. I spoke with her on the street and asked if she was going on vacation like most of Paris in August. "Too old," she said, "Don't want to spend the money to struggle on stairs by the sea. I have my own stairs in Paris for free. I just hope I don't die in August. No one will be here for the party. All on holiday!" I asked about her health. "Same! But at my age I could 'expire' at any moment. Then she went "Pouff" with her hands.

So I've been keeping an eye out for both her and her cat. I have also recruited Christophe to report when he sees her on the street. Today I saw her dancing at the Sunday market. Every Sunday on Rue Mouffetard there is music, dancing, and a sing-a-long. She was dancing with a handsome man. She had a sparkle in her eye that led me to believe there might be other reasons she's not interested in going anywhere any time soon.

— Janice

279

September 2020, Paris

Dear Áine,

I love Starbucks. I love Starbucks for the lemonade and anonymity, for the global decor so I can feel all at once that I am in all the places I've lived. I love Starbucks for the ample seating that seems to encourage both solitude and company. I love Starbucks for the clean washrooms and powerful WiFi, and for solid tables along the windows. I love the coffee bean aroma—the same in all locations—like candles and incense in churches. Wherever I am in my life and the world, I can return and be a citizen of Starbucks. But on the day when my electricity went out in the wee hours of the morning, I knew I could not turn to Starbucks. There, they have friendly faces but not FAMILIAR faces. There, they are open exactly on time but not a minute sooner. So I went looking for light in the familiar faces of my local bistro—TournBride at 104 rue Mouffetard. They weren't open either, but no corporate cash register said they couldn't unlock the door. I entered, grateful, and explained. I was handed a coffee and could camp out in the corner until the electricity came back on. From here, I watched the street awaken: Delivery trucks, lights flickering on, and a symphony of Bonjours. The wine merchant came by for two coffees to go, in porcelain cups and saucers. One for him and one for the cheesemonger next door. They stood side by side, each on the edge of their shops to sip and chat. Later, the cheesemonger returned for refills and they continued their conversation until customers arrived. All this I would have missed at Starbucks. I may love Starbucks, but it was a Paris café that lit up this dark day.

Janice

"What do you want?"
"Just coffee. Black—like my soul."

Cassandra Clare, *City of Bones*

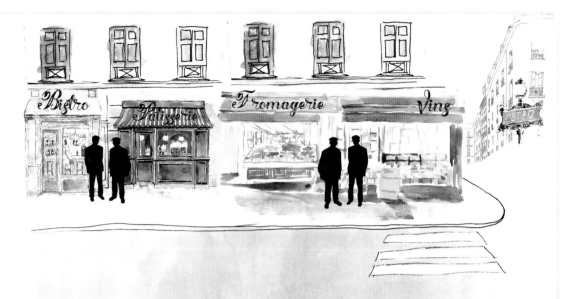

September 2020, Paris

Dear Áine,

I love Starbucks. I love Starbucks for the lemonade and anonymity, for the global decor so I can feel all at once that I am in all the places I've lived. I love Starbucks for the ample seating that seems to encourage both solitude and company. I love Starbucks for the clean washrooms and powerful WiFi, and for solid tables along the windows. I love the coffee bean aroma — the same in all locations — like candles and incense in churches. Wherever I am in my life and the world, I can return and be a citizen of Starbucks. But on the day when my electricity went out in the wee hours of the morning, I knew I could not turn to Starbucks. There, they have friendly faces but not FAMILIAR faces. There, they open exactly on time but not a minute sooner. So I went looking for light in the familiar faces of my local bistro - TownBride at 104 rue Mouffetard. They weren't open either, but no corporate cash register said they couldn't unlock the door. I entered, grateful, and explained. I was handed a coffee and could camp out in the corner until the electricity came back on. From here, I watched the street awaken: Delivery trucks, lights flickering on, and a symphony of Bonjours. The wine merchant came by for two coffees to go, in porcelain cups and saucers. One for him and one for the cheesemonger next door. They stood side by side, each on the edge of their shops to sip and chat. Later, the cheesemonger returned for refills and they continued their conversation until customers arrived. All this I would have missed at Starbucks. I may love Starbucks, but it was a Paris café that lit up this dark day. — Janice

Le Dome

October 2020, Paris

Dear Áine,

I had a colleague who would call me all the time, and by "all the time" I mean annually, which meant he wanted something. The constant requests felt like such an invasion. It was as though he walked in on me in the ladies' room whilst at the sink. It didn't feel like a bathroom stall invasion. He wasn't a pervert, just astounding. At the restaurant, he would begin. "I had a dream the other night," he says. "You were laughing at a funny story I was telling." Spare me. If it were reality, he would be talking and I would be, at most, nodding politely. He likes to regale me with stories of his witty retorts in sticky situations. "Wow, you really got him with that zinger," I would say. He's a Zinger Bragger—likes to go on about his brilliant comebacks. And me, in my highly polished facial expression of Calm Amuse, I was thinking three things: What time is it? What does he want? And why did I agree to this? We met for lunch because I read somewhere that you should do the hardest tasks early in the day if you want a productive life. Plus, I like to pair dinner with fun things that don't feel like work. When the dessert arrived (he insisted), he delivered his punch line: "I think you should write a book about me." There it was. "I couldn't pay you, of course." Of course not. In response, I had a zinger of my own: "Speaking of writing," I began. "I have a little translation project if you're interested. I couldn't pay you, of course. It's not TOO big." The French loathe three things: Talk of a foreign wine being superior, a draft (causes illness), and requests for translation. *"On va voir,"* he said. We will see. We parted in cheek kisses and promises to repeat this glorious event sooner rather than later. I left relieved but unsatisfied knowing I would probably get another call a mere year later.

Janice

———— ≈ ————

"At night I would climb the steps to the Sacré-Coeur, and I would watch Paris, that futile oasis, scintillating in the wilderness of space. I would weep, because it was so beautiful, and because it was so useless."

Simone de Beauvoir, *Memoirs of a Dutiful Daughter*

Dear Áine, October 2020, Paris

I had a colleague who would call me all the time, and by "all the time" I mean
annually, which meant he wanted something. The constant requests felt like
such an invasion. It was as though he walked in on me in the ladies' room
whilst at the sink. It didn't feel like a bathroom stall invasion. He wasn't a pervert,
just astounding. At the restaurant, he would begin. "I had a dream the other night,"
he says. "You were laughing at a funny story I was telling." Spare me. If it were
reality, he would be talking and I would be, at most, nodding politely. He likes
to regale me with stories of his witty retorts in sticky situations. "Wow, you
really got him with that zinger," I would say. He's a Zinger Bragger — likes
to go on about his brilliant come backs. And me, in my highly polished
facial expression of Calm Amuse, I was thinking three things: What time is it?
What does he want? And why did I agree to this? We met for lunch because

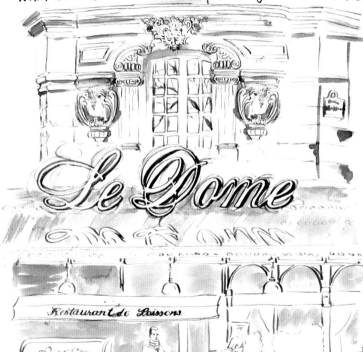

I read somewhere that
you should do the hardest
tasks early in the day if
you want a productive life.
Plus, I like to pair dinner
with fun things that don't
feel like work. When the
dessert arrived (he insisted),
he delivered his punch
line: "I think you
should write a book
about me." There it was.
"I couldn't pay you, of
course." Of course not.
In response, I had a
zinger of my own:
"Speaking of writing,"
I began. "I have a little
translation project if you're
interested. I couldn't pay you,
of course. It's not too big."
The French loathe three things: Talk of a
foreign wine being superior, a draft (causes illness),
and requests for translation. "On va voir," he said.
We will see. We parted in cheek kisses and promises to repeat
this glorious event sooner rather than later. I left relieved but
unsatisfied knowing I would probably get another call a more year later. — Jania

Ghostly Monuments

November 2020, Paris

Dear Áine,

I was outside the central post office admiring the ornate public clocks when the air raid sirens went off. Fear not. The city was not under attack. These sirens go off at midday on the first Wednesday of every month. They sound just as you'd expect—a piercing loud wail—the same alarm we've been fortunate enough to have heard in movies and not because of an actual emergency. When you hear them and know what they are, you do a mental check. Is it Wednesday at noon? Yes. Whew. This is just a test. If it were indeed an emergency, one must seek shelter, stay away from windows, and turn on the TV for news, updates, and instructions. Creepy. To me, this air raid test of the system is an auditory monument of darker days. When I hear the alarm, I imagine the ghosts of Paris scurrying about and rushing en masse down to the Métro stations. There are even ghost stations in Paris. These are stations that were either closed as the map of Paris evolved (usually due to close proximity to another more useful station), or they were built but never opened for one reason or another. They are also creepy. The tracks are still in use, so you can see these stations as you rumble by. The platforms are dark and sullen with time slowly peeling away old posters. Another auditory monument, but this one is deafeningly silent.

Janice

"It was the kind of conversation you could only hold in whispers."

Aimee Bender, *The Particular Sadness of Lemon Cake*

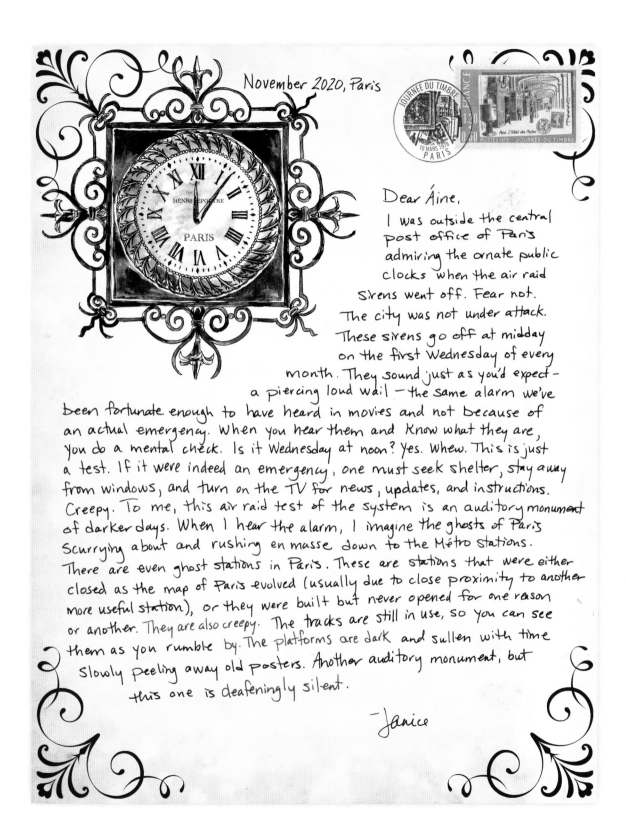

November 2020, Paris

Dear Áine,

I was outside the central post office of Paris admiring the ornate public clocks when the air raid sirens went off. Fear not. The city was not under attack. These sirens go off at midday on the first Wednesday of every month. They sound just as you'd expect — a piercing loud wail — the same alarm we've been fortunate enough to have heard in movies and not because of an actual emergency. When you hear them and know what they are, you do a mental check. Is it Wednesday at noon? Yes. Whew. This is just a test. If it were indeed an emergency, one must seek shelter, stay away from windows, and turn on the TV for news, updates, and instructions. Creepy. To me, this air raid test of the system is an auditory monument of darker days. When I hear the alarm, I imagine the ghosts of Paris scurrying about and rushing en masse down to the Métro stations. There are even ghost stations in Paris. These are stations that were either closed as the map of Paris evolved (usually due to close proximity to another more useful station), or they were built but never opened for one reason or another. They are also creepy. The tracks are still in use, so you can see them as you rumble by. The platforms are dark and sullen with time slowly peeling away old posters. Another auditory monument, but this one is deafeningly silent.

—Janice

285

Bonjour & Au Revoir

December 2020, Paris

Dear Áine,

Capturing the beauty of Paris at Christmas with words? Well, you have to see it to believe it. Every year I am astounded at just how crafty they are with twinkle lights. It's a masterpiece of bling. Every year I hear from friends who are fretting over their suitcases—trying to squeeze another gift inside to take back home, everyone asking how much cheese they can take and fretting over sniffing airport security dogs. Every year people are arriving, too, for a Christmas vacation. They start by visiting monuments, of course, propelling themselves through the city like human pinballs. On subsequent trips, the monuments they visit will get smaller and smaller. "There's the window of the hotel where we stayed." Some monuments will be lost forever. I still can't find the bistro where I had the best meal of my life. I was lost when I found it. There is also this door on Île Saint-Louis where I stood out from the rain. While waiting for the downpour to subside, I checked my messages on my phone. Seems there will be a book of these letters. There is just the question of a title. What would best encompass how to present my dear Paris?

Janice

"Now it's closing time, the music's fading out
Last call for drinks
I'll have another stout
Well I turn around to look at you
You're nowhere to be found
I search the place for your lost face
Guess I'll have another round
And I think that I just fell in love with you"

Tom Waits, "I Hope That I Don't Fall in Love with You"

Dear Áine,

Capturing the beauty of Paris at Christmas with words? Well, you have to see it to believe it. Every year I am astounded at just how crafty they are with twinkle lights. It's a masterpiece of bling. Every year I hear from friends who are fretting over their suitcases—trying to squeeze another gift inside to take back home, everyone asking how much cheese they can take and fretting over sniffing airport security dogs. Every year people are arriving, too, for a Christmas vacation. They start by visiting monuments, of course, propelling themselves through the city like human pinballs. On subsequent trips, the monuments they visit will get smaller and smaller. "There's the window of the hotel where we stayed." Some monuments will be lost forever. I still can't find the bistro where I had the best meal of my life. I was lost when I found it. There is also this door on Île Saint-Louis where I stood out from the rain. While waiting for the downpour to subside, I checked my messages on my phone. Seems there will be a book of these letters. There is just the question of a title. What would best encompass how to present my dear Paris?

—Janice

287

Thanks.

Thank you to my agent Laura Yorke and the Carol Mann Agency. You make it all run smoothly. Thank you to my editor Patty Rice and everyone at Andrews McMeel Publishing for taking on this project, and a special high five to Elizabeth Garcia for your sharp eyes and to Julie Barnes, who elevated this project with her elegant design.

To Sharon Yamamoto, who first offered up the title of this book, which are the first few words of the book. To Jeff Gelberg for introducing me to the Tom Waits song, which are the final few words of the book. And to my Paris friends who walked beside me for all the words in between. To Bernadette Lutz and her mother, Patricia Lutz, for nudging this project along. To Áine Magennis for being a wonderful pen pal, friend, and travel companion. To Karen VanOoteghem and Rob Sale, who introduced me to the work of Percy Kelly and inspired this journey. To Small House Big Pony for the help with the flower paintings. To Etsy for creating a marketplace to help artists do what they do best.

To my mother, Agnes MacLeod, who dutifully added each letter to her binder month after month, year after year. This is for you.

And to dear Paris.

About the Author

Janice MacLeod is best known as a Paris artist. She lives with her husband, Christophe, and daughter, Amélie, in Port Dover, Canada. She thinks any day spent creating art and stationery in her studio for her Etsy shop is a day well spent. This is her fifth book.

Shop: JaniceMacLeodStudio.Etsy.com
Info: JaniceMacLeod.com